OBAMA

THE HISTORIC FRONT PAGES

★

FROM ANNOUNCEMENT TO INAUGURATION,
CHRONICLED BY LEADING
U.S. AND INTERNATIONAL NEWSPAPERS

★

Created by **David Elliot Cohen**
and **Mark Greenberg**

★

Introduction by **Howard Dodson**
*Director, Schomburg Center for Research in Black Culture,
New York Public Library*

★

With photographs by **David Burnett, Dirck Halstead**
and ***The Washington Times* photo staff**

STERLING

New York / London
www.sterlingpublishing.com

STERLING and the distinctive Sterling logo are registered
trademarks of Sterling Publishing Co., Inc.

10 9 8 7 6 5 4 3 2 1

Published by Sterling Publishing Co., Inc.
387 Park Avenue South, New York, NY 10016

Copyright ©2009 Western Arts Management, Tiburon, CA,
and FirstLight Productions

Distributed in Canada by
Sterling Publishing Co.
c/o Canadian Manda Group
165 Dufferin Street
Toronto, Ontario, Canada M6K 3H6

Distributed in the United Kingdom by
GMC Distribution Services
Castle Place, 166 High Street
Lewes, East Sussex, England BN7 1XU

Distributed in Australia by
Capricorn Link (Australia) Pty. Ltd.
P.O. Box 704
Windsor, NSW 2756, Australia

Printed in Canada
All rights reserved

Designed by Lori Barra, TonBo designs
Production by Peter Truskier, Premedia Systems, Inc.

Sterling ISBN 978-1-4027-6902-3

For more information about custom editions, special sales, and premium
and corporate purchases, please contact the Sterling Special Sales
Department at 800-805-5489 or specialsales@sterlingpublishing.com.

Your comments welcome: editor.whatmatters@gmail.com.

PHOTOGRAPH BY DAVID BURNETT/CONTACT PRESS IMAGES

AN UNLIKELY JOURNEY

by Howard Dodson

★

"We are one people; we are one nation; and together, we will begin the next great chapter in the American story with three words that will ring from coast to coast − from sea to shining sea: **Yes We Can.**" –BARACK OBAMA

Who but the man himself, and perhaps his wife, Michelle, could have imagined a year earlier that **Barack Hussein Obama**, the 47-year-old African-American junior senator from the state of Illinois, could be elected the **44th president of the United States**? All of the cards were seemingly stacked against him − his youth, his race, his relative political inexperience, his limited name recognition and his complete lack of national campaign experience.

The photographs in this book capture the spirit of a nation on the brink of change, the power of a campaign, the beauty and support of a family, and the strength and determination of Barack Obama. Obama's key speeches articulate the campaign's vision and substance. And the national and international front pages included herein document the candidate's ascent.

November 4, 2008, will always be remembered as the day that transformed America's political history. And thanks to newspapers from around the world, November 5 will be remembered as the day that confirmed and memorialized for posterity the truly historic nature of Obama's victory.

It's hard to imagine now, but just 12 months before Barack Obama's Grant Park victory speech, the front-runners for the Democratic and Republican parties had

Photomosaic of Barack Obama constructed from front-page newspaper clippings from around the world on the day after Obama's election as president of the United States. PHOTOMOSAIC BY ROBERT SILVERS, BASED ON A PORTRAIT BY DAVID BURNETT

been declared. Obama's name was among them, but while he had announced his intent to run on February 10, 2007, and had put together a fledgling campaign organization, most thought that Hillary Clinton was a shoo-in. **They likely believed that white America was not yet ready to support a black candidate for the presidency of the United States in 2008.** Equally significant, they probably wondered where a black man would get the money to compete. Serious candidates for the presidency would have to raise a minimum of $100 million to be competitive in the 2008 election. Where could Obama expect to find that kind of money?

In addition, both of the other Democratic front-runners had national name recognition and presidential campaign experience. Senator John Edwards from North Carolina had been the Democratic candidate for vice president in 2004. He was an experienced national campaigner and fund-raiser, and a passionate defender of the poor and oppressed. Hillary Rodham Clinton, the high-profile senator from the state of New York and the former first lady of the United States, had entered the campaign as the presumptive nominee of the Democratic Party. In addition to her own considerable name recognition and political acumen, she had essentially inherited the political apparatus of the Democratic Party from her husband, popular ex-president Bill Clinton. Terry McAuliffe, former Democratic National Committee chairman, was her campaign manager, and Bill Clinton himself, one of the most brilliant political minds in the world, was one of her chief political strategists.

Finally, the Democratic Party had restructured the Democratic primary campaign process to culminate on "Super Tuesday" – February 5, 2008. It was presumed that Clinton would capture the majority of the 24 primaries held on that date and essentially lock up the nomination. Seemingly, all of the cards in the Democratic primary were stacked against an Obama nomination and eventual presidency.

And even if he managed somehow to win the Democratic nomination, Obama would have to face one of the Republican front-runners in the general election. They also comprised an impressive group with considerable presence and name recognition in American politics: Rudolph Giuliani, former mayor of New York City; Mitt Romney, former governor of Massachusetts; John McCain, long-term senator from Arizona; and even Fred Thompson, former Tennessee senator and nationally recognized actor on the popular *Law and Order* television series. **Every one of them was better known and more experienced than Barack Obama.**

Undaunted by the enormity of the challenges, Obama concluded that he could win the nomination and the presidency itself if he could come up with an out-of-the-box campaign strategy.

He did just that. First he targeted Iowa and other caucus states that were not controlled by the Democratic Party apparatus. He organized grassroots campaigns that turned out enough votes to capture those states' delegates. As many of these caucus states, like Iowa, had white, middle-class majorities, he took his campaign to white America first, before he confirmed widespread black support for his candidacy. He also used the Internet and other technology platforms to engage, mobilize and involve young people in the political process, from voter registration drives to campaign rallies and mobilizations.

A victory in Iowa, a near-win in New Hampshire and a victory in South Carolina confirmed his status as a serious challenger. After splitting the vote on Super Tuesday, Obama took eight consecutive victories including Maryland, Virginia and the District of Columbia. And as the Democratic field thinned, the Democratic primaries turned into a titanic struggle between Barack Obama and his populist supporters versus Hillary Clinton and the Democratic Party machine.

Obama's performance in the primaries was remarkable. His aggressive and highly disciplined strategic grassroots organizing, brilliant speeches, record-breaking campaign rallies and successful debate performances thrust him into the lead in terms of delegate count – a lead that he held through June, when the primaries ended, despite a torrid effort by Hillary Clinton. On August 28, 2008, forty-five years after Martin Luther King Jr.'s historic "I Have a Dream" speech advocating racial harmony, Barack Obama was officially named the party's candidate at the Democratic National Convention in Denver, Colorado. In his historic acceptance speech, he uttered the mantra "Yes We Can," advocating a win for the Democratic Party against John McCain, who had wrapped up the Republican nomination in the spring of 2008.

Obama's success was fueled by perhaps the most phenomenal fund-raising strategy in American political history. Howard Dean had raised substantial funds through the Internet during his 2004 primary campaign, an admirable accomplishment surpassed in unprecedented ways by Obama. In addition to raising more than $700 million to finance his primary and general election campaigns (most of it through small contributions via the Internet), Obama and his new-media consultant, 24-year-old Facebook cofounder Chris Hughes, tapped the Internet's social networking, podcasting, and mobile-messaging capabilities and turned them into social networking communications resources that nurtured and developed grassroots political action for the Obama campaign.

More than two million supporters signed up on Facebook, and 112,000 more on Twitter; YouTube carried over 1,800 videos on the BarackObama.com channel, which itself had more than 115,000 subscribers, 18 million visitors and 97 million-plus video views. Obama also used electronic messaging and podcasts to mobilize and organize constituents, register voters and recruit campaign workers.

At the heart of Obama's outside-the-box political strategy was the oft-maligned concept of community organizing. "Meaningful change always begins at the grassroots," Obama has said. "Change in America doesn't start from the top down; it starts from the bottom up." The grassroots, bottom-up political strategy employed throughout the campaign came straight out of Community Organizing 101. What Obama added was the use of the Internet and other electronic media to reach ever-larger networks of grassroots organizers and supporters and keep them informed, mobilized and participatory. Community organizing techniques developed during his pre-electoral work in New York and Chicago undergirded his national campaign for the presidency of the United States.

The primaries and general election transformed Barack Hussein Obama into an international icon. He had become a media favorite the day he delivered the keynote address at the Democratic National Convention in 2004. Then he stoked the public's fascination with his best-selling autobiographies and his media-friendly visits to South Africa and to his father's homeland, Kenya. During the campaign, Obama's ability to draw large crowds at home and abroad enhanced his status as a media darling and kept his image and name before a public that became insatiable for anything Obama. His campaign's commercially produced memorabilia soon gave way to popularly produced caps, T-shirts, buttons, posters, calendars and other souvenirs sporting his image, his slogans or his name. Street vendors and entrepreneurs invented, produced and sold their own original iconic Barack Obama memorabilia. Similarly, independently produced videos like "Yes We Can," the YouTube video by the Black Eyed Peas' will.i.am, became more popular with the public than campaign-produced commercials.

The Obama campaign's mass rallies broke all previous attendance records: 250,000 in Berlin (where they couldn't even vote), over 100,000 in St. Louis (where they could). A midnight rally in Orlando, Florida, drew

upwards of 50,000 people; 86,000 packed Invesco Field in Denver to hear his acceptance speech; and more than 250,000 gathered in Chicago for the victory speech on November 4.

The speeches themselves were masterworks of oratory that will someday be counted among the greatest speeches in American political history. The two-pronged core of his message – that it was time for a change in America, and that it was time for Americans of all races, creeds, colors, religions, and sexual and political persuasions to come together and finally create "one nation, indivisible, with liberty and justice for all" – galvanized the electorate. The quality of his oratory so threatened his political challengers that they began to characterize him as "just words" – a great speaker, but nothing else. For a while, this line of attack was so effective that Obama toned down his powerful oratory. Fortunately for us, he brought it back in the home stretch and rode it to victory on November 4.

As you will see from the press coverage in this book, much has been made of the fact that Obama was the first African-American to win a major political party nomination, and even more was made of the fact that he was the first African-American elected president of the United States. Much should be made of these milestones in U.S. political history. But the 2008 presidential election campaign was marked by other historic milestones: It was the longest, most expensive election campaign in American history. Barack Obama raised more money (some $745 million) than any previous presidential candidate. More American citizens cast votes (129,883,523) than in any previous presidential election campaign, and the percentage of eligible voters who cast their ballots (more than 61 percent) marked a return to a level last seen during the Nixon-Kennedy match in 1960. Voter participation had hovered around 50 to 55 percent since the 1970s, reaching a low of 49 percent in 1996.

The 2008 election was also the first in 50 years in which no incumbent president or vice president from either party was running. It was also the first time that two sitting senators ran against each other. **Finally, it was the first time in recent memory that people of all races, colors and creeds held raucous victory parties in the streets of America and around the world.** The most energized and exciting presidential campaign in American history, the Obama campaign changed the nature and character of American electoral politics forever.

As Barack Obama takes office as the 44th president of the United States, one is struck by the new president's sheer inclusiveness. First, he selected his fiercest competitor for the nomination, Hillary Rodham Clinton, as his secretary of state. Joe Biden, who in the primaries questioned Obama's readiness to lead, is his vice president. And John McCain, whom he handily defeated in the general election, has pledged to work with him across party lines to get America moving again.

A new America is aborning! In the midst of the worst economic crisis since the Great Depression, a new America came into view. The old America was driven into the shadows of the past by the audacity of hope unleashed by the Obama campaign. Equally important, that campaign has redefined what America is and what it aspires to be. It inspired Americans – all Americans – to be their best selves, their best American selves. It has affirmed the American-ness – the long-term American-ness – of people of African descent. And it has reiterated the American ideals of freedom, justice and equality for *all* of its people as the defining basis of America's national identity. In so doing, it has awakened in some and reawakened in others the realization that black people have been integral and at times central actors in the making of the American past. It has also made it clear that they intend to be central actors in defining America's future. Finally, Obama himself has reminded us that we Americans are one people, one nation, that can together write the next great chapter in the American story. Yes We Can! ★

First campaign buttons on sale at Barack Obama's announcement of his candidacy in Springfield, Illinois, on February 10, 2007.
PHOTOGRAPH BY
JASON REED/REUTERS

Barack Obama Announces His Candidacy

The Old State House
Springfield, Illinois
February 10, 2007

Let me begin by saying thanks to all of you who've traveled, from far and wide, to brave the cold today. I know it's a little chilly — but I'm fired up.

We all made this journey for a reason. It's humbling to see a crowd like this, but in my heart I know you didn't just come here for me. You came here because you believe in what this country can be. In the face of war, you believe there can be peace. In the face of despair, you believe there can be hope. In the face of a politics that's shut you out, that's told you to settle, that's divided us for too long, you believe that we can be one people, reaching for what's possible, building that more perfect union.

That's the journey we're on today. But let me tell you how I came to be here. As most of you know, I am not a native of this great state. I moved to Illinois over two decades ago. I was a young man then, just a year out of college; I knew no

Senator Barack Obama waves to the crowd after announcing his quest for the highest office in the land. PHOTOGRAPH BY MARTIN H. SIMON/CORBIS

one in Chicago when I arrived, was without money or family connections. But a group of churches had offered me a job as a community organizer for the grand sum of $13,000 a year. And I accepted the job sight unseen, motivated then by a single, simple, powerful idea — that I might play a small part in building a better America.

My work took me to some of Chicago's poorest neighborhoods. I joined with pastors and laypeople to deal with communities that had been ravaged by plant closings. I saw that the problems people faced weren't simply local in nature — that the decision to close a steel mill was made by distant executives; that the lack of textbooks and computers in a school could be traced to skewed priorities of politicians a thousand miles away; and that when a child turns to violence, I came to realize that there's a hole in that boy's heart no government alone can fill.

It was in these neighborhoods that I received the best education that I ever had, and where I learned the true meaning of my Christian faith.

After three years of this work, I went to law school, because I wanted to understand how the law *should* work for those in need. I became a civil rights lawyer, and taught constitutional law, and after a time, I came to understand that our cherished rights of liberty and equality depend on the active participation of an awakened electorate. It was with these ideas in mind that I arrived in this capital city as a state senator.

It was here, in Springfield, where I saw all that is America converge: farmers and teachers, businessmen and laborers, all of them with a story to tell, all of them seeking a seat at the table, all of them clamoring to be heard. I made lasting friendships here — friends that I see in the audience here today.

It was here where we learned to disagree without being disagreeable – that it's possible to compromise so long as you know those principles that can never be compromised; and that so long as we're willing to listen to each other, we can assume the best in people instead of the worst.

It's why we were able to reform a death penalty system that was broken. That's why we were able to give health insurance to children in need. That's why we made the tax system right here in Springfield more fair and just for working families. And that's why we passed ethics reform that the cynics said could never, ever be passed.

It was here in Springfield, where North, South, East and West come together, that I was reminded of the essential decency of the American people – where I came to believe that through this decency, we can build a more hopeful America.

And that is why, in the shadow of the Old State Capitol, where Lincoln once called on a house divided to stand together, where common hopes and common dreams still live, I stand before you today to announce my candidacy for president of the United States of America.

I recognize that there is a certain presumptuousness in this, a certain audacity to this announcement. I know that I haven't spent a lot of time learning the ways of Washington. But I've been there long enough to know that the ways of Washington must change.

The genius of our founders is that they designed a system of government that *can* be changed. And we should take heart, because we've changed this country before. In the face of tyranny, a band of patriots brought an empire to its knees. In the face of secession, we unified a nation and set the captives free. In the face

of Depression, we put people back to work and lifted millions out of poverty. We welcomed immigrants to our shores, we opened railroads to the west, we landed a man on the moon, and we heard a King's call to let justice roll down like water, and righteousness like a mighty stream. We've done this before.

Each and every time, a new generation has risen up and done what's needed to be done. Today we are called once more, and it is time for our generation to answer that call.

For that is our unyielding faith: that in the face of impossible odds, people who love their country can change it.

That's what Abraham Lincoln understood. He had his doubts. He had his defeats. He had his setbacks. But through his will and his words, he moved a nation and helped free a people. It is because of the millions who rallied to his cause that we are no longer divided, North and South, slave and free. It is because men and women of every race, from every walk of life, continued to march for freedom long after Lincoln was laid to rest, that today we have the chance to face the challenges of this millennium together, as one people − as Americans.

All of us know what those challenges are today: a war with no end, a dependence on oil that threatens our future, schools where too many children aren't learning, and families struggling paycheck to paycheck despite working as hard as they can. We know the challenges. We've heard them. We've talked about them for years.

What's stopped us from meeting these challenges is not the absence of sound policies and sensible plans. What's stopped us is the failure of leadership, the smallness of our politics, the ease with which we're distracted by the petty and trivial, our chronic avoidance of tough decisions, our preference for scoring cheap political points instead of rolling up our sleeves and building a working consensus to tackle the big problems of America.

For the past six years we've been told that our mounting debts don't matter. We've been told that the anxiety Americans feel about rising health care costs and stagnant wages are an illusion. We've been told that climate change is a hoax. We've been told that tough talk and an ill-conceived war can replace diplomacy and strategy and foresight. And when all else fails – when Katrina happens, or the death toll in Iraq mounts – we've been told that our crises are somebody else's fault. We're distracted from our real failures, and told to blame the other party, or gay people, or immigrants.

And as people have looked away in disillusionment and frustration, we know what's filled the void: the cynics, the lobbyists, the special interests who have turned our government into a game only they can afford to play. They write the checks and you get stuck with the bill. They get the access while you get to write a letter. They think they own this government, but we're here today to take it back. The time for that kind of politics is over. It is through. It's time to turn the page, right here and right now.

We have made some progress already. I was proud to help lead the fight in Congress that led to the most sweeping ethics reforms since Watergate.

But Washington has a long way to go. And it won't be easy. That's why we'll have to set priorities. We'll have to make hard choices. And although government will play a crucial role in bringing about the changes we need, more money and programs

alone will not get us to where we need to go. Each of us, in our own lives, will have to accept responsibility: for instilling an ethic of achievement in our children, for adapting to a more competitive economy, for strengthening our communities and sharing some measure of sacrifice. So let us begin. Let us begin this hard work together. Let us transform this nation.

Let us be the generation that reshapes our economy to compete in the digital age. Let's set high standards for our schools and give them the resources they need to succeed. Let's recruit a new army of teachers, and give them better pay and more support in exchange for more accountability. Let's make college more affordable, and let's invest in scientific research, and let's lay down broadband lines through the heart of inner cities and rural towns all across America. **We can do that.**

And as our economy changes, let's be the generation that ensures our nation's workers are sharing in our prosperity. Let's protect the hard-earned benefits their companies have promised. Let's make it possible for hardworking Americans to save for retirement. Let's allow our unions and their organizers to lift up this country's middle class again. **We can do that.**

Let's be the generation that ends poverty in America. Every single person willing to work should be able to get job training that leads to a job, and earn a living wage that can pay the bills, and afford child care so their kids can have a safe place to go when they work. **We can do this.**

Let's be the generation that, after all these years, finally tackles our health care crisis. We can control costs by focusing on prevention, by providing better treatment to the chronically ill and using technology to cut the bureaucracy. Let's be the generation that says, right here, right now, that we will have universal health care in America by the end of the next president's first term. **We can do that.**

Let's be the generation that finally frees America from the tyranny of oil. We can harness homegrown alternative fuels like ethanol and spur the production of more fuel-efficient cars. We can set up a system for capping greenhouse gases. We can turn this crisis of global warming into a moment of opportunity for innovation, and job creation, and an incentive for businesses that will serve as a model for the world. Let's be the generation that makes future generations proud of what we did here.

Most of all, let's be the generation that never forgets what happened on that September day, and confront the terrorists with everything we've got. Politics doesn't have to divide us on this anymore – we can work together to keep our country safe. I've worked with Republican Senator Dick Lugar to pass a law that will secure and destroy some of the world's deadliest weapons. We can work together to track down terrorists with a stronger military, we can tighten the net around their finances, and we can improve our intelligence capabilities and finally get homeland security right. But let us also understand that ultimate victory against our enemies will come only by rebuilding our alliances and exporting those ideals that bring hope and opportunity to millions of people around the globe. **We can do those things.**

But all of this cannot come to pass until we bring an end to this war in Iraq. Most of you know I opposed this war from the start. I thought it was a tragic mistake. Today we grieve for the families who have lost loved ones, the hearts that have been broken, and the young lives that could have been. America. It is time to start bringing our troops home. It's time to admit that no amount of American lives can resolve the political disagreement that lies at the heart of someone else's civil war. That's why I have a plan that will bring our combat troops home by March of 2008. Letting the Iraqis know that we will not be there forever is our last, best hope to pressure the Sunni and Shia to come to the table and find peace.

And there is one other thing that is not too late to get right about this war. And that is the homecoming of the men and women – our veterans – who have sacrificed the most. Let us honor their courage by providing the care they need and rebuilding the military they love. Let us be the generation that begins that work.

I know there are those who don't believe we can do all these things. I understand the skepticism. After all, every four years, candidates from both parties make similar promises, and I expect this year will be no different. All of us running for president will travel around the country offering 10-point plans and making grand speeches; all of us will trumpet those qualities we believe make us uniquely qualified to lead this country. But too many times, after the election is over, and the confetti is swept away, all those promises fade from memory, and the lobbyists and special interests move in, and people turn away, disappointed as before, left to struggle on their own.

That is why this campaign can't only be about me. It must be about us – it must be about what we can do together. This campaign must be the occasion, the vehicle, of *your* hopes and *your* dreams. It will take your time, your energy and your advice – to push us forward when we're doing right, and let us know when we're not. This campaign has to be about reclaiming the meaning of citizenship, restoring our sense of common purpose, and realizing that few obstacles can withstand the power of millions of voices calling for change.

By ourselves, this change will not happen. Divided, we are bound to fail.

But the life of a tall, gangly, self-made Springfield lawyer tells us that a different future is possible. He tells us that **there is power in words**. He tells us that

there is power in conviction. That beneath all the differences of race and region, faith and station, we are one people. He tells us that **there is power in hope.**

As Lincoln organized the forces arrayed against slavery, he was heard to say this: "Of strange, discordant, and even hostile elements, we gathered from the four winds, and formed and fought to battle through."

That is our purpose here today. That is why I'm in this race. Not just to hold an office, but to gather with you to transform a nation. I want to win that next battle — for justice and opportunity. I want to win that next battle — for better schools, and better jobs, and better health care for all. **I want us to take up the unfinished business of perfecting our union, and building a better America.**

And if you will join with me in this improbable quest, if you feel destiny calling, and see, as I see, the future of endless possibility stretching out before us; if you sense, as I sense, that the time is now to shake off our slumber, and slough off our fears, and make good on the debt we owe past and future generations, then I am ready to take up the cause, and march with you, and work with you. Today, together, we can finish the work that needs to be done, and usher in a new birth of freedom on this Earth. ★

An Obama campaign rally in Des Moines, Iowa, Saturday, December 8, 2007. PHOTOGRAPH BY ASTRID RIECKEN/THE WASHINGTON TIMES

Barack Obama exchanges views with opponent Hillary Clinton at the CNN/ Univision debate at the University of Texas in Austin, on Thursday, February 21, 2008. PHOTOGRAPH BY BEN SKLAR/ GETTY IMAGES

Barack Obama Accepts Democratic Nomination

Democratic National Convention
Denver, Colorado
August 28, 2008

With profound gratitude and great humility, I accept your nomination for the presidency of the United States.

Let me express my thanks to the historic slate of candidates who accompanied me on this journey, and especially the one who traveled the farthest – a champion for working Americans and an inspiration to my daughters and yours – Hillary Rodham Clinton. To President Clinton, who last night made the case for change as only he can make it; to Ted Kennedy, who embodies the spirit of service; and to the next vice president of the United States, Joe Biden, I thank you. I am grateful to finish this journey with one of the finest statesmen of our time, a man at ease with everyone from world leaders to the conductors on the Amtrak train he still takes home every night.

To the love of my life, our next first lady, Michelle Obama, and to Malia and Sasha, I love you so much, and I'm so proud of you.

Barack Obama waves before addressing the 2008 Democratic National Convention in Denver on August 28, 2008.

PHOTOGRAPH BY CHRIS WATTIE/REUTERS

Four years ago, I stood before you and told you my story, of the brief union between a young man from Kenya and a young woman from Kansas who weren't well off or well-known, but shared a **belief** that in America, their son could achieve whatever he put his mind to.

It is that promise that's always set this country apart, that through hard work and sacrifice, each of us can pursue our individual dreams but still come together as one American family, to ensure that the next generation can pursue their dreams as well.

That's why I stand here tonight. Because for 232 years, at each moment when that promise was in jeopardy, ordinary men and women − students and soldiers, farmers and teachers, nurses and janitors − found the courage to keep it alive.

We meet at one of those defining moments, a moment when our nation is at war, our economy is in turmoil, and the American promise has been threatened once more.

Tonight, more Americans are out of work and more are working harder for less. More of you have lost your homes and even more are watching your home values plummet. More of you have cars you can't afford to drive, credit card bills you can't afford to pay, and tuition that's beyond your reach.

These challenges are not all of government's making. But the failure to respond is a direct result of a broken politics in Washington and the failed policies of George W. Bush. America, we are better than these last eight years. We are a better country than this.

This country is more decent than one where a woman in Ohio, on the brink of retirement, finds herself one illness away from disaster after a lifetime of hard

work. We're a better country than one where a man in Indiana has to pack up the equipment that he's worked on for 20 years and watch as it's shipped off to China, and then chokes up as he explains how he felt like a failure when he went home to tell his family the news.

We are more compassionate than a government that lets veterans sleep on our streets and families slide into poverty; that sits on its hands while a major American city drowns before our eyes.

Tonight, I say to the people of America, to Democrats and Republicans and Independents across this great land, **enough!** This moment, this election, is our chance to keep, in the 21st century, the American promise alive. Because next week, in Minnesota, the same party that brought you two terms of George Bush and Dick Cheney will ask this country for a third. And we are here because we love this country too much to let the next four years look just like the last eight. On November 4th, we must stand up and say, "Eight is enough."

Let there be no doubt. The Republican nominee, John McCain, has worn the uniform of our country with bravery and distinction, and for that we owe him our gratitude and our respect. And next week, we'll also hear about those occasions when he's broken with his party as evidence that he can deliver the change that we need.

But the record's clear: John McCain has voted with George Bush 90 percent of the time. Senator McCain likes to talk about judgment, but really, what does it say about your judgment when you think George Bush has been right more than 90 percent of the time? I don't know about you, but I'm not ready to take a 10 percent chance on change.

The truth is, on issue after issue that would make a difference in your lives – on health care and education and the economy – Senator McCain has been anything but independent. He said that our economy has made "great progress" under this president. He said that the fundamentals of the economy are strong. And when one of his chief advisors, the man who wrote his economic plan, was talking about the anxieties Americans are feeling, he said that we were just suffering from a "mental recession," and that we've become, and I quote, "a nation of whiners."

A nation of whiners? Tell that to the proud auto workers at a Michigan plant who, after they found out it was closing, kept showing up every day and working as hard as ever, because they knew there were people who counted on the brakes that they made. Tell that to the military families who shoulder their burdens silently as they watch their loved ones leave for their third or fourth or fifth tour of duty. These are not whiners. **They work hard and they give back and they keep going without complaint.** These are the Americans that I know.

Now, I don't believe that Senator McCain doesn't care what's going on in the lives of Americans. I just think he doesn't know. Why else would he define "middle-class" as someone making under five million dollars a year? How else could he propose hundreds of billions in tax breaks for big corporations and oil companies but not one penny of tax relief to more than one hundred million Americans? How else could he offer a health care plan that would actually tax people's benefits, or an education plan that would do nothing to help families pay for college, or a plan that would privatize Social Security and gamble your retirement?

It's not because John McCain doesn't care. It's because John McCain doesn't get it. For over two decades, he's subscribed to that old, discredited Republican philosophy: give more and more to those with the most, and hope that prosperity trickles down to everyone else. In Washington, they call this the Ownership Society, but what it really means is that you're on your own. Out of work? Tough luck.

You're on your own. No health care? The market will fix it. You're on your own. Born into poverty? Pull yourself up by your own bootstraps, even if you don't have boots. You are on your own.

Well, it's time for them to own their failure. It's time for us to change America. **And that's why I am running for president of the United States.**

You see, we Democrats have a very different measure of what constitutes progress in this country. We measure progress by how many people can find a job that pays the mortgage; whether you can put a little extra money away at the end of each month so you can someday watch your child receive her college diploma. We measure progress in the 23 million new jobs that were created when Bill Clinton was president, when the average American family saw its income go up $7,500 instead of down $2,000 like it has under George Bush.

We measure the strength of our economy not by the number of billionaires we have or the profits of the Fortune 500, but by whether someone with a good idea can take a risk and start a new business, or whether the waitress who lives on tips can take a day off and look after a sick kid without losing her job, an economy that honors the dignity of work. The fundamentals we use to measure economic strength are whether we are living up to **that fundamental promise that has made this country great,** a promise that is the only reason I am standing here tonight.

Because in the faces of those young veterans who come back from Iraq and Afghanistan, I see my grandfather, who signed up after Pearl Harbor, marched in Patton's Army, and was rewarded by a grateful nation with the chance to go to college on the GI Bill.

In the face of that young student who sleeps just three hours before working the night shift, I think about my mom, who raised my sister and me on her own while she worked and earned her degree; who once turned to food stamps but was still able to send us to the best schools in the country with the help of student loans and scholarships.

When I listen to another worker tell me that his factory has shut down, I remember all those men and women on the South Side of Chicago who I stood by and fought for two decades ago, after the local steel plant closed.

And when I hear a woman talk about the difficulties of starting her own business, or making her way in the world, I think about my grandmother, who worked her way up from the secretarial pool to middle management, despite years of being passed over for promotions because she was a woman. **She's the one who taught me about hard work.** She's the one who put off buying a new car or a new dress for herself so that I could have a better life. She poured everything she had into me. And although she can no longer travel, I know that she's watching tonight, and that tonight is her night as well.

Now, I don't know what kind of lives John McCain thinks that celebrities lead, but this has been mine. These are my heroes. Theirs are the stories that shaped my life. And it is on behalf of them that I intend to win this election and keep our promise alive as president of the United States.

What is that American promise? It's a promise that says each of us has the freedom to make of our own lives what we will, but that we also have the obligation to treat each other with dignity and respect.

It's a promise that says the market should reward drive and innovation and generate growth, but that businesses should live up to their responsibilities to create American jobs, to look out for American workers, and play by the rules of the road.

Ours is a promise that says government cannot solve all our problems, but what it should do is that which we cannot do for ourselves: protect us from harm and provide every child a decent education; keep our water clean and our toys safe; invest in new schools and new roads and science and technology.

Our government should work for us, not against us. It should help us, not hurt us. It should ensure opportunity not just for those with the most money and influence, but for every American who's willing to work.

That's the promise of America, the idea that we are responsible for ourselves, but that we also rise or fall as one nation; the fundamental belief that I am my brother's keeper; I am my sister's keeper. That's the promise we need to keep. That's the change we need right now. So let me spell out exactly what that change would mean if I am president.

Change means a tax code that doesn't reward the lobbyists who wrote it, but the American workers and small businesses who deserve it. Unlike John McCain, I will stop giving tax breaks to companies that ship jobs overseas, and I will start giving them to companies that create good jobs right here in America. I'll eliminate capital gains taxes for the small businesses and start-ups that will create the high-wage, high-tech jobs of tomorrow. I will cut taxes − cut taxes − for 95 percent of all working families, because in an economy like this, the last thing we should do is raise taxes on the middle class.

And for the sake of our economy, our security and the future of our planet, I will set a clear goal as president: **In 10 years, we will finally end our dependence on oil from the Middle East.** We will do this. Washington has been talking about our oil addiction for the last 30 years, and by the way John McCain has been there for 26 of them. And in that time, he's said no to higher fuel-efficiency standards for cars, no to investments in renewable energy, no to renewable fuels. And today, we import triple the amount of oil that we did the day that Senator McCain took office. Now is the time to end this addiction, and to understand that drilling is a stopgap measure, not a long-term solution. Not even close.

As president, I will tap our natural gas reserves, invest in clean coal technology, and find ways to safely harness nuclear power. I'll help our auto companies re-tool, so that the fuel-efficient cars of the future are built right here in America. I'll make it easier for the American people to afford these new cars. And I'll invest 150 billion dollars over the next decade in affordable, renewable sources of energy – wind power and solar power and the next generation of biofuels, an investment that will lead to new industries and five million new jobs that pay well and can't be outsourced.

America, now is not the time for small plans.

Now is the time to finally meet our moral obligation to provide every child a world-class education, because it will take nothing less to compete in the global economy. Michelle and I are only here tonight because we were given a chance at an education. And I will not settle for an America where some kids don't have that chance. I'll invest in early childhood education. I'll recruit an army of new teachers, and pay them higher salaries and give them more support. And in exchange, I'll ask for higher standards and more accountability. And we will keep our promise to every young American: If you commit to serving your community or our country, we will make sure you can afford a college education.

Now is the time to finally keep the promise of affordable, accessible health care for every single American. If you have health care, my plan will lower your premiums. If you don't, you'll be able to get the same kind of coverage that members of Congress give themselves. And as someone who watched my mother argue with insurance companies while she lay in bed dying of cancer, I will make certain those companies stop discriminating against those who are sick and need care the most.

Now is the time to help families with paid sick days and better family leave, because nobody in America should have to choose between keeping their job and caring for a sick child or an ailing parent. Now is the time to change our bankruptcy laws, so that your pensions are protected ahead of CEO bonuses; and the time to protect Social Security for future generations. And now is the time to keep the promise of equal pay for an equal day's work, because I want my daughters to have the exact same opportunities as your sons. Now, many of these plans will cost money, which is why I've laid out how I'll pay for every dime by closing corporate loopholes and tax havens that don't help America grow. But I will also go through the federal budget line by line, eliminating programs that no longer work and making the ones we do need work better and cost less, because we cannot meet 21st-century challenges with a 20th-century bureaucracy.

And Democrats, we must also admit that fulfilling America's promise will require more than just money. It will require a renewed sense of responsibility from each of us to recover what John F. Kennedy called our "intellectual and moral strength." Yes, government must lead on energy independence, but **each of us must do our part** to make our homes and businesses more efficient. Yes, we must provide more ladders to success for young men who fall into lives of crime and despair. But we must also admit that programs alone can't replace parents; that government can't turn off the television and make a child do her homework;

that fathers must take more responsibility to provide love and guidance to their children. Individual responsibility and mutual responsibility – that's the essence of America's promise.

And just as we keep our promise to the next generation here at home, so must we keep America's promise abroad. If John McCain wants to have a debate about who has the temperament and judgment to serve as the next commander-in-chief, that's a debate I'm ready to have.

For while Senator McCain was turning his sights to Iraq just days after 9/11, **I stood up and opposed this war,** knowing that it would distract us from the real threats that we face. When John McCain said we could just "muddle through" in Afghanistan, I argued for more resources and more troops to finish the fight against the terrorists who actually attacked us on 9/11, and made clear that we must take out Osama bin Laden and his lieutenants if we have them in our sights. You know, John McCain likes to say that he'll follow bin Laden to the Gates of Hell, but he won't even follow him to the cave where he lives.

And today, as my call for a time frame to remove our troops from Iraq has been echoed by the Iraqi government and even the Bush administration, even after we learned that Iraq has $79 billion in surplus while we're wallowing in deficits, John McCain stands alone in his stubborn refusal to end a misguided war.

That's not the judgment we need. That won't keep America safe. **We need a president who can face the threats of the future, not keep grasping at the ideas of the past.**

You don't defeat a terrorist network that operates in 80 countries by occupying Iraq. You don't protect Israel and deter Iran just by talking tough in Washington. You can't truly stand up for Georgia when you've strained our oldest alliances. If

John McCain wants to follow George Bush with more tough talk and bad strategy, that is his choice, but that is not the change that America needs.

We are the party of Roosevelt. We are the party of Kennedy. So don't tell me that Democrats won't defend this country. Don't tell me that Democrats won't keep us safe. The Bush-McCain foreign policy has squandered the legacy that generations of Americans, Democrats and Republicans, have built, and we are here to restore that legacy.

As commander-in-chief, **I will never hesitate to defend this nation,** but I will only send our troops into harm's way with a clear mission and a sacred commitment to give them the equipment they need in battle and the care and benefits they deserve when they come home.

I will end this war in Iraq responsibly, and finish the fight against al Qaeda and the Taliban in Afghanistan. I will rebuild our military to meet future conflicts. But I will also renew the tough, direct diplomacy that can prevent Iran from obtaining nuclear weapons and curb Russian aggression. I will build new partnerships to defeat the threats of the 21st century: terrorism and nuclear proliferation; poverty and genocide; climate change and disease. And I will restore our moral standing, so that America is once again that last, best hope for all who are called to the cause of freedom, who long for lives of peace and who yearn for a better future.

These are the policies I will pursue. And in the weeks ahead, I look forward to debating them with John McCain.

But what I will not do is suggest that the senator takes his positions for political purposes. Because one of the things that we have to change in our politics is the idea that people cannot disagree without challenging each other's character and each other's patriotism.

The times are too serious, the stakes are too high, for this same partisan playbook. So let us agree that patriotism has no party. I love this country, and so do you, and so does John McCain. The men and women who serve in our battlefields may be Democrats and Republicans and Independents, but they have fought together and bled together and some died together under the same proud flag. They have not served a red America or a blue America – they have served the United States of America. So I've got news for you, John McCain. We all put our country first.

America, our work will not be easy. The challenges we face require tough choices, and Democrats as well as Republicans will need to cast off the worn-out ideas and politics of the past. For part of what has been lost these past eight years can't just be measured by lost wages or bigger trade deficits. What has also been lost is our sense of common purpose. And that's what we have to restore.

We may not agree on abortion, but surely we can agree on reducing the number of unwanted pregnancies in this country. The reality of gun ownership may be different for hunters in rural Ohio than for those plagued by gang violence in Cleveland, but don't tell me we can't uphold the Second Amendment while keeping AK-47s out of the hands of criminals. I know there are differences on same-sex marriage, but surely we can agree that our gay and lesbian brothers and sisters deserve to visit the person they love in the hospital and to live lives free of discrimination. You know, passions may fly on immigration, but I don't know anyone who benefits when a mother is separated from her infant child or an employer undercuts American wages by hiring illegal workers. This too is part of America's promise, the promise of a democracy where we can find the strength and grace to bridge divides and unite in common effort.

I know there are those who dismiss such beliefs as happy talk. They claim that our insistence on something larger, something firmer and more honest in our public life, is just a Trojan horse for higher taxes and the abandonment of traditional values. And that's to be expected. Because if you don't have any fresh ideas, then you use stale tactics to scare voters. If you don't have a record to run on, then you paint your opponent as someone people should run from. You make a big election about small things.

And you know what? It's worked before. Because it feeds into the cynicism we all have about government. When Washington doesn't work, all its promises seem empty. If your hopes have been dashed again and again, then it's best to stop hoping, and settle for what you already know.

I get it. **I realize that I am not the likeliest candidate for this office.** I don't fit the typical pedigree, and I haven't spent my career in the halls of Washington. But I stand before you tonight because all across America something is stirring. What the naysayers don't understand is that this election has never been about me. It's about you.

For 18 long months, you have stood up, one by one, and said *enough* to the politics of the past. You understand that in this election, the greatest risk we can take is to try the same old politics with the same old players and expect a different result. You have shown what history teaches us, that at defining moments like this one, the change we need doesn't come *from* Washington. Change comes *to* Washington. Change happens because the American people demand it, because they rise up and insist on new ideas and new leadership, a new politics for a new time. America, this is one of those moments.

I believe that, as hard as it will be, **the change we need is coming** – because I've seen it, because I've lived it. Because I've seen it in Illinois, when we provided health care to more children and moved more families from welfare to work. I've seen it in Washington, where we worked across party lines to open up government and hold lobbyists more accountable, to get better care for our veterans and keep nuclear weapons out of the hands of terrorists.

And I've seen it in this campaign. In the young people who voted for the first time, and in the young at heart, those who got involved again after a very long time. In the Republicans who never thought they'd pick up a Democratic ballot, but did. I've seen it. I've seen it in the workers who would rather cut their hours back a day, even though they can't afford it, than see their friends lose their jobs, in the soldiers who re-enlist after losing a limb, in the good neighbors who take a stranger in when a hurricane strikes and the floodwaters rise.

You know, this country of ours has more wealth than any nation, but that's not what makes us rich. We have the most powerful military on Earth, but that's not what makes us strong. Our universities and our culture are the envy of the world, but that's not what keeps the world coming to our shores.

Instead, **it is that American spirit, that American promise, that pushes us forward** even when the path is uncertain, that binds us together in spite of our differences, that makes us fix our eye not on what is seen, but what is unseen, that better place around the bend.

That promise is our greatest inheritance. It's a promise I make to my daughters when I tuck them in at night, and a promise that you make to yours, a promise

that has led immigrants to cross oceans and pioneers to travel west; a promise that led workers to picket lines, and women to reach for the ballot.

And it is that promise that, 45 years ago today, brought Americans from every corner of this land to stand together on a Mall in Washington, before Lincoln's Memorial, and hear a young preacher from Georgia speak of his dream.

The men and women who gathered there could've heard many things. They could've heard words of anger and discord. They could've been told to succumb to the fear and frustrations of so many dreams deferred.

But what the people heard instead — people of every creed and color, from every walk of life — is that **in America, our destiny is inextricably linked.** That together, our dreams can be one.

"We cannot walk alone," the preacher cried. "And as we walk, we must make the pledge that we shall always march ahead. We cannot turn back."

America, we cannot turn back. Not with so much work to be done. Not with so many children to educate, and so many veterans to care for. Not with an economy to fix and cities to rebuild and farms to save. Not with so many families to protect and so many lives to mend. America, we cannot turn back. We cannot walk alone. At this moment, in this election, we must pledge once more to march into the future. Let us keep that promise — that American promise — and in the words of Scripture hold firmly, without wavering, to the hope that we confess.

Thank you, God bless you, and God bless the United States of America. ★

Democratic presidential nominee Barack Obama and his wife Michelle and vice presidential nominee Joe Biden and his wife Jill celebrate the closing of the Democratic National Convention at Invesco Field in Denver, Thursday, August 28, 2008. PHOTO BY ALLISON SHELLEY/ THE WASHINGTON TIMES

The emotion of the moment was heightened because the speech coincided with the 45th anniversary of the day the Rev. Martin Luther King Jr. marched to Washington and proclaimed, "I have a dream."

San Jose Mercury News

50 CENTS | VALLEY FINAL LIVE

AUGUST 29, 2008 | FRIDAY

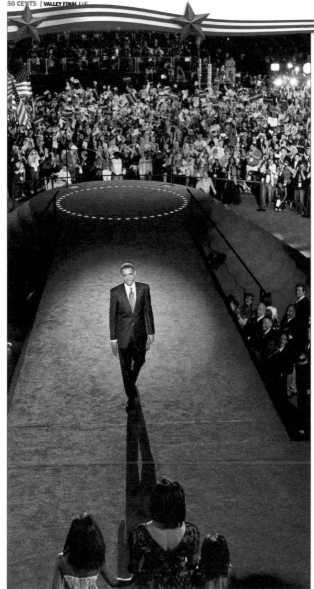

Ready for the fight

ATTACK ON MCCAIN
OBAMA SHARPENS CRITICISM OF RIVAL

VISION FOR CHANGE
VOWS TO END WAR, REBUILD ECONOMY

By Mary Anne Ostrom
Mercury News

DENVER — On a memorable night that juxtaposed the past and the future, Barack Obama told Americans that the nation has reached a defining moment again, and it will take a Democrat to meet the challenges of war and a faltering economy.

Before a jubilant 84,000-strong crowd, Obama mounted the stage and entered history as the first black candidate to accept a major party's nomination for America's highest office.

The emotion of the moment was heightened because the speech coincided with the 45th anniversary of the day the Rev. Martin Luther King Jr. marched to Washington and proclaimed, "I have a dream."

"I realize that I am not the likeliest candidate for this office," Obama said. "I don't fit the typical pedigree, and I haven't spent my career in the halls of Washington. But I stand before you tonight because all

See **OBAMA**, *Page 15A*

A GRAND SETTING
With an Olympian backdrop, Obama reaches out to America

By Dana Milbank
Washington Post

DENVER — It was a ceremony fit for the gods.

Fireworks exploded overhead. A skycam soared through the air the way it does during "Monday Night Football." Strobe lights flashed, spotlights circled. At least 84,000 adoring fans, after waiting hours to enter Invesco Field at Mile High, waved flags, tossed

beach balls and undulated in a massive human wave.

In the middle of it all stood Barack Obama, accepting the Democratic presidential nomination with "great humility." On a stage with ancient Greek ruins.

Well, maybe not so ancient: On closer inspection, the columns turned out to be drywall and laminated

See **SCENE**, *Page 15A*

MCCAIN PICKS RUNNING MATE
Is it Minn. governor? | Page 16A

SEE HIS CHOICE ONLINE TODAY
www.mercurynews.com

WIN MCNAMEE — AGENCE FRANCE-PRESSE VIA GETTY IMAGES

Governor to GOP: Stop 'hiding'

SAYS OWN PARTY FEARS DISCLOSING 'SHOCKING' BUDGET CUTS

By Mike Zapler
Mercury News Sacramento Bureau

SACRAMENTO — As the state's budget crisis lumbered into its third month, Gov. Arnold Schwarzenegger on Thursday intensified the pressure on the one powerful group that has done little to end the standoff: legislators from his own party.

In an interview with the Mercury News in his Capitol office, Schwarzenegger accused GOP politicians of "hiding" their ideas for deep spending cuts and borrowing to close California's massive deficit and suggested the reason is that the public would find their proposals "quite shocking."

"I'm calling on Republicans to show me your plan," said

RICH PEDRONCELLI — ASSOCIATED PRESS
Gov. Arnold Schwarzenegger is at odds with members of his own party over the budget gap.

the governor, who claimed they "obviously are worried about putting their (proposal) out because they know it would not be good."

Schwarzenegger is deeply at odds with Republicans about how to solve a $15.2 bil-

lion shortfall. The governor is calling for a mix of spending cuts and a temporary 1-cent sales tax increase; GOP legislators vow to never vote for a tax hike and say deeper spending cuts are needed.

Because passing a budget takes a two-thirds vote in California, it's become increasingly clear during the standoff that the power to end the crisis rests with GOP legislators. Yet Republicans have yet to fully engage: They have repeated a no-tax mantra and

See **BUDGET**, *Page 17A*

ONLINE EXTRA
Check for updates on the California state budget stalemate at www.mercurynews.com.

Copyright 2008
San Jose Mercury News

6 40493 00001 1

Mostly sunny
High: 90-94
Low: 58-63
Complete forecast, 8B

OBAMA'S PROMISE

On historic night, nominee vows path to prosperity, justice

Barack Obama returns the thunderous applause Thursday at Invesco Field before accepting the Democratic Party's presidential nomination. *Andy Cross, The Denver Post*

By Michael Riley and Karen E. Crummy *The Denver Post*

Barack Obama accepted his party's nomination for president in front of a rapturous crowd Thursday night, achieving a remarkable milestone in American politics even as he launched his most cutting attack yet against John McCain.

As the first African-American to carry the nomination of a major party, the Illinois Democrat used one of the most anticipated speeches of the campaign — and the biggest of his life — to cast this election in stark terms: The nation is at a critical precipice, and voters are faced with two fundamentally different visions of how to proceed.

"Tonight, I say to the American people, to Democrats and Republicans and independents across this great land — enough! This moment — this election — is our chance to keep, in the 21st century, the American promise alive," Obama implored a crowd estimated by the Secret Service at more than 84,000.

He vowed to help struggling American families by turning around the country's faltering economy, criticized the Bush-Cheney administration, stated his case to be commander in chief and retold a personal story of struggle and accomplishment. And he savaged the policies of Republicans and their nominee, launching the kind of broad counterattack that nervous Democrats have been seeking for weeks in the face of tightening national polls.

"For over two decades," Obama said, "(McCain has) subscribed to that old, discredited Republican philosophy — give more and more to those with the most, and hope that prosperity trickles down to everyone else. In Washington, they call this the Ownership Society, but what it really means is you're on your own.

"Well, it's time for them to own their failure. It's time for us to change America."

Obama gestured only briefly to the history of the moment — evoking the Rev. Martin Luther King Jr. at the end of the speech —

OBAMA » 6P

Campaign 2008

STORM CAUSES COMPLICATIONS

Republicans consider delaying the start of their convention because of Tropical Storm Gustav. **» NEWS, 1A**

50 CENTS PRICE MAY VARY
OUTSIDE METRO DENVER

0 842765 6

DEMOCRATS' WESTERN PUSH

Party targets battleground states of Colorado, New Mexico and Nevada.
» POLITICS, 2P

Historic nomination»
"It's impossible to believe that this is happening." **» 3P**

RJ Sangosti, The Denver Post

Inside Invesco»
The atmosphere inside the stadium was electric. **» 5P**

RITTER ASSAILS GOP ON ENERGY

Colorado's governor pushes renewable energy and investment in new technologies. **» POLITICS, 13P**

What they said»
Excerpts from the stadium speeches. **» 13P**

IN DENVER, OUTSIDE INVESCO

People gather in bars, living rooms and parking lots to share in American history.
» ENTERTAINMENT, 19P

Going green» Convention generates 4 tons of recyclables a day. **» 30P**

dp **ONLINE»** VIDEO, PHOTOS OF OBAMA'S ACCEPTANCE SPEECH. **»** denverpost.com/extras **// READ THE TRANSCRIPT »** politicswest.com

The Illinois Democrat used one of the most anticipated speeches of the campaign – and the biggest of his life – to cast this election in stark terms: The nation is at a critical precipice, and voters are faced with two fundamentally different visions of how to proceed.

LA VOZ DEL VALLE

ElNuevoHerald

Viernes 29 de agosto • 2008 .25 Diario • .50 Domingo

Busque las noticias al momento en **www.elnuevoheraldo.com**

Suprema Corte a favor del aborto

Valida la despenalización en la capital de México

EDUARDO CASTILLO
The Associated Press

CIUDAD DE MEXICO — La Suprema Corte declaró ayer constitucional una norma por la que en 2007 se despenalizó el aborto en la ciudad de México, un fallo criticado por grupos civiles y la iglesia católica que se declaró en luto.

En una votación que la mayoría ya había anticipado, la validez de la norma fue avalada por ocho de los 11 ministros de la Corte, en un fallo que abre la posibilidad a que en otros estados se presenten iniciativas de ley similares.

"La resolución de la Suprema Corte no penaliza ni despenaliza el aborto, no es facultad de este tribunal constitucional establecer los delitos ni las penas", dijo el ministro Guillermo Ortiz, presidente del máximo tribunal al término de la cuarta y última sesión en que se abordó el tema.

"Hemos determinado únicamente la constitucionalidad de una norma aprobada por el órgano respectivo y en este caso en particular hemos participado en una definición de trascendencia nacional", añadió.

La norma declarada constitucional y en vigor desde abril del 2007 despenaliza la interrupción del embarazo durante las primeras 12 semanas de gestación.

El secretario de Salud capitalino, Armando Ahued, dijo que hasta la fecha unas 12 mil 700 mujeres han interrumpido su embarazo en los 14 hospitales y una clínica en que se práctica el procedimiento. Dijo que

VEA ABORTO, 5

Iglesia inconforme
| México 9 |

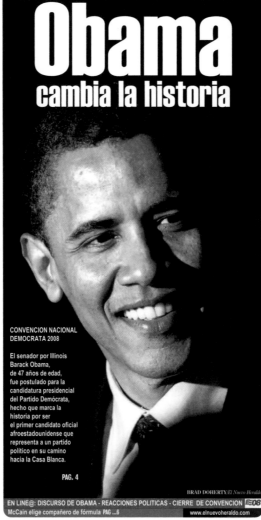

Obama
cambia la historia

CONVENCION NACIONAL DEMOCRATA 2008

El senador por Illinois Barack Obama, de 47 años de edad, fue postulado para la candidatura presidencial del Partido Demócrata, hecho que marca la historia por ser el primer candidato oficial afroestadounidense que representa a un partido político en su camino hacia la Casa Blanca.

PAG. 4

BRAD DOHERTY/*El Nuevo Heraldo*

EN LINE@: DISCURSO DE OBAMA - REACCIONES POLITICAS - CIERRE DE CONVENCION
McCain elige compañero de fórmula PAG ...6
www.elnuevoheraldo.com

ESPECTACULOS

PESOS
Compra: $10.02
Venta: $10.34
VALOR DEL DOLAR

EL VALLE

Repercusiones
Ambientalistas advierten sobre el futuro de las especies en peligro ante la relajación de las leyes que las protegen.
PAG. 2

MEXICO

Decapitados en Mérida
En un hecho violento sin precedentes del crimen organizado, el estado de Yucatán encontró 12 cuerpos decapitados, todos ejecutados ayer y con rastros de tortura.
PAG. 9

SACRILEGIO

Controversia escultórica
Un museo del norte de Italia dijo ayer que no retirará la escultura de una rana verde crucificada, tallada en madera pintada, pese al enfado del papa Benedicto XVI y de las autoridades locales.

Max. 88
Min. 76
CLIMA

Vol. 8 • No 297

638153 00003 7

Gustav se acerca a Jamaica

Las autoridades locales mantienen alerta constante

LAURA B. MARTINEZ
El Nuevo Heraldo

BROWNSVILLE – Las autoridades del Manejo de Emergencias de alrededor del Valle del Río Grande están en estado de alerta mientras que monitorean no solamente al Huracán Gustav sino también otras formaciones en la región del Atlántico.

VEA ALERTA, 5

The Associated Press

El paso de la tormenta Gustav por Haití dejó daños en las diferentes comunidades. Se espera que la tormenta pase por Jamaica.

Causa al menos 51 muertos en la isla de Haití

HOWARD CAMPBELL
The Associated Press

KINGSTON, Jamaica — La tormenta tropical Gustav cobraba fuerza ayer y amenazaba con convertirse en huracán mientras se dirigía hacia Jamaica y las Islas Caimán luego de dejar al menos 51 muertos en Haití.

En previsión, los turistas se apresuraban a retirarse de las

VEA GUSTAV, 4

Miami, Florida

"Obama Makes History"

www.elnuevoheraldo.com

A MAYOR IN CRISIS

SPECIAL COVERAGE STARTS ON 1B

MAYOR AIMS TO STOP HEARING

■ Avoiding jail time is key sticking point to any plea deal

■ Hearing will continue without attorney testimony

■ Ousted lawyer says he was opposed to any guilty plea

■ Plea, even without jail time, can handcuff careers

ON GUARD FOR 177 YEARS

Detroit Free Press

50 CENTS WWW.FREEP.COM **FRIDAY** AUG. 29, 2008 METRO FINAL ◆◆

'TOGETHER, OUR DREAMS CAN BE ONE'

Photos by ROB CURTIS/USA Today

OBAMA ACCEPTS PRESIDENTIAL NOMINATION

Democrat's historic speech urges 'new politics for a new time'

MORE ON FREEP.COM

■ PHOTOS AND VIDEOS FROM CONVENTION
■ JOIN THE DISCUSSION

MICHIGAN IS FIRST STOP FOR OBAMA, McCAIN

Both candidates plan visits to Michigan after conventions.
PAGE 7A

EXCERPTS FROM THE SPEECH

Michigan, auto industry pieces of historic message.
PAGE 8A

DETROIT MINISTERS CALLED FOR HELP

Quietly, Barack Obama asks black ministers to mobilize vote.
PAGE 10A

McCAIN READIES TO NAME VP

Signs point to Minnesota Gov. Tim Pawlenty. Announcement expected today.
PAGE 10A

BARACK OBAMA, THE FIRST BLACK PRESIDENTIAL NOMINEE for a major U.S. political party, thanks the crowd of 75,000 people who gathered to hear him at Invesco Field on Thursday, the final day of the Democratic National Convention in Denver. With him after his speech are his wife, Michelle, and daughters Malia, 10, and Sasha, 7. His nomination came on the 45th anniversary of Dr. Martin Luther King Jr.'s "I Have a Dream" speech in Washington.

Metro Detroiters cheer, call for action

By SUZETTE HACKNEY, ALEX P. KELLOGG AND NAOMI R. PATTON
FREE PRESS STAFF WRITERS

From living rooms to union halls to bar stools, metro Detroiters gathered Thursday night to witness history: Illinois Sen. Barack Obama accepting the nomination for president of the United States from a major political party — the first African American to do so.

It was a night steeped in nostalgia and hopefulness — Obama's nomination speech was juxtaposed against the 45-year anniversary of Dr. Martin Lu-

ther King Jr.'s monumental "I Have a Dream" speech during a march on Washington. In the 1963 speech, King said he dreamed of the day his four children would not be judged by the color of their skin but the content of their character.

Obama supporters echoed the same sentiment about their candidate.

"This is a mark in history — all that we've been working toward has not been in vain," said Charnese Stewart, 22, a Wayne State University pre-pharmacy major. "I just pray that Ameri-

See GATHERINGS, 7A

KIMBERLY P. MITCHELL/Detroit Free Press

Rukiya Shabazz, 57, of Detroit, left, marches next to Dalton Roberson Jr., 35, also of Detroit, as he holds his daughter Avery Roberson, 2. They were among the marchers who went from Cobo Hall to Eastern Market.

HE GIVES VISION FOR NATION'S REVIVAL

By TODD SPANGLER
FREE PRESS WASHINGTON STAFF

DENVER — Outlining his vision of a resurgent, revitalized nation, Barack Obama entered the pantheon of groundbreaking African Americans on Thursday, accepting the Democratic nomination for president and calling for a "new politics for a new time" shorn of partisanship and division.

Taking the latest step in an improbable journey in which he has become the first black presidential nominee for a major U.S. political party, the 47-year-old who was born in Hawaii, raised by a single mother, educated at Harvard and elected to the Senate four years ago joined Rosa Parks, Jackie Robinson and Dr. Martin Luther King Jr. among African-American heroes, role models and icons.

"I get it," he said during a historic speech before 75,000 people at Invesco Field at Mile High, where the Democratic National Convention concluded. "I realize that I am not the likeliest candidate for this office. I don't fit the typical pedigree, and I haven't spent my career in the halls of Washington.

"But I stand before you tonight because all across America something is stirring. What the naysayers don't understand is that this election has never been about me. It's about you."

Thomas A. Wilson Jr., a 61-year-old African-American physical education teacher in Detroit, was among thousands of Michi-

See CONVENTION, 6A

THE SUN IS BACK!
A little rain makes way for sun and warmer temps.
Chuck Gaidica's forecast, 6B

84 HIGH **63** LOW

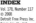

INDEX
Vol. 178, Number 117
© 2008
Detroit Free Press Inc.
Printed in the U.S.

Business1E
Classified1F
Comics9D, 10D
Corrections2A
Deaths4B

Editorials12A
Horoscope8D
Life1D
The List!8D
Lottery2A

Movie Guide5D
Puzzle Page7F
Television9D

CONTACT US
Delivery questions: 800-395-3300
News tip hotline: 313-222-6600
Classified: 586-977-7500; 800-926-8237

Newsday

His Moment

» Obama is first black to win major-party presidential nod
» Clinton puts him over top » His big speech tonight

COVERAGE BEGINS ON A2-7

HOLIDAY WEEKEND
Mixture of sun and clouds today with highs in the 70s; increasing clouds tonight.
Forecast, E12

The Providence Journal

projo.com

FRIDAY
AUGUST 29, 2008

75¢
Home Delivery 401.277.7600

DEMOCRATIC CONVENTION 2008

Obama vows a 'better' America

On a clear night in Denver, Democratic presidential nominee Barack Obama takes the stage outdoors at Invesco Field at Mile High last night.

MCT / CHUCK KENNEDY

Amid nearly 80,000 supporters at an outdoor stadium, Sen. Barack Obama accepts his party's presidential nomination and calls for a break from "the failed presidency of George W. Bush."

BY ADAM NAGOURNEY
and JEFF ZELENY
THE NEW YORK TIMES

DENVER — Sen. Barack Obama accepted the Democratic Party's presidential nomination last night, declaring that the "American promise has been threatened" by eight years under President Bush and that Sen. John McCain represented a continuation of policies that undermined the nation's economy and imperiled its standing around the world.

The speech by Obama, in front of an audience of nearly 80,000 people on a warm night in a football stadium refashioned into a vast political stage for television viewers, left little doubt how he intended to press his campaign against McCain this fall.

In cutting language, and to cheers that echoed across the stadium, he linked McCain to what he described as the "failed presidency of George W. Bush" and — reflecting what has been a central theme of his campaign since he entered the race — "the broken politics in Washington."

"America, we are better than these last eight years," he said. "We are a better country than this."

But Obama went beyond attacking McCain by linking him to Mr. Bush and his policies. In the course of a 42-minute speech that ended with a booming display of fireworks and a shower of con-

SEE **OBAMA, A9**

projo.com
Your turn: React to Barack Obama's speech at **projo.com**

For R.I. delegate, a step toward the dream

BY JOHN E. MULLIGAN
JOURNAL WASHINGTON BUREAU

DENVER — A lot of Walter Stone's friends made the pilgrimage to Washington 45 years ago to watch Dr. Martin Luther King Jr. stake his claim to a dream of racial harmony near the great marble statue of Abraham Lincoln.

"It was a moving moment," recalled Stone, but he was busy preparing for college classes, nurturing a dream of his own that had sprung from the searing experience of being one of the black students who integrated Henry Clay High School in Lexington, Ky.

Stone was determined to get himself to law school and work for civil rights through the system. Along the way, he encountered the likes of John Lewis,

another Fisk University student, who was bloodied in the civil-rights marches. Stone went on to earn that law degree, took a legal fellowship in Providence, became a community organizer, and became active in Democratic politics.

Last night, Walter Stone stood in a football arena framed by the Rocky Mountains to witness an enactment of a piece of the dream. Another man with black skin, Barack Obama, accepted the Democratic nomination for president of the United States.

As Stone applauded with tens of thousands of others, Obama introduced himself not only as the son of a black father from Kenya and a white mother from Kansas, but also as a member, in

his words, of "one American family."

Recalled the 64-year-old Stone: "The moment with Dr. King was almost like the seed. And now tonight, you are seeing the fruit. You are seeing the blossoming of the flower."

As for last night's spectacle at Invesco Field, Stone said, "This is the march of '63, Woodstock and the Super Bowl of politics all in one. This is so much bigger than race. It's a movement. He just happens to be the face of it."

All the same, Stone — who has been through some political struggles — made clear that he is gratified by Obama's nomination, but not satisfied. Like

SEE **STONE, A7**

Democratic presidential nominee Barack Obama and his wife, Michelle, on stage last night at Invesco Field at Mile High in Denver after he delivered his acceptance speech.

AP / ALEX BRANDON

In Gustav's sights, Gulf hopes it's ready this time

On the third anniversary of Hurricane Katrina, New Orleans and the surrounding area is staring down a massive storm.

BY BECKY BOHRER
ASSOCIATED PRESS

NEW ORLEANS — With Tropical Storm Gustav approaching hurricane strength and showing no signs of veering off a track to slam into the Gulf Coast, authorities across the region began laying the groundwork yesterday to get the sick, elderly and poor away from the shoreline.

The first batch of 700 buses that

could ferry residents inland were being sent to a staging area near New Orleans, and officials in Mississippi were trying to decide when to move Katrina-battered residents along the coast who were still living in temporary homes, including trailers vulnerable to high wind.

The planning for a potential evacuation is part of a massive outline drafted after Hurricane Katrina slammed ashore three years ago today, flooding 80 percent of New Orleans and stranding thousands who couldn't get out in time. As the region prepared to mark the storm's anniversary,

SEE **GUSTAV, A4**

From left, Melvin McGuire, Brad Sapia and Wayne Brown prepare a building in the French Quarter of New Orleans to withstand the impending storm.

AP / CHERYL GERBER

Mediation ordered for governor, union

Chief Justice Frank J. Williams wants the stalemate over higher health-care costs for state employees worked out.

BY STEVE PEOPLES
JOURNAL STATE HOUSE BUREAU

PROVIDENCE — Supreme Court Chief Justice Frank J. Williams has refused to allow Governor Carcieri to force new health-care costs on nearly 5,000 unionized state workers.

Instead, Williams yesterday ordered the Republican governor and the largest state employees union to resolve their high-profile

contractual stalemate through mediation and arbitration, a process outlined in state law. The outcome has a substantial bearing on the state budget and the paychecks of more than one-third of state government's work force.

"Chief Justice Williams firmly believes that mediation and negotiation can produce a far better

SEE **MEDIATION, B6**

projo.com
Extra: Read the Supreme Court chief justice's stipulation and order on **projo.com**

The Providence Journal
SUMMERTIME FUND

Mail your donation to
The Providence Journal
Summertime Fund
75 Fountain Street
Providence, RI 02902

SERVICE RESTORATION AT ISSUE
Advocates for low-income families meet with the state Public Utilities Commission to implore the regulators to lower the down-payment needed to restore electricity and gas service. **F1**

PUTIN LASHES OUT AT U.S.
Russian Prime Minister Vladimir Putin blames the upcoming U.S. election for the recent increase in tensions between Moscow and Washington. **A2**

PATRIOTS FALL TO GIANTS
New England's Tom Brady sat on the sidelines; so did New York quarterback Eli Manning as the Giants beat the Patriots, 19-14, in the final exhibition game before the regular season. **C1**

Barack Obama reached for Martin Luther King Jr.'s dream Thursday night as he embarked on the final lap of his history-making bid to become the nation's first black president. And Obama, surrounded by an enormous and adoring crowd, said it is time for America to live up to the ideals and hopes of the slain civil rights leader.

deseretnews.com

Go to *deseretnews.com* for a multimedia look at Harley-Davidson riders passing through Utah on their way to a 105th anniversary party in Milwaukee for the motorcycle maker.

Moab crash victims mourned

Gov. Jon Huntsman Jr. takes comfort in the fact that the 10 people who died in a plane crash were on a mission of mercy. "These great people . . . know something about lifting others."

LOCAL **B1**

Golden memories

Utah Jazz player Deron Williams returns to Salt Lake and proudly displays the gold medal he won earlier this week in Beijing.

SPORTS **D1**

SALT LAKE CITY, UTAH

Deseret News

VOL. 159/NO. 76 FRIDAY, AUGUST 29, 2008

Democratic National Convention

A dream fulfilled

WIN MCNAMEE, GETTY IMAGES

Thousands cheer Democratic presidential candidate Barack Obama at Invesco Field in Denver Thursday — the 45th anniversary of Martin Luther King Jr.'s "I Have a Dream" speech.

■ Demos: Obama evokes King as he lays out his goals

**By Bob Bernick Jr.
and Lee Davidson**
Deseret News

DENVER — BARACK OBAMA reached for Martin Luther King Jr.'s dream Thursday night as he embarked on the final lap of his history-making bid to become the nation's first black president. And Obama, surrounded by an enormous and adoring crowd, said it is time for America to live up to the ideals and hopes of the slain civil rights leader.

"Tonight, more Americans are out of work and more are working harder for less," said Obama in a nomination acceptance speech before an estimated 84,000 people in Invesco Field at Mile High Stadium.

"More of you have lost your homes and more are watching your home values plummet. More of you have cars you can't afford to drive,

Please see **OBAMA** *on A4*

More inside

■ **Reaction:** Utah delegates find hope, optimism in Obama speech./ **A3**

■ **Lee Benson:** Obama's political ascent indicates America is going colorblind./ **A4**

■ **In our view:** Barack Obama's nomination is one for the history books./ **A16**

■ **Impact:** Experts say post-convention 'bounce' averages 10 points. / **A5**

McCain may name v.p. today

**By Lisa Riley Roche
and Leigh Dethman**
Deseret News

Gov. Jon Huntsman Jr. said Thursday that no matter who John McCain chooses as his running mate, the GOP presidential ticket will be good for Utah. McCain is expected to announce his pick this morning in Ohio.

Huntsman, a longtime sup-

porter of McCain, said during a taping of his monthly press conference on KUED Ch. 7 that he had "no unique insights" into whom the Arizona senator will tap as vice president.

The governor later declined to handicap the so-called "veepstakes," reportedly between Salt Lake City's 2002

Please see **V.P.** *on A3*

Ancient Brazilian settlements excite scientists

By Randolphe E. Schmid
Associated Press

WASHINGTON — Roads and canals connected walled cities and villages. The communities were laid out around central plazas. Nearby, smaller settlements focused on agriculture and fish farming.

The place: the now-overgrown jungles of Brazil.

The time: centuries before Europeans landed in the Americas.

Once, about 1,500 years

ago, an essentially urban culture existed in what is now jungle settled by scattered tribes, researchers report in Friday's edition of the journal Science.

They weren't as sophisticated as well-known cultures like the Maya to the north, but their culture was more complex than anthropologists had thought.

The find "requires a rethinking of what early urbanism may have been like, in diverse and variant

forms," said Michael J. Heckenberger of the University of Florida, lead author of the study.

Heckenberger and colleagues first reported evidence of the culture — which he calls Xingu after the local river — in 2003 and now have unearthed details of the ancient communities.

The researchers found evidence of 28 prehistoric residential sites. Initial colo-

Please see **VILLAGE** *on A7*

Shurtleff hoping surgery will save his leg

By Ben Winslow
Deseret News

If an unusual surgery today doesn't save his shattered left leg, Utah Attorney General Mark Shurtleff will have to choose between misery and amputation.

Shurtleff is scheduled to go in for several hours of surgery to repair the leg that was badly broken in a motorcycle accident last year.

"This has got to work," he said in an interview Thurs-

Mark Shurtleff

day with the Deseret News. "They feel there really aren't too many choices left."

Shurtleff said his leg bones are not healing, leaving him with a condition called

"nonunion." To repair it, the attorney general is undergoing a procedure known as the "Ilizarov technique." Surgeons will go in and scrape out the nongrowing bone and make a paste with some other bone. His leg will be inserted in metal halos with wires and pins being used to affix the bones to the rings.

"The purpose is to keep it completely steady so it can

Please see **SHURTLEFF** *on A7*

"America, we are better than these last eight years. We are a better country than this."

Our 143rd year | FRIDAY | 08.29.08 | 50¢

The Virginian-Pilot

ROBYN BECK | AFP | GETTY IMAGES

Now is the time to let our faith guide us to action once again."

Virginia Gov. Timothy M. Kaine in his speech Thursday night before the crowd at Invesco Field

KAINE'S TIME IN THE SPOTLIGHT

On "The Daily Show," in interviews with Newsweek, the BBC and CBS, and on the convention stage – this week, the Virginia governor is all over the national scene.

Full story, Page 12

DELORES JOHNSON | THE VIRGINIAN-PILOT

AMID SEA OF SUPPORT, OBAMA ACCEPTS NOD

From wire reports

DENVER

SURROUNDED BY AN ENORMOUS, ADORING CROWD, Sen. Barack Obama promised a clean break from the "broken politics in Washington and the failed policies of George W. Bush" on Thursday night as he embarked on the final lap of his bid to become president of the United States.

"America, now is not the time for small plans," the 47-year-old Illinois senator told an estimated 84,000 people packed into Invesco Field at Mile High, a stadium backdropped by the Rocky Mountains.

He vowed to cut taxes for nearly all working-class families, end the war in Iraq and break America's dependence on Mideast oil.

"For the sake of our economy, our security and the future of our

See DEMOCRATIC CONVENTION, PAGE 14

DEMOCRATIC NATIONAL CONVENTION

KERRY'S VIEW FROM DENVER

Out of the camera's view, chaos ruled at the big show, says Pilot columnist Kerry Dougherty.
PAGE 12

LOCAL CELEBRATION

The party's party was on TV. So these Obama supporters held their own party.
PAGE 13

ONLINE

Read Kerry's blog, see more photos, check for updates and get the full text of speeches made Thursday night at the Democratic convention at **PilotOnline.com.**

POLICY POSITIONS | FROM OBAMA'S SPEECH

health care

"If you have health care, my plan will lower your premiums. If you don't, you'll be able to get the same kind of coverage that members of Congress give themselves."

jobs in the U.S.

"I will stop giving tax breaks to corporations that ship our jobs overseas, and I will start giving them to companies that create good jobs right here in America."

foreign oil

"I will set a clear goal as president: In 10 years, we will finally end our dependence on oil from the Middle East."

the war in Iraq

"I will end this war in Iraq responsibly and finish the fight against al-Qaida and the Taliban in Afghanistan."

related stories

Republican officials consider delaying the start of their convention in Minnesota because of Gustav.
Page 7

Storm fears likely to push gas prices higher.
Business

THREE YEARS AFTER KATRINA

GUSTAV RAISES CONCERNS IN NEW ORLEANS ABOUT LEVEES

By Cain Burdeau and Becky Bohrer
The Associated Press

NEW ORLEANS

Just three years after Hurricane Katrina, New Orleans confronts a new threat from Gustav and a stark question: Will the partially rebuilt le-

vees hold?

Despite $2 billion in improvements, including 220 miles of repaired, raised and replaced floodwalls, 17 new pump stations and more flood-resistant pump stations, nobody can say for sure the city won't be swamped again. And if it is, could it ever recover?

"It's scary, man," said Robert Russell, 63, a plumber whose house in Gentilly Woods is close to floodwalls on the Industrial Canal that are so suspect the Army Corps of Engineers is buffering them with large baskets filled with sand.

"They say it's not up to

See GUSTAV, PAGE 5

GUNS AT SCHOOL

DISTRICT IN TEXAS ALLOWS ITS TEACHERS TO BE ARMED

By James C. McKinley Jr.
The New York Times

HARROLD, TEXAS

Students in this tiny town of grain silos and ranch-style houses spent much of the first couple of days in school this week trying to guess which of their teachers were carrying

pistols under their clothes.

"We made fun of them," said Eric Howard, 16, a high school junior. "Everybody knows everybody here. We will find out."

The school board in this impoverished rural hamlet in North Texas has drawn national attention with its decision to let some teachers carry concealed weapons, a policy no other school in the country has followed. The idea is to ward off a massacre along the lines of what happened at Columbine High School in Colorado in 1999.

"Our people just don't want their children to be fish in a bowl," said David Thweatt,

See GUNS, PAGE 10

inside

Hard times blamed for private school drop

As people choose how to cut back, they seem to be turning to public school educations instead.
HAMPTON ROADS

coming tomorrow

A guide to the best of the 2008-09 arts season – theater, dance, music and art.

scattered storms

High, low 80s. Low, low 70s.

Details on the back page of Business

73811 00050

Hampton Roads, Virginia

hamptonroads.com/pilotonline

FRIDAY, AUGUST 29, 2008

The Seattle Times

RAIN AND WIND
High, 69. Low, 50.
> LOCAL B6

50¢ King, Pierce, Snohomish, Island, Kitsap and Thurston counties | 75¢ elsewhere

Independent and locally owned since 1896 | **seattletimes.com**
1.5 million readers weekly in Western Washington, in print and online

ELECTIONS'08 DEMOCRATIC NATIONAL CONVENTION

"TIME FOR US TO CHANGE AMERICA"

LOCAL SUPPORTERS REJOICE AS OBAMA MAKES HISTORY

CHRIS CARLSON / THE ASSOCIATED PRESS
Democratic vice-presidential nominee Sen. Joseph Biden, D-Del., and wife, Jill, left, and Democratic presidential nominee Sen. Barack Obama, D-Ill., and wife, Michelle, greet the crowd of 84,000 after Obama's acceptance speech at the Democratic National Convention in Denver on Thursday.

BY MARK Z. BARABAK
AND JIM TANKERSLEY
Chicago Tribune

DENVER – Barack Obama accepted the Democratic presidential nomination Thursday night with a scathing assessment of John McCain and a searing indictment of the Bush administration, promising to repair "the broken politics of Washington" and preside over a more prosperous and equitable America.

Speaking to a rapturous audience of more than 84,000, the largest convention crowd ever assembled, Obama delivered an address that was outraged and uplifting, personal and political. He blasted President Bush and McCain, the presumptive Republican nominee, with some of his harshest language of the campaign, painting a grim picture of economic hardship: rising unemployment, falling wages, plunging home values and rising costs for gasoline and college tuition.

"Tonight," Obama said, speaking from

a specially constructed soundstage on the floor of Invesco Field, "I say to the American people, to Democrats and Republicans and independents across this great land — enough! This moment — this election — is our chance to keep, in the 21st century, the American promise alive."

In a 44-minute speech, Obama rode a line between policy and personal revelation, between high-flown oratory and an

Please see **> SPEECH, A3**

THURSDAY'S HIGHLIGHTS

The scene: Politics, spectacle and history in the making > Close-up A3

WEB EXTRA
Rate Thursday night's acceptance speech by Barack Obama:
seattletimes.com

Locals: Campaign gives hope for future

BY JIM BRUNNER,
ROBERT FATURECHI
AND NICOLE TSONG
Seattle Times staff reporters

As Barack Obama thrilled thousands of Democrats with his acceptance speech at a stadium in Denver, local supporters gathered in houses and bars to share the moment.

More than 65 speech-watching parties were held across the state, according to the Obama campaign.

At Showbox SoDo, a Seattle music club, an energetic crowd of hundreds mingled, sipped cocktails and cheered

wildly for Obama as his speech was beamed to a large projection screen on the main stage.

Democratic organizers worked the crowd to sign up new volunteers. And the campaign of Democratic Gov. Christine Gregoire sought to tap into the energy, selling "Obama-Gregoire" signs and showing video attacking her Republican rival Dino Rossi.

Much has been made of Obama's historic status as the first nonwhite presidential nominee from a major

Please see **> LOCALS, A16**

Work starts to convey vision to real-life America

BY MIKE DORNING
Chicago Tribune

DENVER – The mile-high celebration of Barack Obama's historic presidential nomination now gives way to an intense, fast-moving campaign that depends heavily on connecting Obama's vision of change with the lives of ordinary voters.

He and running mate Joseph Biden are to

climb aboard a campaign plane this morning to fly to the industrial heartland of America and make their case to white working-class residents of western Pennsylvania, a region known more for steel production and football quarterbacks than oratorical flourishes.

After a marathon primary fight that stretched for 19 months, Obama dashes into a fall general-

election campaign that leaves less than 10 weeks before the Nov. 4 vote.

And in some states, early voting begins in less than half that time, with balloting opening in the crucial state of Ohio on Sept. 30, a little more than one month away. Early voting is allowed in 35 states, including Washington.

Please see **> MESSAGE, A16**

GOP says hurricane may delay convention

GUSTAV MIGHT HIT NEW ORLEANS

Images of political celebration as thousands flee could be disastrous, senior Republicans say

BY DAN EGGEN
AND MICHAEL D. SHEAR
The Washington Post

WASHINGTON – Republican officials said Thursday that they are considering delaying the start of the GOP convention because of Tropical Storm Gustav, which is on track to hit the Gulf Coast, and possibly New Orleans, as a full-force hurricane early next week.

The threat is serious enough that White House officials also are debating whether President Bush should cancel his scheduled convention appearance Monday, the first day of the convention, according to administration officials and others familiar with the discussion.

For Bush and Republican presidential candidate John McCain, Gustav threatens to provide an untimely reminder of Hurricane Katrina. A new major storm along the Gulf Coast would renew memories of one of the low points of the Bush administration, while pulling public attention away from McCain's formal coronation as the GOP presidential nominee.

Senior Republicans said images of political celebration in the Twin Cities while thousands of Americans flee a hurricane could be

Please see **> GUSTAV, A17**

WHO'S THE VP PICK?
McCain expected to announce today
> A17

WEB EXTRA
Find out the VP pick when it's announced:
seattletimes.com

Seattle voters may end up with last word on bag fee

FOES SUBMIT 22,252 SIGNATURES AGAINST 20-CENT FEE

If information is verified, issue will be on ballot

BY STEVE MILETICH
Seattle Times staff reporter

Seattle voters moved a step closer Thursday to getting a chance to repeal the 20-cent bag fee the city wants all grocery, convenience and drugstores to charge for paper and plastic bags.

A coalition of plastic and grocery industries submitted 22,252 signatures to the city this week to allow voters to decide whether they favor the fee — 14,374 of them must be verified to put the issue on the ballot. The deadline was Thursday to submit the signatures.

The King County Elections Division will check the signatures to make sure they came from registered Seattle voters and that valid voters did not sign twice. No timetable has been set for that process, but election officials are required to act with reasonable promptness.

"People should have the right to vote on it," said George Griffin, a spokesman for the Coalition to Stop the Seattle Bag Tax, which gathered the signatures and was formed by the American Chemistry Council and the Washington Food Industry, an association that represents Washington's independent grocery industry.

Regina LaBelle, Mayor Greg Nickels's legal

Please see **> FEE, A14**

Copyright 2008 Seattle Times Co.

60% of The Seattle Times newsprint contains recycled fiber. The inks are also reused.

7 59423 25000 3

The candidate rushes up an escalator at Omaha Civic Auditorium, where he addressed a crowd of 10,000 supporters on February 7, 2008. PHOTOGRAPH BY DAVID BURNETT

Presidential contender Barack Obama meets the press on a campaign flight from Omaha to New Orleans on February 7, 2008.

PHOTOGRAPH BY DAVID BURNETT

Barack Obama's Victory Speech

Grant Park
Chicago, Illinois
November 4, 2008

If there is anyone out there who still doubts that America is a place where all things are possible; who still wonders if the dream of our founders is alive in our time; who still questions the power of our democracy, tonight is your answer.

It's the answer told by lines that stretched around schools and churches in numbers this nation has never seen; by people who waited three hours and four hours, many for the first time in their lives, because they believed that this time must be different; that their voices could be that difference.

It's the answer spoken by young and old, rich and poor, Democrat and Republican, black, white, Hispanic, Asian, Native American, gay, straight, disabled and not disabled – Americans who sent a message to the world that we have never been just a collection of individuals or a collection of red states and blue states. We are, and always will be, the United States of America.

victory

The newly elected president of the United States, Barack Obama, with daughters Malia and Sasha and wife Michelle. The emotional crowd in and around Grant Park numbered in the hundreds of thousands.
PHOTOGRAPH BY DAVID BURNETT

It's the answer that led those who have been told for so long by so many to be cynical, and fearful, and doubtful about what we can achieve, to put their hands on the arc of history and bend it once more toward the hope of a better day.

It's been a long time coming, but tonight, because of what we did on this day, in this election, at this defining moment, **change has come to America.**

A little earlier this evening, I received an extraordinarily gracious call from Senator McCain. Senator McCain fought long and hard in this campaign, and he's fought even longer and harder for the country he loves. He has endured sacrifices for America that most of us cannot begin to imagine. We are better off for the service rendered by this brave and selfless leader. I congratulate him; I congratulate Governor Palin for all they have achieved, and I look forward to working with them to renew this nation's promise in the months ahead.

I want to thank my partner in this journey, a man who campaigned from his heart and spoke for the men and women he grew up with on the streets of Scranton and rode with on the train home to Delaware, the vice president-elect of the United States, Joe Biden.

I would not be standing here tonight without the unyielding support of my best friend for the last 16 years, the rock of our family, the love of my life, our nation's next first lady, Michelle Obama.

Sasha and Malia, I love you both more than you can imagine, and you have earned the new puppy that's coming with us to the White House.

And while she's no longer with us, I know my grandmother is watching, along with the family that made me who I am. I miss them tonight, and I know that my debt to them is beyond measure. To my sister Maya, my sister Auma, all my other

brothers and sisters, thank you so much for all the support you have given to me. I am grateful to them.

To my campaign manager David Plouffe, the unsung hero of this campaign, who built the best political campaign, I think, in the history of the United States of America; to my chief strategist David Axelrod, who has been a partner with me every step of the way; to the best campaign team ever assembled in the history of politics – you made this happen, and I am forever grateful for what you've sacrificed to get it done.

But above all, I will never forget who this victory truly belongs to. It belongs to you. It belongs to you.

I was never the likeliest candidate for this office. We didn't start with much money or many endorsements. Our campaign was not hatched in the halls of Washington. **It began in the backyards of Des Moines, in the living rooms of Concord, on the front porches of Charleston.**

It was built by working men and women who dug into what little savings they had to give five dollars, ten dollars, twenty dollars to this cause. It grew strength from the young people who rejected the myth of their generation's apathy; who left their homes and their families for jobs that offered little pay and less sleep. It drew strength from the not-so-young people who braved the bitter cold and scorching heat to knock on doors of perfect strangers; and from the millions of Americans who volunteered, and organized, and proved that more than two centuries later, a government of the people, by the people and for the people has not perished from the Earth. **This is your victory.**

And I know you didn't do this just to win an election, and I know you didn't do it for me. You did it because you understand the enormity of the task that lies ahead. For

even as we celebrate tonight, we know the challenges that tomorrow will bring are the greatest of our lifetime – two wars, a planet in peril, the worst financial crisis in a century. Even as we stand here tonight, we know there are brave Americans waking up in the deserts of Iraq and the mountains of Afghanistan to risk their lives for us. There are mothers and fathers who will lie awake after their children fall asleep and wonder how they'll make the mortgage, or pay their doctors' bills, or save enough for their child's college education.

There is new energy to harness, new jobs to be created, new schools to build, and threats to meet, alliances to repair.

The road ahead will be long. Our climb will be steep. We may not get there in one year or even in one term, but America – I have never been more hopeful than I am tonight that we will get there. I promise you: We as a people will get there.

There will be setbacks and false starts. There are many who won't agree with every decision or policy I make as president, and we know that government can't solve every problem. But I will always be honest with you about the challenges we face. I will listen to you, especially when we disagree. And above all, I will ask you to join in the work of remaking this nation, the only way it's been done in America for 221 years – block by block, brick by brick, calloused hand by calloused hand.

What began 21 months ago in the depths of winter cannot end on this autumn night. **This victory alone is not the change we seek. It is only the chance for us to make that change.**

And that cannot happen if we go back to the way things were. It can't happen without you, without a new spirit of service, a new spirit of sacrifice. So let us

summon a new spirit of patriotism, of responsibility, where each of us resolves to pitch in and work harder and look after not only ourselves, but each other.

Let us remember that if this financial crisis taught us anything, it's that we cannot have a thriving Wall Street while Main Street suffers. In this country, we rise or fall as one nation, as one people.

Let us resist the temptation to fall back on the same partisanship and pettiness and immaturity that have poisoned our politics for so long. Let us remember that it was a man from this state who first carried the banner of the Republican Party to the White House, a party founded on the values of self-reliance, individual liberty and national unity. Those are values that we all share, and while the Democratic Party has won a great victory tonight, we do so with a measure of humility and determination to heal the divides that have held back our progress.

As Lincoln said to a nation far more divided than ours, "We are not enemies, but friends . . . though passion may have strained, it must not break, our bonds of affection." And to those Americans whose support I have yet to earn, I may not have won your vote tonight, but I hear your voices. **I need your help, and I will be your president too.**

And to all those watching tonight from beyond our shores, from parliaments and palaces to those who are huddled around radios in the forgotten corners of our world − our stories are singular, but our destiny is shared, and a new dawn of American leadership is at hand. To those who would tear the world down: We will defeat you. To those who seek peace and security: We support you. And to all those who have wondered if America's beacon still burns as bright: Tonight we proved once more that the true strength of our nation comes not from the might of our arms or the scale of our wealth, but from the enduring power of our ideals: democracy, liberty, opportunity and unyielding hope.

That's the true genius of America, that America can change. Our union can be perfected. And what we have already achieved gives us hope for what we can and must achieve tomorrow.

This election had many firsts and many stories that will be told for generations. But one that's on my mind tonight's about a woman who cast her ballot in Atlanta. She is a lot like the millions of others who stood in line to make their voice heard in this election, except for one thing: Ann Nixon Cooper is 106 years old.

She was born just a generation past slavery; a time when there were no cars on the road or planes in the sky; when someone like her couldn't vote for two reasons, because she was a woman and because of the color of her skin.

And tonight, I think about all that she's seen throughout her century in America: the heartache and the hope, the struggle and the progress, the times we were told that we can't, and the people who pressed on with that American creed: **Yes we can.**

At a time when women's voices were silenced and their hopes dismissed, she lived to see them stand up and speak out and reach for the ballot. **Yes we can.**

When there was despair in the Dust Bowl and Depression across the land, she saw a nation conquer fear itself with a New Deal, new jobs and a new sense of common purpose. **Yes we can.**

When the bombs fell on our harbor and tyranny threatened the world, she was there to witness a generation rise to greatness and a democracy was saved. **Yes we can.**

She was there for the buses in Montgomery, the hoses in Birmingham, a bridge in Selma, and a preacher from Atlanta who told a people that "We Shall Overcome." **Yes we can.**

A man touched down on the moon. A wall came down in Berlin. A world was connected by our own science and imagination. And this year, in this election, she touched her finger to a screen and cast her vote, because after 106 years in America, through the best of times and the darkest of hours, she knows how America can change. **Yes we can.**

America, we have come so far. We have seen so much. But there is so much more to do. So tonight, let us ask ourselves, if our children should live to see the next century, if my daughters should be so lucky to live as long as Ann Nixon Cooper, what change will they see? What progress will we have made?

This is our chance to answer that call. This is our moment. This is our time: to put our people back to work and open doors of opportunity for our kids; to restore prosperity and promote the cause of peace; to reclaim the American Dream and reaffirm that fundamental truth that out of many, we are one; that while we breathe, we hope; and where we are met with cynicism, and doubt, and those who tell us that we can't, we will respond with that timeless creed that sums up the spirit of a people: **Yes we can.**

Thank you, God bless you, and may God bless the United States of America. ★

President-elect Barack Obama repeats his campaign credo to the huge Grant Park crowd: "Yes we can."

PHOTOGRAPH BY DAVID BURNETT

Montgomery Advertiser

montgomeryadvertiser.com

WEDNESDAY *Nov. 5, 2008* *Montgomery Edition* *75 cents*

SINCE 1829

INSIDE
▶ PSC race too close to call
— 1B
▶ State courts
— 4B

PLAY VIDEO ▶

@ montgomeryadvertiser.com
▶ Interactive map of returns
▶ Election Day photo galleries
▶ Voters share their stories
▶ Precinct-by-precinct totals
◀ Plus video from polling places

'Defining moment'

Obama challenges America to hope, dream

By David Espo
The Associated Press

WASHINGTON — Barack Obama was elected the nation's first black president Tuesday night in a historic triumph that overcame racial barriers as old as America itself.

The son of a black father from Kenya and a white mother from Kansas, the Democratic senator from Illinois sealed his victory by defeating Republican Sen. John McCain in a string of wins in hard-fought battleground states — Ohio, Florida, Virginia and Iowa. Alabama went squarely for McCain.

A huge crowd in Grant Park in Chicago erupted in jubilation at the news of Obama's victory. Some wept.

McCain called his former rival to concede defeat — and the end of his own 10-year quest for the White House.

"The American people have spoken, and spoken clearly," McCain told disappointed supporters in Arizona.

A short time later, Obama strolled onto the stage in Grant Park.

"Hello, Chicago," the president-elect said. The audience erupted in shouts and applause.

"If there is anyone out there who still doubts that America is a place where all things are possible, who still wonders if the dream of our founders is alive in our time, tonight is your answer.

"It's a long time coming, but because of what we did on this day, at this defining moment, change has come to America."

Obama went on to talk about his opponent, describing the telephone call from McCain as "gracious."

"He has endured sacrifices in America that most of us cannot begin to image," Obama said of McCain's six years as a prisoner during the Vietnam War.

McCain extended the GOP's presidential winning streak in Alabama to eight straight, garnering the state's nine electoral votes. The last time a Democratic presidential candidate carried Alabama in the general election was 1976, when Georgia's Jimmy Carter was the nominee.

From early in the evening, the veteran Arizona senator had a 10-point lead over the freshman senator from Illinois. The lead widened to nearly 20 percent, 60 percent to 39 percent, as the night wore on.

Obama Page 9A

ELECTORAL VOTE

Shortly after 10 p.m., The Associated Press count showed:
■ **Barack Obama:** 338
■ **John McCain:** 127
▶ Analysis **8A**

President-elect Barack Obama and his family celebrate at the election night rally in Chicago.
Jae C. Hong AP

Bright victorious in close District 2 race

By Sebastian Kitchen
skitchen@gannett.com

Bobby Bright joined the top of his party's ticket in making history Tuesday by becoming the first Democrat elected to represent Congress from the 2nd District since 1962.

Bright, the popular three-term mayor of Montgomery, defeated Republican state Rep. Jay Love by a razor-thin margin. The race was not called by The Associated Press until close to midnight with Bright ahead by less than 1,800 votes with 98 percent of precincts reporting.

Republicans have won the seat in every election since 1964. The seat in-cludes all or part of 16 counties stretching from the border with Florida to Montgomery, Autauga and Elmore counties. The candidates were vying to replace U.S. Rep. Terry Everett, R-Rehobeth, who is retiring after eight terms.

Bright's win in the Republican-leaning district demonstrated the difficulties Republicans faced in Tues-

CONGRESS DISTRICT 2	
450 of 457 precincts	
Bobby Bright (I)	143,997
Jay Love	142,231

day's election as Democrats won the White House and picked up seats in the U.S. House and Senate.

Bright came out to claim victory a little after 11:30 p.m., addressing supporters who waited for hours. Standing with his family, including his three children and his wife, former District Judge Lynn Bright, he addressed an energetic crowd.

"Whatever we do, I am determined not to let you down," Bright told his supporters. " ... You will be proud of what we do in District 2."

Some results were slow to come

Bright Page 9A

COUNTY COMMISSION

Ingram retains seat

By Jill Nolin
jnolin@gannett.com

The Republican incumbent for Montgomery County Commission District 5 squeaked into another term on the commission with a narrow victory Tuesday.

Reed Ingram, who is finishing his first term, won his bid for re-election by 363 votes.

With 32 of 33 precincts counted Tuesday night, Ingram had 50.69 percent, or 12,900 votes while Randy Rushton had 49.27 percent, or 12,537.

"We knew it was going to be a close race. We just didn't figure it would be this close, by no means," Ingram said late Tuesday night. "We've very happy that our supporters got out and that everybody worked as hard as they did."

Ingram was the only one of the five county commissioners who faced opposition this year. Voters decided to keep the current commission — which is composed of three Republicans and two Democrats — intact.

Ingram Page 9A

MONTGOMERY COUNTY COMMISSION	
District 5	
32 of 33 precincts	
Reed Ingram (I)	12,900
Randy Rushton	12,537

A Gannett Newspaper
36 pages

Volume 181, Number 310
© 2008 The Advertiser Co.

For home delivery
877-424-0007
Toll free

0 40901 12301 9

TODAY'S FORECAST
☁ **78°** Mostly sunny; nice
☀ **47°** Clear

For more weather updates go online at montgomeryadvertiser.com

CHECK IT OUT ONLINE
@ **www.montgomeryadvertiser.com**

Find out if you're owed a stimulus check, refund from the IRS | Data Central: Find crime reports, licenses, homicides and more

Barack Obama was elected
the nation's first black president
Tuesday night in a historic
triumph that overcame racial
barriers as old as America itself.

This is not an African-American win, it's a win for everybody. The whole world is celebrating, said Eleanor Andrews, board president of the Anchorage Urban League.

50 cents

ELECTION2008

Final Edition

Anchorage Daily News

Wednesday, November 5, 2008 — BREAKING NEWS AT ADN.COM — Alaska's Newspaper

U.S. SENATE
Stevens leads tight race

Found guilty of seven felony counts last month, Sen. Ted Stevens was leading challenger Mark Begich.

- Begich, Mark (D) 46.46%
- Stevens, Ted (R) 48.12%

96% of precincts reporting

Story, Page A-9

ADN.COM

Go online for the latest results, videos and more photos from election night and to join the conversation on the Alaska Politics blog.

U.S. HOUSE
Young holds solid advantage

Despite polls that predicted a defeat, Rep. Don Young was ahead of challenger Ethan Berkowitz.

- Berkowitz, Ethan (D) 43.89%
- Young, Don (R) 51.55%

96% of precincts reporting

Story, Page A-10

Obama makes history

President-elect Barack Obama acknowledges a cheering crowd at an election night party in Chicago's Grant Park on Tuesday. Obama won the electoral vote by more than a 2-to-1 margin.

MORRY GASH / The Associated Press

Illinois senator is elected nation's first black president

By STEVEN THOMMA | McClatchy Newspapers

WASHINGTON — Barack Obama was elected the 44th president of the United States on Tuesday, swept to victory by a country eager to change course at home and abroad. Obama, 47, becomes the first African-American in U.S. history to win the presidency and the first from the generation that came of age after the turbulence of the 1960s.

See Page A-6, **OBAMA**

Winner by state

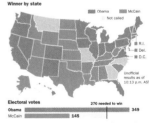

Obama McCain
 Not called

■ R.I.
■ Del.
■ D.C.

Unofficial results as of 10:13 p.m. AST

Electoral votes 270 needed to win

Obama 349
McCain 145

The Associated Press

Gov. Sarah Palin is joined by her husband, Todd, at a Phoenix rally where Sen. John McCain made his concession speech Tuesday evening. The McCain-Palin ticket was a big winner in Alaska.

ELISE AMENDOLA / The Associated Press

Inside

PRESIDENTIAL ELECTION
PAGE A-6 & A-7

GOV. SARAH PALIN
PAGE A-8

ALASKA LEGISLATURE
PAGE A-11

VOTE RESULTS
PAGE A-11

Anchorage, Alaska

www.adn.com

ARPAIO, THOMAS CRUISE TO WINS AA12
DEMS CONTROL ARIZONA'S U.S. HOUSE DELEGATION AA14

THE ARIZONA REPUBLIC
SPECIAL ELECTION EDITION

50¢ azcentral.com WEDNESDAY, NOVEMBER 5, 2008

OBAMA SEIZES HISTORIC WIN

Dominance in swing states leads to decisive victory

Arizonan McCain gracious in defeat, calls for unity

PABLO MARTINEZ MONSIVAIS/ASSOCIATED PRESS

Before a crowd of more than 100,000 in Chicago's Grant Park, President-elect Barack Obama took the stage to declare a "defining moment" in American politics.

20-PAGE SPECIAL SECTION

ACROSS THE NATION

Congressional gains

Democrats pick up at least five Senate seats in Congress but look likely to fall short of a filibuster-proof majority. The party is expected to pick up 20 House seats. **AA6**

Revolutionary victory

Barack Obama wins at least seven states carried by President Bush in the previous election, making good on his promise to redraw the electoral map. An analyst calls his triumph "truly revolutionary." **AA5**

IN ARIZONA

GOP retains Legislature

Republicans appear to keep their hold on the state Legislature. **AA14**

School mergers fail

Voters pass only one of six plans to unify school districts. **AA16**

PROPOSITIONS

100: REAL-ESTATE TAX BAN . . . **YES**
102: GAY-MARRIAGE BAN **YES**
202: HIRING SANCTIONS **NO**

All proposition results, AA15

ROB SCHUMACHER/THE ARIZONA REPUBLIC

John McCain, with wife Cindy and supporters at the Arizona Biltmore Resort in Phoenix, accepted defeat and noted "the special significance" of Obama's win.

U.S. POPULAR VOTE		ELECTORAL VOTE *(270 needed to win)*	
With 85 percent of precincts reporting		*Tally does not include Mo., Mont., N.C.*	
52%	**47%**	**349**	**159**
OBAMA	McCAIN	OBAMA	McCAIN

Obama shatters barrier to become 1st Black president

By Dan Nowicki
THE ARIZONA REPUBLIC

Barack Obama, the cool and collected Hawaiian-born son of a man from Kenya and woman from Kansas, whose promise of "change" inspired a generation of young people, shattered the last racial ceiling in U.S. politics Tuesday to become the first African-American elected president.

Obama, a freshman Democratic senator from Illinois, crushed his Republican foe, Sen. John McCain of Arizona, to capture a White House controlled for the past eight years by GOP President George W. Bush. In a striking repudiation of the Bush era, Obama won in an Electoral College landslide.

Obama's historic win comes 40 years after the assassination of civil-rights icon Martin Luther King Jr. and 45 years after King's dramatic "I Have a Dream" speech. And it comes at a time when the United States is militarily engaged in Iraq and Afghanistan and reeling under economic pressures not felt in decades.

"It's been a long time coming, but tonight, because of what we did on this

See **OBAMA** Page AA2

GET THE LATEST UPDATES, BLOGS, SLIDE SHOWS AND MORE AT
ELECTIONS.AZCENTRAL.COM

THE ARIZONA REPUBLIC

Cities balking at crime lab fees

Your daily 'Republic' inside: A second mistrial ends the murder case against an Arizona border agent. Find this story inside, along with Valley & State, Sports and Food & Drink.

A Gannett Newspaper
119th year, No. 171. Copyright 2008, The Arizona Republic

IT'S OBAMA

DECISIVE VICTORY MAKES HISTORY

◇

In California, gay-marriage ban takes early lead

'CHANGE HAS COME': President-elect Barack Obama celebrates with his wife, Michelle, their daughters, Sasha and Malia, and more than 240,000 supporters gathered along Chicago's waterfront. Many wept at the landmark moment.

TANNEN MAURY European Pressphoto Agency

The first black president-elect wins a solid mandate and a fortified Democratic majority in Congress.

MARK Z. BARABAK

Barack Obama, the son of a father from Kenya and a white mother from Kansas, was elected the nation's 44th president Tuesday, breaking the ultimate racial barrier to become the first African American to claim the country's highest office.

A nation founded by slave owners and seared by civil war and generations of racial strife delivered a smashing electoral college victory to the 47-year-old first-term senator from Illinois, who forged a broad, multiracial, multiethnic coalition. His victory was a leap in the march toward equality: When Obama was born, people with his skin color could not even vote in parts of America, and many were killed for trying.

"If there is anyone out there who still doubts that America is a place where all things are possible, who still wonders if the dream of our founders is alive in our time, who still questions the power of our democracy, tonight is your answer," Obama told more than 240,000 celebrants gathered along Chicago's waterfront. Many had tears streaking their faces.

"It's been a long time coming," said Obama, who strode on stage with his wife, Michelle, and their two daughters, Sasha and Malia. "But tonight, because of what we did on this day, in this election, at this defining moment, change has come to America."

Obama was beating Republican John McCain in every state Democrats carried four years ago, including Pennsylvania, which McCain had worked vigorously to pry away. Obama also made significant inroads into Republican turf, carrying Ohio, Colorado and Virginia; the latter voted Democratic for the first time in more than 40 years. He won the swing states of Florida, New Hampshire, Iowa and New Mexico, which backed President Bush in 2004.

In winning the White House, Obama to a large degree remade the electorate: About 1 in 10 of those casting ballots Tuesday were doing so for the first time. Though that number
[See **Election,** Page A8]

MATTHEW CAVANAUGH EPA
"Whatever our differences, we are fellow Americans," John McCain conceded.

NEWS ANALYSIS

Now it's idealism versus realism

DOYLE McMANUS
REPORTING FROM WASHINGTON

Barack Obama won the presidency Tuesday by persuading voters to embrace a seeming paradox: leadership based on contradictory principles of change and reassurance.

The Illinois senator combined ambitious goals and a cautious temperament. He promised tax cuts, better healthcare, new energy programs and fiscal discipline all at the same time, and all without the bitterness and stalemate that arose when those issues were tackled in the past.

Now, as Obama moves through his transition to the White House, this effort to square the political circle becomes the defining challenge in the months ahead. Which Barack Obama will dominate as he begins to govern?

Too much of the ambitious
[See **Analysis,** Page A11]

Nation watches as state weighs ban

Prop. 8 battle drew money and attention from across the U.S.

JESSICA GARRISON,
CARA MIA DiMASSA
AND RICHARD PADDOCK

A measure to ban gay marriage in California led in early returns Tuesday although the final outcome remained in doubt, leaving advocates on both sides in suspense about the most divisive and emotionally fraught contest in the state this year.

Proposition 8 would amend the California Constitution to define marriage as being only between a man and a woman.

Proposition 8 was the most expensive proposition on any ballot in the nation this year, with more than $74 million spent by both sides.

The measure's most fervent

proponents believed that nothing less than the future of traditional families was at stake, while opponents believed that they were fighting for the fundamental right of gay people to be treated equally under the law.

In San Francisco, supporters of gay marriage packed a ballroom at the Westin St. Francis Hotel on Tuesday night.

"You decided to live your life out loud. You fell in love and you said 'I do.' Tonight, we await a verdict," San Francisco Mayor Gavin Newsom said to a
[See **Prop. 8,** Page A21]

Weather PageB10	Printed with soy inks on partially recycled paper.
Complete IndexA2	

TODAY'S INSIDE SECTIONS
California, Business,
Sports, Calendar and Food

7 85944 00050 6

ELECTORAL VOTES
270 needed to win

OBAMA	McCAIN	UNDECIDED
349	144	45

PROPOSITION 8
Eliminate gay marriage

YES	NO
52.5%	47.5%

Results as of 11:33 p.m. Pacific time with 48% of precincts reporting

111TH CONGRESS
The House of Representatives
218 seats to control the House

DEMOCRATS	REPUBLICANS	UNDECIDED
242	160	33

The Senate
51 seats to control the Senate

DEMOCRATS	REPUBLICANS	UNDECIDED
56*	40	4

* Includes 2 independents. All results as of 11:10 p.m. Pacific time

Analysis: Erasing race assumptions
Even in Virginia, heart of the Confederacy, Obama prevails. A11

They wouldn't miss this for the world
Voters turn out in droves to take their part in history. A15

Roundup of state propositions
Measures on redistricting and farm animals are ahead. A20

latimes.com

All the latest news
View interactive maps detailing results for elections around the country and for all statewide measures and propositions.

Where hope has wrestled with fear

SANDY BANKS
REPORTING FROM CLEVELAND

I could not have imagined that less than four years later, he would be elected president. His name was so unfamiliar, I kept stumbling over it during our 45-minute interview about the role of race in his life and in his politics. Was it Barack Obama or Obama Barack?

The next morning, unbidden, he called me back.

"Hey Sandy," he said. "This is Barack. I've been thinking about what we talked about, and I wanted to add some thoughts."

By the time we finished our second chat, there were two things I thought I knew:

Barack Obama was determined to force this country to confront its "legacy of slavery."

And what he was asking — and offering — was too much for a nation still bitterly divided by skin color.

"His candidacy would make this country squirm and shudder and maybe even come unglued," I wrote back then.

Clearly, I underestimated him — and us.

How could I have been so wrong? Last week, as Obama closed in on the presidency, I went back to my hometown to look for answers.

◇

Cleveland was a step up for my parents. My father's family fled Georgia in the 1920s, one step ahead of a lynch mob set on teaching my uncle a lesson for daring to sass a white man. Twenty years later, my mother led her siblings north from a farm in Alabama. She met my father in Cleveland. They married, and I was the oldest
[See **Banks,** Page A12]

U.S. VOTERS EMBRACE CALL FOR CHANGE WITH HISTORIC WIN FOR OBAMA

THE ORANGE COUNTY REGISTER

PRICE: 50 CENTS • WEDNESDAY, NOV. 5, 2008 • FOUNDED IN 1905

FIRST BLACK PRESIDENT RACKS UP ELECTORAL COLLEGE LANDSLIDE

OH-BAMA!

JAE C. HONG, THE ASSOCIATED PRESS

THE WINNER: President-elect Barack Obama, his wife, Michelle, and daughters Malia, 7, and Sasha, 10, wave Tuesday in Chicago.

By DENA BUNIS
THE ORANGE COUNTY REGISTER

For Democrats, the news Tuesday was all good.

"What an exciting time to be an American," said Wylie Aitken, chairman of the Democratic Foundation of Orange County. "The fact that we elected this human being is going to bring our country together."

The polls had barely closed in California when Barack Obama had enough electoral votes to be declared president.

"If there is anyone out there who still doubts that America is a place where all things are possible; who still wonders if the dream of our founders is alive in our time; who still questions the power of our de-

SEE **OBAMA** • PAGE 4

O.C. congressional districts
incumbents leading in all district elections

OBAMA 60%
MCCAIN 39%

- Republican
- Democratic

How counties in California voted for president

Note: As of 11:30 p.m. Tuesday, with 47% of all California precincts counted

The Register

Gay marriage ban holds slight lead

Required parental notification for girls' abortions lags by 4 points.

By BRIAN JOSEPH and JENNIFER MUIR
THE ORANGE COUNTY REGISTER

SACRAMENTO • While a Democrat easily won California's vote for president, two social issues supported by conservatives held strong late Tuesday, as ballot measures on gay marriage and abortion appeared they could go either way.

With 33 percent of precincts reporting, Proposition 8, the proposal to outlaw gay marriage, was leading, 53 percent to 47 percent – a far cry from the 23-point margin for a 2000 measure that defined marriage as between a man and a woman but a stinging rebuke nonetheless to the activists who labeled this a classic civil rights issue.

Meanwhile, Proposition 4, which would require parental notification 48 hours before a

SEE **PROP. 8** • PAGE 8

* Results as of press time

| 47% McCain | POPULAR VOTE* | 52% Obama | 163 McCain | ELECTORAL COLLEGE* | 349 Obama | 40 Republicans | SENATE SEATS* | 56 Democrats | 173 Republicans | HOUSE SEATS* | 256 Democrats |

ELECTION SUMMARY: 12 PAGES OF COVERAGE INSIDE

KEY STATE PROPOSITIONS
FULL COVERAGE ON NEWS 8

PROP. 10: BEHIND
Renewable energy measure

PROP. 11: AHEAD
Redistricting measure

PROP. 1A: AHEAD
High-speed rail measure

PROP. 4: BEHIND
Parental notification measure for abortions

PROP. 5: FAIL
Non-violent drug rehab measure

PROP. 2: PASS
Farm animal treatment measure

INCUMBENTS LEAD IN IRVINE
Sukhee Kang, above, held a slight lead over Christina Shea for Irvine mayor while 3 council incumbents were leading. Other local returns. **News 10**

SCHOOLS BONDS AHEAD EARLY
Several school revenue measures were passing, while a deceased candidate made a run at an Anaheim seat. More early results. **News 12**

DEMOCRATS LEADING IN LEGISLATURE
Democrats looked to boost their majority in the state Legislature to two-thirds for the first time in at least three decades. **News 9**

DEMOCRATS GAIN SEATS IN SENATE
Sen. Elizabeth Dole, R-N.C., lost to Democrat Kay Hagan, above, but Democrats were short of a filibuster-proof majority. **News 5**

The Orange County Register is a Freedom Communications newspaper.
Copyright 2008
Customer service toll-free:
1-877-OCR-7009 (627-7009)
Online: www.ocregister.com

INSIDE: OPERA PACIFIC CANCELS SEASON, MAY SHUT FOR GOOD/NEWS 17 • CARONA TRIAL TESTIMONY/NEWS 14

Orange County, California

www.ocregister.com

What an exciting time to be an American, said Wylie Aitken, chairman of the Democratic Foundation of Orange County. "The fact that we elected this human being is going to bring our country together."

The nation's journey from selling African slaves to electing an African-American president is one marked by many detours and dead-ends, bloodshed and brutality. For those who took part in that journey – like San Diego's Rev. George Walker Smith – few dared to even dream that road would someday lead to the White House. "Cold chills went over me as I filled out that ballot," said Smith, the son of an Alabama sharecropper. "It was a great feeling I never thought I'd have. I have a great-grandson and I never thought he would live to see this."

The San Diego Union-Tribune.

Wednesday
November 5, 2008

75¢
PLUS TAX

LATEST ELECTION NEWS AT UNIONTRIB.COM

'CHANGE HAS COME'

President-elect Barack Obama's family — wife Michelle and daughters Malia and Sasha — joined him onstage after his victory speech last night in Chicago. *Jewel Samad / AFP/ Getty Images*

Obama leads Democratic surge

**By Michael D. Shear
and Robert Barnes**
THE WASHINGTON POST

WASHINGTON — Sen. Barack Obama of Illinois was elected the nation's 44th president yesterday, riding a message of change and an inspirational exhortation of hope to become the first African-American to ascend to the White House.

Obama, 47, the son of a Kenyan father and a white mother from Kansas, led a tide of Democratic victories across the nation in defeating Republican Sen. John McCain of Arizona, a 26-year veteran of Washington who could not overcome his connections to President

Bush's increasingly unpopular administration.

"If there is anyone out there who still doubts that America is a place where all things are possible, who still wonders if the dream of our founders is alive in our time, who still questions the power of our democracy, tonight is your answer," Obama told a throng of supporters during a victory celebration in Chicago's Grant Park.

"It's been a long time coming. But tonight, because of what we did on this date, in this election, change has come to America."

Obama became the first

SEE **President, A4**

2008 ELECTORAL COLLEGE RESULTS

270 electoral votes
needed to win

349 Barack Obama 160 John McCain
15 Leaning Obama 14 Leaning McCain

Total: **364** **174**

Dark outlines indicate key battleground states.

As of 11 p.m. yesterday

SOURCES: Associated Press; New York Times News Service UNION-TRIBUNE

An improbable tale reaches its zenith

By George E. Condon Jr. and Finlay Lewis
U-T WASHINGTON BUREAU

WASHINGTON — The nation's journey from selling African slaves to electing an African-American president is one marked by many detours and dead-ends, bloodshed and brutality. For those who took part in that journey — like San Diego's Rev. George Walker Smith — few dared to even dream that road would someday lead to the White House.

"Cold chills went over me as I filled out that ballot," said Smith, the son of an Alabama sharecropper. "It was a great feeling I never thought I'd have. I have a great-grandson and I never thought he would live to see this."

Across the nation, it was a feeling shared by millions of blacks, from those old enough — like Smith — to remember "colored" and "whites only"

SEE **History, A5**

Gay marriage ban remains undecided

**By Michael Gardner
and Michael Stetz**
STAFF WRITERS

SACRAMENTO — The future of same-sex marriage in California remained in limbo late last night, with neither side mustering an early election lead sadle enough to declare victory.

Proposition 8, which would overturn the landmark state Supreme Court ruling in May legalizing same-sex marriage, started out strong but the gap narrowed as returns came in from the San Francisco area.

The Rev. Jim Garlow, pastor of Skyline Church in Rancho San Diego and a leading propo-

PROP. 8
Eliminates right of same-sex couples to marry

YES 53%
NO 47%

49% of precincts reporting

nent of the measure, celebrated the early returns.

"I'm extremely encouraged. ... I'm not sure how the numbers are going to end up, but I'm sure we're going to win," Garlow said.

Crowds at two popular gay bars in San Diego's Hillcrest neighborhood were too caught up in Barack Obama's

SEE **Prop. 8, A7**

CALIFORNIA PROPOSITIONS

PROP. 4: Waiting period and parental notification before termination of minor's pregnancy

NO 52% YES 48%

PROP. 7: Renewable energy generation

NO 66% YES 34%

PROP. 10: Alternative fuel vehicles, renewable energy

NO 62% YES 38%

PROP. 11: Redistricting initiative

YES 51% NO 49%

49% of precincts reporting
COMPLETE RESULTS, A7

Goldsmith claims city attorney post

By Matthew T. Hall
STAFF WRITER

San Diego voters appeared ready to end the tempestuous tenure of City Attorney Michael Aguirre yesterday, ousting him in favor of a judge who campaigned unswervingly on an oath to refocus the office from politics to the law.

Superior Court Judge Jan Goldsmith's apparent defeat of Aguirre would remove someone Mayor Jerry Sanders saw as an obstacle at City Hall — but also take away an excuse if Sanders can't move his agenda forward.

"Should the numbers hold out, we're going to build a law

Michael Aguirre **Jan Goldsmith**

firm for the city of San Diego," Goldsmith said. "And we're going to support the reform of the city of San Diego so we can move forward under the leadership of our mayor and the City Council."

SEE **City attorney, A8**

U.S. CONGRESS

DEMOCRATS ADD SEATS: The party rides historic surge and dramatically increases its majorities in the House and Senate. **A9**

GOVERNORS

DEMOCRATS WIN 2 OPEN RACES: North Carolina elects its first female governor; a Democrat replaces a Republican in Missouri. **A9**

SAN DIEGO PROPOSITION

PROP. D: Making alcohol consumption unlawful at city beaches

YES 62% NO 38%

27% of precincts reporting
STORY, B1

U-T VOICE | TIM SULLIVAN
Crawford High's 0-9 football squad needed a pep talk.
Who better than the Chargers' Kris Dielman? **Sports, D1**

FOR BREAKING NEWS AND MULTIMEDIA:
uniontrib.com

Rocky Mountain News

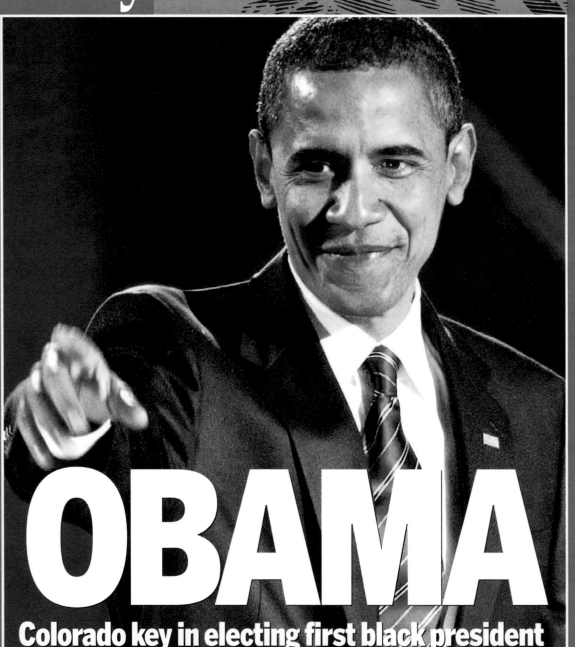

OBAMA

Colorado key in electing first black president

Udall win boosts Dems' margin in U.S. Senate

PABLO MARTINEZ MONSIVAIS/ASSOCIATED PRESS

Denver, Colorado

www.rockymountainnews.com

SENATE 100 seats

Republicans	Democrats
-5	**+5**
40	54

Ind. 2 Undecided 4

KEY RACES
Kentucky: Mitch McConnell (R) defeats Bruce Lunsford (D)
Georgia: Saxby Chambliss (R) vs. Jim Martin (D)
North Carolina: Kay Hagan (D) defeats Elizabeth Dole (R)

McCain 142 Obama 338 Undecided 58

For latest results see
www.washingtontimes.com

HOUSE 435 seats

Republicans	Democrats
-13	**+13**
144	231

Undecided 60

KEY RACES
Maryland 1: Andy Harris (R) vs. Frank Kratovil (D)
Minnesota 6: Michelle Bachmann (R) vs. Elwin Tinklenberg (D)
Connecticut 4: Jim Himes (D) defeats Christopher Shays (R)

The Washington Times

GLOOMY – HIGH 63, LOW 52 **WEDNESDAY, NOVEMBER 5, 2008**

President Obama

Warner, Obama capture Virginia

BY GARY EMERLING
AND TIMOTHY WARREN
THE WASHINGTON TIMES

Virginia completed its march from red to blue Tuesday by electing former Gov. Mark Warner to the U.S. Senate and voting for a Democratic presidential candidate for the first time in 44 years.

Sen. Barack Obama defeated Republican candidate Sen. John McCain in a long, hard-fought race by winning roughly 51 percent of the vote in the state, compared to Mr. McCain's 48 percent, with 94 percent of precincts reporting.

"Virginians said they want the next U.S. senator to focus on results, not rhetoric," Mr. Warner, 53, said during a victory party at the Hilton McLean, in Tysons Corner. "Tonight, this campaign ends about 18 months after it began, based on the notion we could find common ground.

"So here I stand, the new senator from Virginia."

In Maryland, residents settled a decade-old debate by voting to legalize slot machines, while the District, with a major-

» see **VIRGINIA,** page A13

VICTORY: President-elect Barack Obama gives his acceptance speech Tuesday night at Grant Park in Chicago. He thanked his opponents, John McCain and running mate Sarah Palin, for a tough historic race and spoke about his grandmother and children.
ASSOCIATED PRESS

Landslide for first black chief executive

BY STEPHEN DINAN,
CHRISTINA BELLANTONI
AND JOSEPH CURL
THE WASHINGTON TIMES

Americans dissatisfied with their faltering economy and two drawn-out wars elected Barack Obama their 44th president on Tuesday night, shattering the last great racial barrier in U.S. politics and empowering Democrats with larger congressional majorities to pursue the young Illinois senator's agenda of change.

Mr. Obama, the 47-year-old son of a Kenyan father and a Kansan mother, defeated Republican Sen. John McCain to become the nation's first black president-elect and in so doing also reshaped the electoral map on the strength of historic turnout among both enthusiastic young and minority voters.

His landslide victory ended a two-decade era of politics dominated by the Bush and Clinton families.

"Change has come to America," said Mr. Obama, who took the stage in Grant Park in Chicago just before midnight

» see **ELECTION,** page A11

Issues

Economy turns voters left, but may delay agenda

BY DONALD LAMBRO
THE WASHINGTON TIMES

America took a sharp left turn Tuesday with the election of Barack Obama and a more liberal Congress, voting for a change in the economy's direction, U.S. troop withdrawals from Iraq and a nationwide system for affordable health care.

The economy's nose-dive into recession, deeper job losses and a collapsed stock market that flattened worker retirement accounts were the driving forces behind the liberal freshman senator's victory, according to exit polls of some 10,000 voters. Six in 10 voters said the economy was the most important issue facing the country.

ANALYSIS

» see **ANALYSIS,** page A10

ELATION: Crowds celebrate the Democratic candidate's victory on election night at the corner of 14th and U streets in Northwest.
ALLISON SHELLEY/THE WASHINGTON TIMES

History

Obama breaks barriers for black Americans

"I stand here knowing that my story is part of the larger American story, that I owe a debt to all of those who came before me, and that, in no other country on Earth, is my story even possible."
— Barack Obama, Democratic National Convention, July 27, 2004

BY DAVID R. SANDS
THE WASHINGTON TIMES

Four years after he burst onto the national scene, Barack Obama's improbable story has another precedent-shattering chapter, as the 47-year-old first-term senator from Illinois, the Hawaii-born son of a Kenyan father and a white mother from Kansas, adds another title to an already remarkable resume: president-elect.

Many black voters, patiently waiting at packed polling stations across the country, said

they had never thought they would live to see one of their own win the world's most powerful office.

The long lines leading to the voting booths in the morning gave way to exultant open-air street parties as Mr. Obama's victory became apparent in the evening, topped by a massive open-air bash in the candidate's home city of Chicago.

"I believed it would happen one day because my father told me to believe one day it would

» see **HISTORY,** page A12

WEATHER ON C8

Cloudy and rainy
▲63° ▼52°

8 am : 54° Cloudy
Noon : 62° Cloudy
4 pm : 60° Rain

VOLUME 27, NUMBER 288

McCain campaign: Warrior's last hurrah

BY JOSEPH CURL
THE WASHINGTON TIMES

PHOENIX | If there is one word that has encapsulated the life and career of Sen. John McCain, it is "survivor."

Three times as a Navy pilot, he crashed planes he was flying; three times he walked away without a scratch. Once, when sitting in his jet on the deck of the USS Forrester, a rocket from another plane hit his plane, which exploded. Mr. McCain scurried through the flames; 134 other men died.

And when he ejected from his jet over Hanoi, breaking both arms and a leg, he fell into a lake but was pulled out by Vietnamese, who beat him unconscious. Given up for dead — he weighed less than 100 pounds at one point during 5½ years of imprisonment in the "Hanoi Hilton" — he survived once more.

"This guy is literally unkillable," a top aide said the night in January when the senator from Arizona pulled off a stunning

» see **MCCAIN,** page A10

HEARTFELT: Sen. John McCain concedes defeat to Mr. Obama in Phoenix.
KATIE FALKENBERG/THE WASHINGTON TIMES

ELECTION COVERAGE INSIDE

▶ Marylanders throw support to slot machines. **B1**

▶ Democrats close in on Senate supermajority. **B1**

▶ Enthusiasm overwhelms polling systems nationwide. **B2**

▶ Democrats take Missouri governor's seat from GOP. **B4**

AAA

The Washington Post

Weather

Today: Rain. High 64.
Low 51.
Thursday: Mostly cloudy.
Low 63. High 52.

Details, **B6**

131ST YEAR No. 336 S DM VA K *Printed using recycled fiber* WEDNESDAY, NOVEMBER 5, 2008 Mr Ms Ms Ms Vs Vs Vs Vs

NEWSSTAND 50¢
HOME DELIVERY 41¢

Obama Makes History

U.S. DECISIVELY ELECTS FIRST BLACK PRESIDENT

DEMOCRATS EXPAND CONTROL OF CONGRESS

President-elect Barack Obama, with wife Michelle and daughters Sasha, 7, and Malia, 10, greets more than 100,000 people celebrating his victory in Grant Park, in his home town of Chicago.

BY NIKKI KAHN — THE WASHINGTON POST

*By Robert Barnes
and Michael D. Shear
Washington Post Staff Writers*

Sen. Barack Obama of Illinois was elected the nation's 44th president yesterday, riding a reformist message of change and an inspirational exhortation of hope to become the first African American to ascend to the White House.

Obama, 47, the son of a Kenyan father and a white mother from Kansas, led a tide of Democratic victories across the nation in defeating Republican Sen. John McCain of Arizona, a 26-year veteran of Washington who could not overcome his connections to President Bush's increasingly unpopular administration.

Standing before a crowd of more than 100,000 who had waited for hours at Chicago's Grant Park, Obama acknowledged his own accomplishment and the dreams of his supporters.

"If there is anyone out there who still doubts that America is a place where all things are possible, who still wonders if the dream of our founders is alive in our time, who still questions the power of our democracy, tonight is your answer," he said just before midnight Eastern time.

"The road ahead will be long. Our climb will be steep. We may not get there in one year or even one term, but America — I have never been more hopeful than I am tonight that we will get there. I promise you — we as a people will get there."

The historic Election Day brought millions of new voters, long lines at polling places nationwide and a new era of Democratic dominance in Congress, even though the party fell short of the 60 votes needed for a veto-proof majority in the Senate. In the House, Democrats made major gains, adding to their already sizable advantage and returning them to a position of power that predates the 1994 Republican revolution.

Democrats will use their new legislative muscle to advance an economic and foreign policy agenda that Bush has largely blocked for eight years. Even when the party seized

See **ELECTION**, A38, Col. 1

HOW HE WON

Measured Response To Financial Crisis Sealed the Election

*By Anne E. Kornblut
Washington Post Staff Writer*

Sen. Barack Obama, so steady in public, did not hide his vexation when he summoned his top advisers to meet with him in Chicago on Sept. 14.

His general-election campaign had gone stale. For weeks, he had watched Sen. John McCain suck up the oxygen in the race, driving the news coverage after the boisterous Republican convention in St. Paul, Minn., and suddenly drawing huge crowds with his new running mate, Alaska Gov. Sarah Palin.

Convening the meeting that Sunday in the office of David Axelrod, his chief strategist, Obama was blunt: It was time to get serious.

"He said, 'You know, maybe we can just win it on the issues. But I don't think so,' " recalled senior adviser Anita Dunn. With the debates approaching and just seven weeks until the election, "his charge to everybody was 'Guys, we're back in combat mode,' " Dunn said.

And then, the next morning, a global earthquake hit: Lehman Brothers, the giant investment firm, filed for bankruptcy, triggering the biggest corporate collapse in U.S. history and an international financial meltdown, and transforming the presidential race.

It was a moment neither the senator from Illinois nor his advisers had anticipated, but one for which they were uniquely prepared. In the days that followed, the newly chastised Obama team became more aggressive, with a message they had refined over the summer. The candidate himself, criticized as too cool, too cerebral and too detached, suddenly had the opportunity to show those qualities to be reassuring and presidential.

For McCain, already struggling with the economic

See **OBAMA**, A34, Col. 1

At an election party at Busboys and Poets, Tiffany Payton and Barbara Mack, right, embrace as CNN declares Obama the winner.

BY BILL O'LEARY — THE WASHINGTON POST

A DAY OF TRANSFORMATION

America's History Gives Way to Its Future

*By Kevin Merida
Washington Post Staff Writer*

After a day of runaway lines that circled blocks, of ladies hobbling on canes and drummers rollicking on street corners, the enormous significance of Barack Obama's election finally began to sink into the landscape. The magnitude of his win suggested that the country itself might be in a gravitational pull toward a rebirth that some were slow to recognize.

Tears flowed, not only for Obama's historic achievement, but because many were happily discovering that perhaps they had underestimated possibility in America.

When the novelist Kim McLarin watched her vote being recorded at her polling station in Milton, Mass., she stood still for a moment with her 8-year-old son, Isaac. "My heart was full. I could scarcely breathe," she said. "What I've been

forced to acknowledge is there has been a shift — it's not a sea change. But there's been a decided shift in the meaning of race. It's not an ending. It's a beginning."

What kind of beginning it is, Americans were wrestling with late into the night, some popping champagne and others burdened with unease. Would enduring strains of intolerance lose their power or gain rebellious steam? Could new hope be harnessed to create new solutions? Is America ready to pull itself together or resigned to live divided? The campaign that began for Obama 21 months ago had raised in stark terms whether America was ready for a black president. Last night's answer — a resounding yes — raises the next question: How much more change will America embrace?

When McLarin learned last night that the nation had voted

See **TRANSFORMATION**, A33, Col. 1

THE AGENDA

Hard Choices And Challenges Follow Triumph

*By Dan Balz
Washington Post Staff Writer*

After a victory of historic significance, Barack Obama will inherit problems of historic proportions. Not since Franklin D. Roosevelt was inaugurated at the depths of the Great Depression in 1933 has a new president been confronted with the challenges Obama will face as he starts his presidency.

At home, Obama must revive an economy experiencing some of the worst shocks in more than half a century. Abroad, he has pledged to end the war in Iraq and defeat al-Qaeda and the Taliban in Afghanistan. He ran on a platform to change the country and its politics. Now he must begin to spell out exactly how.

Obama's winning percentage appears likely to be the largest of any Democrat since Lyndon Johnson's 1964 landslide and makes him the first since Jimmy Carter in 1976 to garner more than 50.1 percent. Like Johnson, he will govern with sizable congressional majorities. Democrats gained at least five seats in the Senate and looked to add significantly to their strength in the House.

But with those advantages come hard choices. Among them will be deciding how much he owes his victory to a popular rejection of President Bush and the Republicans and how much it represents an embrace of Democratic governance. Interpreting his mandate will be only one of several critical decisions Obama must make as he prepares

See **AGENDA**, A30, Col. 1

Contents
© 2008
The
Washington
Post

0 70628 21100 3

MARKELL TROUNCES LEE

State Treasurer Jack Markell, a Democrat, rode the promise of change to beat Republican Bill Lee in Delaware's gubernatorial election. Democrats also invoked that theme to win both chambers of the Legislature. **PAGES A10-11**

Among GOP fallen: Spence, Wagner, Valihura, Stone, Lofink. PAGE A11

The News Journal

www.delawareonline.com

WEDNESDAY Nov. 5, 2008 75¢ L **FINAL EDITION**

'YES, WE CAN'

OBAMA ELECTED FIRST BLACK PRESIDENT

BIDEN ACHIEVES HIGHEST OFFICE FOR A DELAWAREAN

"The road ahead will be long. Our climb will be steep. We may not get there in one year or even one term, but America, I have never been more hopeful than I am tonight that we will get there. I promise you — we as a people will get there."

Barack Obama

Barack Obama and Joe Biden acknowledge the cheers of supporters at their victory rally Tuesday night in Chicago.
The News Journal/SUCHAT PEDERSON

COMPLETE RESULTS ★ MORE PHOTOS ★ VIDEO ★ FORUMS GO TO WWW.DELAWAREONLINE.COM

NEW CASTLE, KENT AND SUSSEX COUNTIES AND WILMINGTON RESULTS, PAGE B1

Once unthinkable, black Delawareans fulfill dream.	VP-elect Biden breaks new ground for Delaware.	Redemption for Biden after crushing loss in Iowa.	Long lines, good feelings at polling stations.
PAGE A4	**PAGE A6**	**PAGE A7**	**PAGE B1**

©2008, The News Journal Co.
A Gannett newspaper 130th year, No. 161

TODAY'S FORECAST

HIGH LOW
61 49
WILMINGTON
Details on A4

INSIDE

Former Boscov's execs to buy chain

Retailer hopes to recover under two of its former leaders after rejecting $11 million buyout offer.
PAGE B6

TIDE OF HOPE

BARACK OBAMA ELECTED 44TH PRESIDENT

Florida voters joined Ohio, Pennsylvania and Virginia in catapulting Barack Obama to a historic victory. It is only the second time a Democrat has carried Florida in 32 years.

Getty Images

BY ADAM C. SMITH | *Times Political Editor*

THERE IS A TIDE IN THE AFFAIRS OF MEN which, taken at the flood, leads to fortune. That was Shakespeare, and on Tuesday America embraced the sentiment. It was an absolute flood. An African-American man named Barack Obama is now president-elect of the United States of America. In his youth and eloquence he upended the politics in this country and suggested there is a new way, a new day. Whether you celebrate this outcome or lament it, the American ideal is true: Anything is possible. We are today a very different country than yesterday. This is change.

Election '08 at a glance

Paper ballots pass the test, but glitches plague Hillsborough. Page 3A

Florida voters add gay marriage ban to state Constitution. Page 1B

Elizabeth Dole loses as Democrats gain at least 5 seats in Senate. Page 4A

Complete coverage 2A-11A, 1B-5B and on tampabay.com

The Miami Herald

D2

35¢ MIAMI-DADE, 50¢ MONROE
106TH YEAR, NO. 52 ©2008

MiamiHerald.com Ⓗ

WEDNESDAY, NOV. 5, 2008
FINAL EDITION

PRESIDENT OBAMA

PRESIDENTIAL RACE: FLORIDA PART OF NATIONAL TIDE FOR ILLINOIS SENATOR
BALANCE OF POWER: DEMOCRATS STRENGTHEN GRIP ON U.S. HOUSE, SENATE

NIKKI KAHN/THE WASHINGTON POST

THE WINNER: Sen. Barack Obama, accompanied by his wife, Michelle, and their two daughters, arrives at Grant Park in downtown Chicago for his victory rally.

3 INCUMBENTS PREVAIL

PEDRO PORTAL/EL NUEVO HERALD

Miami's trio of Cuban-American congressional Republicans withstood the toughest, best-financed challenges of their political careers on Tuesday, despite a wave of Democrats turning out.

● With 98 percent of the precincts reporting, Rep. Mario Diaz-Balart narrowly led Democratic Party activist Joe Garcia, 122,530 to 110,112.

● Rep. Lincoln Diaz-Balart (above) cruised to an easy victory over former Hialeah Mayor Raul Martinez, 131,658 to 96,264.

● Rep. Ileana Ros-Lehtinen vanquished political newcomer Annette Taddeo, 136,633 to 99,407.

STORY, 1B

1st black president makes U.S. history

BY BETH REINHARD
breinhard@MiamiHerald.com

Barack Obama will stride into the White House and the history books as the nation's first black president, riding a surge in Democratic voter registration, a tide of discontent with the Republican Party and a hard-fought triumph in Florida.

"If there is anyone out there who still doubts that America is a place where all things are possible, who still wonders if the dream of our founders is alive in our time, who still questions the power of our democracy, tonight is your answer," declared the 47-year-old Illinois senator to an emotional crowd estimated at 150,000 in Grant Park in Chicago. "Tonight, because of what we did on this day, in this election, at this defining moment, change has come to America."

Republican John McCain offered a gracious concession speech that recognized Obama's barrier-breaking achievement for African-Americans. He urged the country to unite.

●TURN TO OBAMA, 4A

How a shift in state boosted Democrat

BY MARC CAPUTO AND ROB BARRY
mcaputo@MiamiHerald.com

Buoyed by massive black support and the crucial votes of Hispanics, Democrat Barack Obama captured Florida by winning on the issues and striking deep into Republican strongholds.

Obama's Florida win over John McCain was a stinging loss for Republicans who control the Legislature and governor's mansion and, until just two months ago, were openly questioning whether the Democrat would campaign full force in the nation's biggest swing state.

But hard financial times, McCain's gaffe in Jacksonville where he said the "fundamentals of the economy are strong" and Obama's juggernaut of a campaign inalterably changed the race.

Obama beat McCain by a 51-48 percent margin, and captured a lopsided share of Florida votes from young people and first-time voters, winning comfortably among independents, and by besting McCain among Hispanic voters by double digits, according to Edison Media

●TURN TO SHIFT, 6A

The new political picture

Partial, unofficial election results by the numbers:

PRESIDENT

BARACK OBAMA	51%
Electoral votes	338
JOHN McCAIN	47%
Electoral votes	156

U.S. SENATE

DEMOCRATS	56
REPUBLICANS	40

U.S. HOUSE (projected)

DEMOCRATS	260
REPUBLICANS	175

GOVERNORS

DEMOCRATS	29
REPUBLICANS	21

A milestone

For voters who lived through the civil rights movement, this historic race was about much more than the presidency. **10A.**

Cuba not only factor

For many Cuban-American voters in Miami-Dade, U.S. policy toward Cuba wasn't only factor, **10A.**

The Atlanta Journal-Constitution

ELECTION2008

WEDNESDAY, NOV. 5, 2008 75¢

BARACK OBAMA | 44th president of the United States

HISTORIC WIN

JOE RAEDLE / Getty Images

President-elect **Barack Obama** — with his wife, **Michelle**, and daughters **Sasha** (second from left), 7, and **Malia**, 10 — acknowledges his supporters at an Election Night party in Chicago's Grant Park.

RICH ADDICKS / raddicks@ajc.com

After news of Sen. Barack Obama's victory, **Kecia Cunningham** cries with joy in the arms of **Steve Vaughn** at the state Democrats' party Tuesday night at Hyatt Regency in Atlanta.

INSIDE COLUMNIST REFLECTS

'Extraordinary times'

"I'm struggling to find my footing on an altered terrain, a landscape where a black man can be elected president of the United States. It's an exciting place, a hopeful and progressive place, but it's unfamiliar. I didn't expect to find myself here so soon." **Cynthia Tucker, A18**

U.S. ELECTS 1ST BLACK PRESIDENT IN 'VICTORY OF FAITH OVER FEAR'

By CAMERON McWHIRTER / cmcwhirter@ajc.com

When the Rev. Martin Luther King Jr. delivered his "I Have a Dream" speech in 1963, calling for equal rights for black Americans, he was never so bold to suggest that one day a black man could become the nation's chief executive.

Forty-five years later, Sen. Barack Obama became the first African-American president-elect of the United States after the longest, costliest and largest election in the country's history.

"If there is anyone out there who still doubts that America is a place where all things are possible, who still wonders if the dream of our founders is alive in our time, who still questions the power of our democracy, tonight is your answer," the 47-year-old Democrat told an estimated crowd of 100,000 gathered in and around Grant Park in his hometown of Chicago Tuesday night.

When news organizations declared Obama the victor, the crowds exploded in jubilation.

"It's been a long time coming, but tonight, because of what we did on this day, in this election, at this defining moment, change has come to America," he declared before a backdrop of U.S. flags.

A homemade banner waved by one man in the throng read, "We have overcome,"

Amid the celebration, Obama cautioned that the country faced profound challenges.

"We know the challenges that tomorrow will bring are the greatest of our lifetime – two wars, a planet in peril, the worst financial crisis in a century," he said.

Obama said he was certain America would solve its

➤ Please see PRESIDENT, Page 10

Vol. 60, No. 310
Copyright ©2008
The Atlanta
Journal-Constitution

The AJC
uses recycled
newsprint.

7 22011 00002 1

ELECTORAL VOTES	STATES CARRIED	STATES CARRIED	POPULAR VOTE
338 Barack Obama - D	**Obama:** Calif., Colo., Conn., Del., Fla., Hawaii, Ill., Iowa, Maine, Mass., Md., Mich., Minn., N.H., N.J., N.M., Nev., N.Y., Ohio, Ore., Pa., R.I., Va., Vt., Wash., Wis.	**McCain:** Ala., Ariz., Ark., Ga., Idaho, Kan., Ky., La., Miss., Neb., N.D., Okla., S.C., S.D., Tenn., Texas, Utah, W.Va., Wyo.	**51%** Barack Obama - D
156 John McCain - R			**48%** John McCain - R

U.S. SENATE

Georgia race closely watched
Incumbent Republican Sen. Saxby Chambliss (top left) was leading Democrat Jim Martin, but it was unclear whether he would avoid a runoff. **Page 6**

Atlanta, Georgia

www.ajc.com

VOTERS ON O'AHU SAY 'YES' TO RAIL

BY SEAN HAO
Advertiser Staff Writer

Frustration over congested roads outweighed concerns about costs as voters approved Honolulu's planned elevated commuter rail project yesterday.

The victory at the polls brings the city closer than it has ever been to building a commuter rail line. Three previous mass-transit plans over the past three decades failed for lack of polit-

ical support.

But yesterday's vote, which favored rail by roughly 51 percent to 46 percent, should give the city the green light to move forward with the controversial $4.28 billion project. Construction is scheduled to begin late next year.

The favorable rail results likely were bolstered by Honolulu Mayor Mufi Hannemann's strong advocacy for the project and a major pro-rail advertis-

146,764	132,268
Votes for rail transit	Votes against rail transit

ing campaign.

Those voting for rail cited the need for transportation alternatives and traffic relief.

"I feel so bad for the people who live out there and have to come into town in this traffic," said Jane Himeda, who voted for

rail at McKinley High School.

Those voting against rail cited concerns about the project's high cost, aesthetics and noise.

Waikīkī resident Charles Gonzalez, 48, was first in line this morning at the Waikīkī Community Center. He said he voted for Hannemann, but against rail.

"I like Mufi as mayor, but I think we have to look into rail

SEE RAIL, A3

ELECTION 2008

Complete coverage of races, issues inside
★ PAGES A2-A11

HONOLULUADVERTISER .COM/ELECTION2008

Blogs, analysis, forums on local races online

WEDNESDAY
NOVEMBER 5, 2008

The Honolulu Advertiser

HAWAI'I'S NEWSPAPER

Reaching 366,000 daily readers

HOME FINAL
75 cents on O'ahu | $1.00 on Neighbor Islands

OBAMA
HAWAI'I'S OWN MAKES HISTORY

Overcomes racial barrier to become president-elect

BY DERRICK DePLEDGE
Advertiser Government Writer

Barack Obama made history last night, becoming the first African-American, and the first person born in Hawai'i, elected president of the United States.

Hawai'i voters, in a show of local pride, gave the Punahou School graduate his largest victory margin of any state in the nation. Obama led U.S. Sen. John McCain of Arizona, the Republican nominee, 71 percent to 26 percent in the Islands with most of the votes counted. The District of Columbia, which has a predominantly African-American population, went for Obama 93 percent to 7 percent.

In a speech to an exhilarated crowd at Grant Park in Chicago, the Illinois senator described his victory as a historic moment and a message to the world that Americans could overcome racial and political differences and unite for change.

"If there is anyone out there who still doubts that America is a place where all things are possible, who still wonders if the dream of our founders is alive in our time, who still questions the power of our democracy," Obama said. "Tonight is your answer."

Obama celebrated his wife, Michelle, and his daughters, Sasha and Malia, and said he missed his late grandmother.

Sadly, his deepest emotional connection to the Islands — his maternal grandmother, Madelyn Dunham — did not live to see him elected. Dunham, who died Monday of cancer, had voted

SEE OBAMA, A4

6 sections, 60 pages ★
© COPYRIGHT, 2008.

0 40901 00001 3

♲ A GANNETT NEWSPAPER

2008 PULITZER PRIZE FINALIST FOR BREAKING NEWS

Boise & West Ada
Boise, Meridian, Eagle
Garden City, Kuna, Star

Idaho Statesman

WEDNESDAY, NOVEMBER 5, 2008 Latest news at IdahoStatesman.com 50 CENTS

In electing Barack Obama as America's first black president, voters make history and pick a new direction for the nation

'CHANGE HAS COME'

President-elect Barack Obama walks on stage to deliver his victory speech Tuesday night at Grant Park in Chicago.

DAVID GUTTENFELDER / The Associated Press

Hunger for healing in U.S., Idaho fueled intense interest in presidential election

BY DAN POPKEY
dpopkey@idahostatesman.com

For Idaho voters, the presidential race was weighted with a singular purpose not seen since Ronald Reagan's election.

So bruised is the country that even in a state that's voted Republican in 11 straight presidential contests, people who thought they couldn't make a difference felt compelled to try.

Among them was Boisean Jolene Hasse, who cast a ballot for Obama. Hasse is 48 years old. She marked her first ballot.

Ever.

"The last four years have been pretty rough," said Hasse. "Everybody needs to get past the 'I don't make a difference,' including me."

Hasse's maiden election was solely focused on the beleaguered national spirit. She waited

almost an hour to vote, filled in the oval for Obama and turned in her ballot, leaving blank every other race.

After the nation spoke, Obama and John McCain rewarded Hasse with vows to put country first and heal an anxious nation.

McCain's concession was a ringing call for national purpose.

See ELECTION, MAIN 2

MCCAIN: 'WE MUST WORK TOGETHER'
MAIN 5

RISCH WINS; SALI-MINNICK DOWN TO THE WIRE
MAIN 8

ADA, CANYON RESULTS COUNTED INTO MORNING
MAIN 8

8 PAGES OF IDAHO AND NATIONAL COVERAGE INSIDE

TODAY'S IDAHO STATESMAN			TUESDAY'S LOTTERY DRAWING	OWN A PIECE OF HISTORY	44°/33°	Is your paper missing? Call 377-6370
ComicsLife 7	MoviesLife 2	StocksBusiness 2	IDAHO PICK 3: 5-1-7	Get a press plate or a poster of today's historic front page. For details, see Main 6.	WEATHER, MAIN 18	Vol. 144 • No. 103 6 sections • 46 pages
Legal ads .Classifieds 11	ObituariesMain 11	TVLife 2				© 2008 Idaho Statesman
Nation/World .Main 13	OpinionMain 17	WeatherMain 18				
Newsmakers ...Main 14	PuzzlesLife 6					

For Idaho voters, the presidential race was weighted with a singular purpose not seen since Ronald Reagan's election. So bruised is the country that even in a state that's voted Republican in 11 straight presidential contests, people who thought they couldn't make a difference felt compelled to try.

Barack Obama first tapped into
what Iowans believed was possible.
And it turned out Tuesday that
America believes it, too . . . "It began
in the backyards of Des Moines,"
Obama, 47, recalled Tuesday. After
the hands of Iowa Democrats shot up
at January's caucuses, the nation's
hands followed. The voices of change
and hope grew loud enough to drown
out the politics of old, even as new
economic challenges appeared.

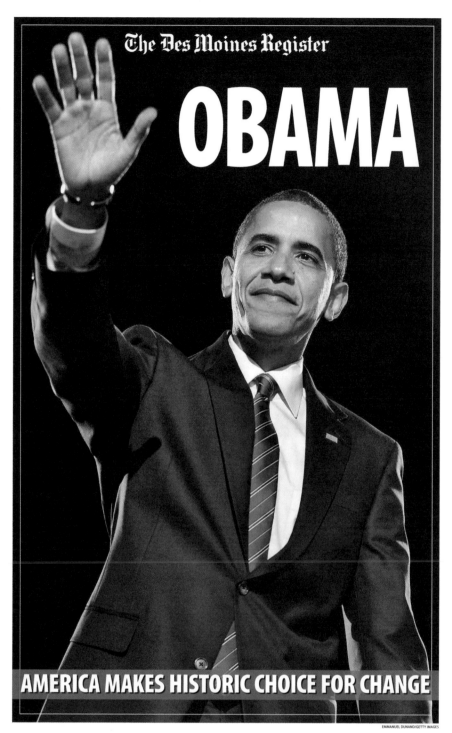

The Des Moines Register

OBAMA

AMERICA MAKES HISTORIC CHOICE FOR CHANGE

EMMANUEL DUNAND/GETTY IMAGES

OBAMA'S ELECTORAL VOTES

367
POPULAR VOTE: 52,977,936

McCAIN'S ELECTORAL VOTES

167
POPULAR VOTE: 48,913,869

Barack Obama first tapped into what Iowans believed was possible.

And it turned out Tuesday that America believes it, too.

Obama will become the 44th president of the United States — and the country's first black president — after his decisive Electoral College victory Tuesday over John McCain.

"I hear your voices," Obama told a nationwide television audience and more than 100,000 supporters gathered at Grant Park in Chicago.

Iowa, which voted for Republican George W. Bush in 2004, was one of the key states that swung Obama's way,

along with Ohio, Florida and Virginia.

"It began in the backyards of Des Moines," Obama, 47, recalled Tuesday.

After the hands of Iowa Democrats shot up at January's caucuses, the nation's hands followed. The voices of change and hope grew loud enough to drown out the politics of old, even as new economic challenges appeared.

And Obama's first message to Americans as president-elect invoked the words of Lincoln and echoed John F. Kennedy.

"Let us summon a new spirit of patriotism, of service and responsibility where each of us resolves to pitch in and work harder," Obama said Tuesday night.

Iowa's Role

Election of a lifetime

Some Iowa residents thought they wouldn't live to see a black man elected president. "I never thought I'd see anything like this. Never." **Marc Hansen's column, Page 6A**

What mattered to Iowans

Across the state, it was a day of tears, a day to take action as Iowans went to the polls. **Article, Page 18A**

HOW IOWA VOTED

OBAMA	McCAIN
54%	45%

18 PAGES OF ELECTION COVERAGE: Iowa's congressional incumbents barely break a sweat as voters re-elect Sen. Tom Harkin and all five congressmen by healthy margins, **Pages 10A-12A.**

MORE ONLINE: Go to DesMoinesRegister.com to participate in a live chat with former Iowa Gov. Tom Vilsack today at 10 a.m. to hear his thoughts on the election. More online features, **Page 2A**

High 67° Low 50° Windy, showers and thunderstorms. **Page 6B** | Copyright 2008, Des Moines Register and Tribune Company | A Gannett Newspaper | **Customer Service:** (877) 424-0225

Des Moines, Iowa

www.desmoinesregister.com

CHICAGO SUN-TIMES

50¢ CITY & SUBURBS • $1 ELSEWHERE | WEDNESDAY, NOVEMBER 5, 2008 | suntimes.com

MR. PRESIDENT

LAWRENCE
JOURNAL-WORLD®

50 CENTS

WEDNESDAY • NOVEMBER 5 • 2008

www.ljworld.com

OBAMA WINS

Election results

PRESIDENTIAL RACE
- ☐ John McCain – Republican
- ☑ Barack Obama – Democrat

FEDERAL RACES
U.S. SENATE
- ☑ Pat Roberts – Republican
- ☐ Jim Slattery – Democrat

U.S. HOUSE, 2ND DISTRICT
- ☑ Lynn Jenkins – Republican
- ☐ Nancy Boyda – Democrat

U.S. HOUSE, 3RD DISTRICT
- ☐ Nick Jordan – Republican
- ☑ Dennis Moore – Democrat

STATE RACES
KANSAS SENATE, 2ND DISTRICT
- ☐ Scott Morgan – Republican
- ☑ Marci Francisco – Democrat

KANSAS SENATE, 3RD DISTRICT
- ☐ Roger Pine – Republican
- ☑ Tom Holland – Democrat

KANSAS SENATE, 19TH DISTRICT
- ☐ Shari Weber – Republican
- ☑ Anthony Hensley – Democrat

KANSAS HOUSE, 10TH DISTRICT
- ☐ John Coen – Republican
- ☑ Tony Brown – Democrat

KANSAS HOUSE, 38TH DISTRICT
- ☑ Anthony Brown – Republican
- ☐ Stephanie Kelton – Democrat

KANSAS HOUSE, 45TH DISTRICT
- ☑ Tom Sloan – Republican
- ☐ John Wilson – Democrat

BOARD OF EDUCATION
4TH DISTRICT (INCOMPLETE RESULTS)
- ☐ Robert Meissner – Republican
- ☐ Carolyn Campbell – Democrat

DOUGLAS COUNTY
COMMISSION, 2ND DISTRICT
- ☐ David Brown – Republican
- ☑ Nancy Thellman – Democrat

COMMISSION, 3RD DISTRICT
- ☑ Jim Flory – Republican
- ☐ Ken Grotewiel – Democrat

CITY OF LAWRENCE
INFRASTRUCTURE SALES TAX
- ☑ Yes
- ☐ No

TRANSIT SALES TAX .2 PERCENT
- ☑ Yes
- ☐ No

TRANSIT SALES TAX .05 PERCENT
- ☑ Yes
- ☐ No

PRESIDENT-ELECT BARACK OBAMA takes the stage Tuesday at his election night victory party in Chicago's Grant Park. He was greeted by an estimated 125,000 people. AP Photo

US elects first black president

By Steven Thomma
McClatchy Newspapers

WASHINGTON — Barack Hussein Obama was elected the 44th president of the United States on Tuesday swept to victory by an anxious country eager to change course at home and abroad.

Obama, 47, becomes the first black in U.S. history to win the presidency and the first from the generation that came of age after the turbulence of the 1960s.

His win suggested a new political order in the making. He drew masses of young people to politics for the first time. His biracial heritage reflected the changing demographics of America. His mastery of the Internet matched the rise of a new information age. And his push into formerly Republican states in the South, Midwest and West marked a new political landscape possibly emerging.

"It's been a long time coming, but tonight, because of what we did on this day, in this election, at this defining moment, change has come to America."

– President-elect Barack Obama

After an epic struggle, the first-term Democratic senator from Illinois defeated Republican John McCain, 72, a hero of the Vietnam War and a four-term senator from Arizona.

"It's been a long time coming, but tonight, because of what we did on this day, in this election, at this defining moment, change has come to America," a

Please see OBAMA, page 9A

CALEB BIGSBY, left, hugs Ashleigh Ferguson as Katie Bieber hoists an Obama-Biden sign Tuesday during election night at Abe and Jake's Landing. Thad Allender/Journal-World Photo

Voters save Lawrence bus system with sales tax

By Chad Lawhorn
clawhorn@ljworld.com

It was two for the T.

Lawrence voters on Tuesday overwhelmingly approved a pair of transit sales taxes: one to keep the city's bus system operating and another to expand it.

In what was billed as a referendum on the value of the T, the city's fixed route bus system, voters approved a new two-tenths of a percent sales tax by 70 percent to 30 percent. A second five-hundredths of a percent sales tax to provide funding for new buses and enhanced transit services won by nearly 69 percent to 31 percent.

"This is the Lawrence I know," said

David Smith, one of the leaders of the citizens' group Campaign to Save the T. "It is a very welcoming community, a very inclusive community with real civic spirit.

"This vote said something very important about Lawrence and its identity. It was about whether we do think about the whole community, about whether we rally together."

City commissioners who voted to put the questions on the ballot had expressed optimism that the votes would prevail. But as they watched the returns roll in at a packed Douglas County Courthouse, they admitted surprise at the large margins of victory.

Please see BUS, page 9A

Late storms

High: 70 Low: 48
Today's forecast, page 14B

COMING THURSDAY

We will introduce you to Anthony Schwager who with his family operates Anthony's Beehive.

Energy smart: The Journal-World makes the most of renewable resources.
www.zephyrenergy.org

Vol.150/No.310
38 pages

Civil rights leader the Rev. Jesse Jackson, who cradled the assassinated Martin Luther King Jr. in his arms in 1968, witnesses the election of the first African-American president four decades later in his hometown of Chicago. PHOTOGRAPH BY DAVID BURNETT

With Barack Obama's election, our nation chose to turn a pivotal page and begin a new chapter in its history. Unlike The Farmer's Almanac, we can't skip ahead and see how it all turns out. But one thing we do know today: Kansas values will help shape Obama's legacy, and on a crisp, clear morning in late January, they will take up residence once again at 1600 Pennsylvania Ave.

The Wichita Eagle

WEDNESDAY, NOVEMBER 5, 2008 ■ 50 CENTS

Kansas●.com

OBAMA TRIUMPHS

ELECTION OF BLACK PRESIDENT IS 'DEFINING MOMENT'

President-elect Barack Obama waves as he takes the stage at his election party in Chicago's Grant Park on Tuesday. Democrats also padded their seats in the U.S. House of Representatives and U.S. Senate. They will control both the White House and Congress for the first time since 1994.

Associated Press

Eagle staff and news services

WASHINGTON — Barack Obama, the son of an African man and a white mother from Kansas, swept to victory as the nation's first black president Tuesday night in an electoral college landslide that overcame racial barriers as old as America itself.

"Change has come," he told a huge throng of jubilant supporters.

The Democratic senator from Illinois sealed his historic triumph by defeating Republican John McCain in hard-fought battleground states — Ohio, Florida, Virginia, Iowa and more.

On a night for Democrats to savor, they not only elected Obama the nation's 44th president but padded their majorities in the House and Senate, and come January will control both the White House and Congress for the first time since 1994.

"It's been a long time coming, but tonight, because of what we did on this day, in this election, at this defining moment, change has come to America,"

Please see **OBAMA**, Page 3A

KANSAS.COM

■ Read the texts and watch the videos of Barack Obama's victory speech and John McCain's concession speech.
■ Get updates on late-breaking election results.

How the states voted

The Wichita Eagle

MAP KEY
■ Obama ■ McCain ☐ Undecided

LOCAL ELECTION RESULTS MORE INSIDE, 8A

■ winner
Numbers are vote totals followed by percentage of vote.
Results are unofficial.

WICHITA SCHOOL BOND
(100% of precincts counted)
■ Yes 51%
☐ No 49%

COUNTY COMMISSION, DISTRICT 2
(100% of precincts counted)
☐ Craig Gabel, R 38%
■ Tim Norton, D 61%

COUNTY COMMISSION, DISTRICT 3
(100% of precincts counted)
☐ Marcey Gregory, D 45%
■ Karl Peterjohn, R 54%

DISTRICT ATTORNEY
(100% of precincts counted)
■ Nola Foulston, D 55%
☐ Mark Schoenhofer, R 44%

U.S. SENATE
(91% of precincts counted)
■ Pat Roberts, R 60%
☐ Jim Slattery, D 37%

U.S. CONGRESS
(91% of precincts counted)
☐ Donald Betts, D 33%
■ Todd Tiahrt, R 63%

BITTER CAMPAIGN
Nola Foulston keeps her seat as Sedgwick County district attorney, winning a bitter race over Mark Schoenhofer, 9A

'HOPE WON OUT OVER HATE'
Black Wichitans celebrate the election of Barack Obama, a historic moment some didn't think they'd live to see, 3A

$370 MILLION PLAN IS LARGEST IN STATE'S HISTORY

School bond narrowly passes

BY LORI YOUNT AND SUZANNE PEREZ TOBIAS
The Wichita Eagle

Wichita voters approved a record-setting $370 million bond issue Tuesday in a close race.

The bond issue passed with "yes" votes scoring 51 percent of the vote, not counting provisional ballots. But bond opponents said the slim margin of about 1,600 votes was far from a mandate for the school district.

"We started way behind," school board president Lynn Rogers said. "We had a lot of ground to make up."

Referring to negative ads, he added that "the opposition overplayed their hand."

Bond opponent Bob Weeks countered that the pro-bond campaign made a lot of promises — now it will have to deliver.

"The Wichita school district has assured the citizens that everything in this bond issue is for student achievement. We hope for the sake of Wichita's schoolchildren that

Please see **BOND**, Page 10A

Fernando Salazar/The Wichita Eagle

Bond supporter Russ Meyer hugs Wichita school board member Connie Dietz after hearing that the Wichita district's $370 million bond issue had passed.

NORTON KEEPS SPOT ON

Peterjohn sweeps into District 3 seat

BY DEB GRUVER
The Wichita Eagle

Anti-tax sentiment swept Republican Karl Peterjohn onto the Sedgwick County Commission on Tuesday.

He said he planned to ask other commissioners to take any new county property tax increase to voters.

"I'm only one of five votes," he said. "I'll try to be very persuasive."

It was unclear late Tuesday whether other commissioners would support his proposal.

Please see **PETERJOHN**, Page 9A

Karl Peterjohn plans to ask commissioners to take new county tax increases to voters.

The Courier-Journal

75 CENTS

METRO EDITION LOUISVILLE, KENTUCKY courier-journal.com WEDNESDAY, NOVEMBER 5, 2008 USPS 135567

OBAMA TURNS HISTORIC PAGE

"Tonight, because of what we did on this date, in this election, at this defining moment, change has come to America."

Morry Gash/Associated Press

Sen. Barack Obama waved to more than 100,000 supporters who gathered last night at Grant Park in Chicago to celebrate his victory as the nation's first African-American president. The Illinois Democrat won the hard-fought race by taking several normally Republican states from Sen. John McCain, including Florida and Ohio. Obama and his running mate, Sen. Joseph Biden of Delaware, will take their oaths of office as president and vice president on Jan. 20, 2009.

Page 3

SENATE

McConnell outlasts Democrat Lunsford

KENTUCKY U.S. SENATE
3,541 of 3,541 precincts
McConnell* (R).....945,067 (53%)
Lunsford (D)...........840,286 (47%)
*Incumbent

Story, Page 5

3RD DISTRICT

Yarmuth easily wins in Northup rematch

**KENTUCKY U.S. HOUSE
DISTRICT 3**
516 of 517 precincts
Yarmuth* (D)..........203,673 (59%)
Northup (R)...............139,446 (41%)
*Incumbent

Story, Page 6

2ND DISTRICT

GOP's Guthrie eases past Boswell

**KENTUCKY U.S. HOUSE
DISTRICT 2**
531 of 531 precincts
Guthrie (R)...............158,398 (53%)
Boswell (D)...............143,204 (47%)
*Incumbent

Story, Page 6

CONGRESSIONAL ROUNDUP

Democrats extend majorities in Senate and House

Page 4

A GANNETT NEWSPAPER

If current generations of
Americans are ever to witness
a time when hope must prevail
over fear, when common good
must be placed above self-
interest and when America must
respond to its highest values
and reject its most deeply
rooted prejudices, surely this
is that moment.

ELECTION 2008

LEXINGTON HERALD-LEADER

WWW.KENTUCKY.COM

NOVEMBER 5, 2008 | **WEDNESDAY** | BLUEGRASS EDITION | 50¢ | 75¢ *outlying areas*

YES, HE CAN: OBAMA WINS

Tens of thousands of supporters of Barack Obama cheered wildly during the Election Night party for the Democratic president-elect at Grant Park in Chicago. PABLO MARTINEZ MONSIVAIS | ASSOCIATED PRESS

FIRST BLACK PRESIDENT

By Adam Nagourney
NEW YORK TIMES NEWS SERVICE

Barack Hussein Obama was elected the 44th president of the United States on Tuesday, sweeping away the last racial barrier in American politics with ease as the country chose him as its first black chief executive.

The election of Obama was a strikingly symbolic moment in the evolution of the nation's fraught racial history, a breakthrough that would have seemed unthinkable just two years ago.

The first-term senator from Illinois defeated Republican Sen. John McCain of Arizona, a former prisoner of war making his second bid for the presidency. To the very end, McCain's campaign was eclipsed by an opponent who was nothing short of a phenomenon, draw-

See OBAMA, A8

Kentucky voter turnout doesn't match nation

■ Few problems, but only 65 percent of state's registered voters turn out. **Page C1**
■ Nation sees sporadic trouble, expects record number of voters. **Page A3**

■ McCain (R) ■ Obama (D) ☐ Undecided

CAMILLE WEBER | cweber3@herald-leader.com

U.S. President

	Votes
McCain	45,755,008
Obama	49,339,106

71% of precincts reporting

Mapping the vote: County-by-county and Fayette precinct results for the presidential and U.S. Senate races. **Pages A6-9**

Congress: Democrats unable to gain in Kentucky, but pick up several seats nationwide. **Page A4-5**

General Assembly: No major changes to power balance. **Page A12**

Lexington council, other local races: Feigel wins tight council race; Danville rejects change. **Page A10**

MCCONNELL RE-ELECTED

Senator now becomes nation's top Republican

By Ryan Alessi
ralessi@herald-leader.com

Fighting against a national Democratic tide, U.S. Senate GOP Leader Mitch McConnell survived what he called an "exhausting" re-election race and emerged as the nation's most powerful Republican.

McConnell, who led in most polls by slim margins down the stretch, benefited from a strong showing by GOP presidential candidate John McCain in Kentucky.

In his campaign against Democratic challenger Bruce Lunsford, McConnell campaigned heavily on the sway he holds as Senate Republican leader.

"We were ready for a tough one and it was. In the end, Bruce earned a lot of votes and he earned my respect," McConnell said. "Campaigns like this force you to work harder and they remind you what a privilege it is to serve."

See MCCONNELL, A6

U.S. Senate

	Votes	Vote %
McConnell	912,307	53%
Lunsford	819,116	47%

118 counties reporting

Kentucky.com

■ Get complete results for local and national races.
■ Search a precinct map of Fayette County that shows vote totals for president and Senate.
■ Read post-election analysis and developments at Pol Watchers.
KYKurmudgeon blog: Join Larry Dale Keeling 12:30 to 1:30 p.m. Wednesday to discuss election results in state races.

SUNNY AND WARM
Chance of precipitation less than 20%. **Weather, C8**
74 HIGH | **48** LOW
© 2008

INDEX
Vol. 25 No. 307

Business	D6	Crossword	B7, C7	Obituaries	C3
City \| Region	C	Dear Abby	B7	Opinions	A16
Classified	C5-7	Horoscope	B6	Sports	D
Comics	B6-7	Movies	B5	Your Health	B8

HOW TO REACH US

Delivery: 1-800-999-8881
Classified: 233-7878 or 1-800-933-7355

Obama has given voice to a widespread yearning not just for a changing of the guard but for a changing of the game. And that ability to express a people's aspirations is a mark of leadership. Like President John F. Kennedy, another senator who electrified young people, Obama also has the substance to transform idealism into action.

– from an earlier Herald-Leader editorial endorsing Obama

THE BALTIMORE SUN
LIGHT FOR ALL
baltimoresun.com

Our 171st year, No. 183 Informing more than 1 million Maryland readers weekly in print and online

It's Obama

Democrat gains historic victory, will be the nation's first black president

ELECTORAL LANDSLIDE President-elect Barack Obama greets the crowd in Chicago's Grant Park after his overwhelming victory over John McCain turned the page on eight years of Republican leadership. PHOTOS: ASSOCIATED PRESS

Barack Obama

NATIONAL VOTE
51.5%

ELECTORAL VOTES
338

John McCain

NATIONAL VOTE
47.2%

ELECTORAL VOTES
141

79 percent reporting

CONGRESS

BLUE STREAK FOR HOUSE, SENATE: Democrats tapped into a sour economy, antipathy toward Bush as they chased larger majorities in both bodies. **Election PG 8**

1ST DISTRICT

KRATOVIL (right)
49%

HARRIS (left)
48%

93 percent reporting

TURNOUT

ENTHUSIASTIC AND EARLY IN MARYLAND: Voters participated in what experts say may be Maryland's biggest turnout for a presidential election since World War II. **Election PG 1**

SPECIAL SECTION

Twelve pages of results, coverage, analysis and photos from Maryland and across the nation. **Election section inside**

ONLINE

Find analysis, developments and updated election results at **baltimoresun.com**

BY DAVID NITKIN | david.nitkin@baltsun.com

Barack Obama, the Illinois Democrat who built a campaign and a movement around the promise of change, won a resounding victory over Republican John McCain last night to become the first black president in U.S. history.

Choosing a steady 47-year-old lawyer and former community organizer to guide the nation, voters looked past Obama's relative lack of national experience to end eight years of Republican leadership amid a once-in-a-century economic crisis and protracted foreign wars.

Hundreds of thousands of supporters gathered in Grant Park in Chicago, which Obama represented in the Illinois Legislature just 46 months ago, as the Democrat was declared the winner about 11 p.m. Eastern time.

Obama said that his victory reaffirmed that America remains a place "where all things are possible."

"It's been a long time coming, but tonight, because of what we did on this date, in this election, at this defining moment, change has come to America," he said.

Celebrations erupted in New York, Washington, Baltimore, Atlanta and other cities.

The son of a mother from Kansas and a father from Kenya, Obama becomes the first U.S. senator to be elected president since John F. Kennedy in 1960. The 44th president will take office at a time of daunting challenges, amid an economic crisis that threatens to overwhelm his promises to spend on education, health care and energy. *See* **PRESIDENT,** *election 5*

Republican John McCain, who campaigned as a maverick, never shook the burden of representing the party of President Bush.

A new American majority takes shape

BY PAUL WEST | paul.west@baltsun.com

WASHINGTON

America turned a page yesterday.

Barack Obama broke through the racial barrier to the Oval Office, becoming the first African-American to gain the presidency. And his electoral landslide delivered a powerful message about a new generation of American leadership.

analysis

The young and minority voters who helped lift the 47-year-old Democrat to the White House are now the foundation of a new majority in U.S. politics. Their emergence likely brings to a close the era of conservative dominance that began with Ronald Reagan's election almost three decades ago.

Obama's campaign, perhaps the most brilliantly run in the modern era, reflected the multicultural diversity of 21st-century America. He sought to move beyond old racial divides, but his victory also means that a descendant of slaves will become first lady of the United States for the very first time.

"A new dawn of American leadership is at hand," the president-elect said last night. "To those who would tear this world down — we will defeat you. To those who seek peace and security — we support you. And to all those who have wondered if America's beacon still burns as bright — tonight we proved once more that the true strength of our nation comes not from the might of our arms or the scale of our wealth, but from the enduring *See* **ANALYSIS,** *election 6*

end of debate

Md. voters give OK to 15,000 slots

Strong majority backs constitutional change

BY LAURA SMITHERMAN
laura.smitherman@baltsun.com
AND GADI DECHTER
gadi.dechter@baltsun.com

Marylanders voted overwhelmingly yesterday to legalize slot-machine gambling in the state after a rancorous campaign, dealing Gov. Martin O'Malley a ballot-box success and settling a debate over which politicians had deadlocked for years.

The constitutional amendment to allow 15,000 slot machines at five locations around the state appeared headed for easy passage late last night.

FOR
59%

AGAINST
41%

85 percent reporting

O'Malley, a Democrat, championed slots as a way to plug the state's budget shortfalls, made worse by a declining economy, while opponents argued that expanding gambling would invite crime and addiction into the most vulnerable communities and burden taxpayers with increased social costs. The final say fell to voters after state lawmakers decided last year to punt the decision to a referendum.

Voter opinions varied from liberal, anti-slots enclaves in the Washington suburbs to *See* **SLOTS,** *election 10*

0 08345 00003 7

VOLUME 274
NUMBER 128

Suggested retail price
75 cents
$1.00 outside of
Greater Boston

The Boston Globe

RESOLUTION
TODAY: *Early fog, cloudy, rain later.*
High 61-66. Low 49-54.
TOMORROW: *Cloudy, a sprinkle.*
High 57-62. Low 50-55.
HIGH TIDE: *3:58 a.m. 4:06 p.m.*
SUNRISE: *6:23 a.m.* SUNSET: *4:32 p.m.*
FULL REPORT: PAGE C8

WEDNESDAY, NOVEMBER 5, 2008

Historic victory

ELECTORAL COLLEGE Obama 338 | 142

270 NEEDED TO WIN

Obama elected nation's first African-American president in a romp

McCain falters on GOP terrain; Democrats increase clout in Congress

President-elect Barack Obama, his daughters Sasha and Malia, and wife Michelle waved to supporters last night in Chicago's Grant Park.

JASON REED/REUTERS

**By Scott Helman
and Michael Kranish**
GLOBE STAFF

CHICAGO — Senator Barack Obama of Illinois was elected the 44th president of the United States and the nation's first black commander in chief yesterday, his triumph ushering in an era of profound political and social realignment in America.

Obama's decisive victory over Republican John McCain is a landmark in the country's 232-year history, especially for the millions of African-Americans around the country energized and inspired by his improbable candidacy. It gives Democrats control of Congress and the White House for the first time in 16 years and it led to impromptu celebrations around the country.

Making good on his promise to draw his own electoral map, Obama captured Virginia, which last voted for a Democrat in 1964, and he beat McCain in key battleground states, including Colorado, Florida, New Hampshire, Ohio, and Pennsylvania, while holding on to Democratic-leaning states. He won in part on the support of new voters, African-Americans, and Hispanics, and as of early today he had 338 electoral votes, far more than the 270 needed to win the presidency, while McCain had 142.

In a grand celebration on a balmy fall night in Chicago's Grant Park, 240,000 supporters gathered to toast the president-elect. When the networks called the race shortly after 10 p.m. local time, tears flowed, flashbulbs

ELECTION, Page A12

New era beginning for party in power

By Susan Milligan
GLOBE STAFF

WASHINGTON — Democrats increased their ranks in Congress last night, picking up seats from the Canadian to the Mexican borders and ushering in a new era of Democratic power in Washington the party has not seen since the 1960s.

In a heavy blow to the GOP, Democrats collected several high-profile Senate seats, ousting veteran Republican lawmaker John Sununu in New Hampshire and replacing him with former governor Jeanne Shaheen. New Mexico and Colorado sent two Democratic brothers to the Senate, with Mark Udall taking the Colorado seat and Tom Udall winning the race in New Mexico.

In Virginia, Mark Warner easily defeated James Gilmore, his GOP opponent, capping a stunning Democratic showing in the Old Dominion State, which also voted for Barack Obama — the first time since 1964 that a Democratic presi-

CONGRESS, Page A15

ELECTORAL COLLEGE ■ Obama ■ McCain □ Not decided

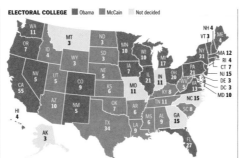

WA 11
OR 7
MT 3
ND 3
MN 10
WI 10
MI 17
NH 4
VT 3
ME 4
ID 4
WY 3
SD 3
IA 7
IL 21
IN 11
OH 20
PA 21
NY 31
MA 12
RI 4
CT 7
NJ 15
NV 5
UT 5
CO 9
NE 5
KS 6
MO 11
KY 8
WV 5
VA 13
DE 3
DC 3
MD 10
CA 55
AZ 10
NM 5
OK 7
AR 6
TN 11
NC 15
HI 4
MS 6
AL 9
GA 15
SC 8
TX 34
LA 9
AK 3
FL 27

Election 2008

JIM WATSON/AFP/GETTY IMAGES

John McCain said he gave his all, while aides said his trouble began when he declared the teetering economy sound. **A14.**

MARK WILSON/GLOBE STAFF

Lines were long at polling places across the nation, but Obama's prodigious field organization helped keep problems to a minimum. **A16.**

SAUL LOEB/AFP/GETTY IMAGES

Emotions ran high in Chicago as tens of thousands poured into Grant Park from near and far for Obama's acceptance speech. **A13.**

Massachusetts voters rejected a repeal of the state income tax, decriminalized possession of small amounts of marijuana, and approved a ban on greyhound racing. **B1.**

Senator John F. Kerry easily won reelection to a fifth term, fending off a challenge by Republican Jeffrey K. Beatty. **B9.**

Sonia Chang-Díaz captured the seat long held by state Senator Dianne Wilkerson, who left the race after being arrested on bribery charges. **B9.**

Coverage, A12-17, B1, B6-10.

NEWS ANALYSIS

Shift in tone will bring a watershed for nation

By Peter Canellos
GLOBE STAFF

CHICAGO — The people who crowded Grant Park last night, straining for a glimpse of President-elect Barack Obama, were aroused by a lot of passionate issues — war, jobs, race — and yet they insisted that no single goal, nothing that could be written out and measured, defined their expectations for the next administration.

"It's everything," said a tearful Teri McClain of Seattle.

"It's having a president with a world view that most Americans can believe in," declared Chris Godfrey of Des Moines, Iowa.

And yet Obama's clear-cut victory, bolstered by strong majorities of his own party in both houses of Congress, can be read as a mandate for some very specific policy changes that could, by themselves, have momentous impact. Withdrawal from Iraq. Renewal of the six-decade quest for national health insurance. The launch of a major government-funded quest for renewable energy.

Beyond the policies, Obama's election will stand forever amid the great milestones of America's racial history, the end of a torturous progression from emancipation to the civil rights movement to the election of the first black

ANALYSIS, Page A13

Among blacks, joy and tears at journey's end

By Michael Levenson
GLOBE STAFF

Sixty-six-year-old Jake Coakley picked cotton as a boy in Beaufort, S.C., just as his father and grandfather did before him. So yesterday, as he stood amid a throng of people hugging, high-fiving, and even weeping outside a Roxbury polling place, he wanted to underscore the significance of the day.

"This," he said to a little boy, patting his head and staring deeply into his eyes, "is history."

At another polling station blocks away, Charles Robinson recalled the racial epithets shouted at him as a student at South Boston High School during the busing crisis of the 1970s.

In St. Petersburg, Fla., Ron Dock spoke of the day he learned that the Rev. Martin Luther King Jr. had been shot. Dock was 18, he said, crouching in a rice paddy in Vietnam, preparing for a firefight. In Alexandria, Va., 83-year-old Flossie Parks recalled turning 21 and being forced to pay a $3 poll tax for the right to vote.

Millions of black voters across the country turned out to help elect Barack Obama the first African-American president yesterday, and as they did, they reflected not just on the course of a historic campaign, but on the history of a nation.

BLACK VOTE, Page A17

For breaking news, updated Globe
stories, and more, visit:

boston.com

45333

0 94772 5 4

Inside

Features
Business B11
Deaths B17-19
Editorials A18
Lottery B2
Weather C8
© Globe Newspaper Co.

Classified
Cars, Homes, Stuff,
Notices & more J
g
TV/Radio, Comics,
Crossword,
Sudoku, KenKen,
Movies, Horoscope

Have a news tip? E-mail
newstip@globe.com or call
617-929-TIPS (8477). Other
contact information, **B2.**

Portland, Maine
www.pressherald.mainetoday.com

Minneapolis–St. Paul, Minnesota
www.startribune.com

Don Smith, 47, a north Minneapolis man, said he was witnessing one of the most important days in history. His only regret, he said, was that his mother, who died in August, wasn't there with him. "I just wish she was alive to see this," said Smith, who was in line to vote before 6 a.m.

SPRINGFIELD NEWS-LEADER

NEWS-LEADER.COM • OZARKSMOBILE.COM SPRINGFIELD, MISSOURI • NOVEMBER 5, 2008 • 75¢

'Change has come'

Obama sweeps to victory, becomes first black president

"Change has come," Barack Obama told a huge throng of jubilant supporters in Chicago on Tuesday night. Across the nation, Democrats padded their majorities in the House and Senate; they will control both houses for the first time since 1994. Obama looked to challenges facing the nation. "The road ahead will be long. Our climb will be steep," he told the Chicago crowd. "But America — I have never been more hopeful than I am tonight that we will get there."

— News-Leader Wire Services

Pages 8-9A

The nation's decision

- Obama's formula for victory
- Ozarks voters reflect on their decisions

BARACK OBAMA
PHOTO BY JAE C. HONG
THE ASSOCIATED PRESS

Winners

Index

Automotive	1E	Merchandise	5E
Business	7B	Movies	9B
Classified	1E	Nation/World	7B
Comics	9C	Real Estate	
Crossword	8C	For Sale	6E
Dear Abby	8C	Rentals	6E
Deaths	4B	Sports	1D
Employment	1E	Stocks	7B
Garage Sales	5E	Taste	1C
Heloise	8C	Television	9B
Horoscope	8C	Voices	1B
Lottery	2A	Weather	8B

Weather

73° Windy and partially sunny
54° today. 8B

Precipitation: 20%

A GANNETT NEWSPAPER
VOL. 118, NO. 310
©2008, NEWS-LEADER

Nation

Presidential: Barack Obama
U.S. House 7th District: Roy Blunt

State

Governor: Jay Nixon
Lt. Governor: Peter Kinder
Secretary of State: Robin Carnahan
State Treasurer: Clint Zweifel
Attorney General: Chris Koster
House 62: Dennis Wood
House 134: undetermined
House 135: Charlie Denison
House 136: Eric Burlison
House 137: Charley Norr
House 138: Sara Lampe
House 139: Shane Schoeller
House 140: Bob Dixon
House 141: Jay Wasson
Amendment 1: Passed
Amendment 4: Passed
Proposition A: Passed
Proposition B: Passed
Proposition C: Passed

Greene County

Commissioner, Dist. 1: Harold Bengsch
Commissioner, Dist. 2: Roseann Bentley
Court Clerk: Steve Helms
Sheriff: Jim Arnott
Assessor: Rick Kessinger
Public Administrator: David Yancy
Question 1 (nonpartisan court plan): Passed

Christian County

Eastern Commissioner: Tom Huff
Western Commissioner: Bill Barnett
Sheriff: Joey Kyle

Webster County

N. Commissioner: Lyndall Fraker
S. Commissioner: Denzil L. Young
Sheriff: Roye H. Cole
Fire District: Passed

More inside

3A: The day at the polls
How the voting went in the Ozarks and across the state and nation

4-6A: The state
Races for governor in Missouri and nationwide; state House, ballot issues

7A: Greene and Christian counties
Sheriff, commissioner races

8-10A: President, congressional races
How Roy Blunt fared in the race for U.S. House District 7, plus congressional trends nationwide

11-12A: Ozarks
Local races in 12 counties

News-Leader.com:
Missouri's presidential tally was too close to call at press time. Check online for updates today.

ELECTION 2008

| PRESIDENT OBAMA DEMOCRAT | VICE PRESIDENT BIDEN DEMOCRAT | SENATOR COCHRAN REPUBLICAN | SENATOR WICKER REPUBLICAN | HOUSE DISTRICT 1 CHILDERS DEMOCRAT | HOUSE DISTRICT 2 THOMPSON DEMOCRAT | HOUSE DISTRICT 3 HARPER REPUBLICAN | HOUSE DISTRICT 4 TAYLOR DEMOCRAT |

6 PAGES: 6A-11A

ONLINE clarionledger.com
Videos: Problems at the poll, voting at JSU; Galleries: Jackson-Hinds voting, Rankin voting, Madison voting

The Clarion-Ledger

Mississippi's No. 1 information source

clarionledger.com Wednesday, November 5, 2008 ■ Jackson, Miss.

PRESIDENT OBAMA

'THE DREAM OF OUR FOUNDERS IS ALIVE'

The Associated Press

President-elect Barack Obama, his wife, Michelle Obama, and their daughters, Malia, 7, and Sasha, 10, soak in the historic moment during Tuesday night's rally at Grant Park in Chicago.

Wicker leads Musgrove, who waits for final count

By Natalie Chandler
natalie.chandler@clarionledger.com

Republican Roger Wicker defeated Democrat Ronnie Musgrove in a bitter Senate race that will require the incumbent to campaign again in four years.

Musgrove had not conceded the race as of late Tuesday, though. His campaign spokesman, Adam Bozzi, said he wanted to wait until "tens of thousands" of affidavit ballots are counted in Hinds County and the Delta.

Bozzi said he expects all the ballots will be counted today, and

added, "We're not going to call an election until all of the votes are counted."

Wicker told supporters at an election night party in Jackson, "It was clear early on (Musgrove) came to play, and he did. We know we've had a race."

With 99 percent of precincts reporting early this morning, Wicker secured 635,237 votes. Musgrove, a former Mississippi governor, received 511,090 votes.

The special election determined who will serve the
See SENATE, 8A

Rick Guy/The Clarion-Ledger
Sen. Roger Wicker, with his wife, Gayle (right), speaks to supporters during a victory party at the Marriott Jackson Downtown after winning the seat vacated by Sen. Trent Lott.

Obama sweeps to victory as first black president

The Associated Press

WASHINGTON — Barack Obama swept to victory as the nation's first black president Tuesday night in an electoral college landslide that overcame racial barriers as old as America itself. "Change has come," he told a huge throng of jubilant supporters.

As the son of a black father from Kenya and a white mother from Kansas, the Democratic senator from Illinois sealed his historic triumph by defeating Republican Sen. John McCain in

a string of wins in hard-fought battleground states — Ohio, Florida, Virginia, Iowa and more.

On a night for Democrats to savor, they not only elected Obama the nation's 44th president but padded their majorities in the House and Senate, and come January will control both the White House and Congress for the first time since 1994.

Obama's election capped a meteoric rise — from mere state senator to president-elect in four years.

See ELECTION, 6A

Not only did the election of Barack Obama bring about a sea change in politics, with the first person of color elected to the White House, but those he defeated set an example of support and unity that is itself a model. Unsuccessful Republican presidential candidate Sen. John McCain, R-Ariz., gave a concession speech Tuesday night that has to be one of the most heartfelt, inspiring and statesmanlike to have been uttered.

Billings Gazette

ELECTION UPDATES
FOR LATEST LOCAL RESULTS, EXTRA PHOTOS, VIDEO AND NATIONAL COVERAGE, VISIT:
billingsgazette.com

WEDNESDAY, NOVEMBER 5, 2008 *The Source* LOCAL EDITION

U.S. HOUSE

- Rehberg wins 5th term/3B
- Republicans losing ground/10A

- Bullock leads in race for state AG/**1B**

- Brown ahead in key race for Legislature/**1B**

- Molnar retains seat on PSC/**1B**

U.S. SENATE

- Baucus takes 6th term/3B
- Dems gaining seats/10A

OBAMA'S TIME

Nation's voters resoundingly elect 1st black president

President–elect Barack Obama gives his acceptance speech Tuesday night at Grant Park in Chicago. Obama, a first-term U.S. senator, is the nation's first black president.

Associated Press

McCain: 'American people have spoken'

WASHINGTON (AP) — Barack Obama swept to victory as the nation's first black president Tuesday night in an electoral college landslide that overcame racial barriers as old as America itself. "Change has come," he told a jubilant hometown Chicago crowd estimated at nearly a quarter-million people.

The son of a black father from Kenya and a white mother from Kansas, the Democratic senator from Illinois sealed his historic triumph by defeating Republican Sen. John McCain in a string of wins in hard-fought battleground states — Ohio, Florida, Iowa and more. Obama captured Virginia, too, the first candidate of his party in 44 years to do so.

On a night for Democrats to savor, they not only elected Obama the nation's 44th president

MCCAIN

but added to their majorities in the House and Senate, and in January will control both the White House and Congress for the first time since 1994.

A survey of voters leaving polling places showed the economy was by far the top Election Day issue. Six in 10 voters said so, and none of the other top issues — energy, Iraq, terrorism and health care — was picked by more than one in 10.

Obama's election capped a meteoric rise — from mere state senator to president-elect in four years.

Please see President, 13A

Election08
Obama wins the presidency

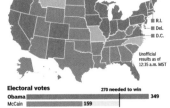

■ Obama ■ McCain ■ Not called

■ R.I.
■ Del.
■ D.C.

Unofficial results as of 12:35 a.m. MST

Electoral votes 270 needed to win

Obama	349
McCain	159

Congress balance of power 50%

HOUSE
435 total DEM - 259 176 - GOP

SENATE
100 total DEM - 56 Other 2 4 seats undecided 40 - GOP

AP

Schweitzer calls victory a ringing endorsement

By CHARLES S. JOHNSON
Gazette State Bureau

HELENA — Democratic Gov. Brian Schweitzer rolled to a decisive win for a second term Tuesday night over Republican challenger Roy Brown and Libertarian Stan Jones.

Schweitzer was declared the winner by The Associated Press minutes after the polls closed at 8 p.m., based on exit poll interviews. He pulled ahead of Brown by a 2-to-1 margin in early returns, with Jones lagging far behind.

With 77 percent of the votes counted, the latest unofficial returns showed:

■ Schweitzer, 66 percent, with 221,865 votes.

■ Brown, 32 percent, with 106,496 votes.

■ Jones, 2 percent, with 6,622 votes.

It was an enthusiastic endorsement of an energetic governor who has become Montana's best salesman.

Schweitzer has traveled widely out of state trying to attract new businesses or persuade existing ones, particularly in the energy field, to move here. Schweitzer also travels the state extensively, usually accompanied by his border collie, Jag, to meet with Montanans.

Speaking to a cheering crowd at a Helena hotel, Schweitzer said Montanans had endorsed the lone fusion ticket in the country. His running mate is Lt. Gov. John Bohlinger, a Republican.

"Now Montanans liked that

Please see Governor, 13A

@2008 The Billings Gazette, a Lee Newspaper, 123rd year, No. 187

41°/28° Showers and breezy Full weather forecast on page 10B

Classified9C	Deaths8B	Health1C	Opinion4A
Comics3C	Food8-9C	Markets8D	TV10C

Billings, Montana
www.billingsgazette.com

OBAMA WINS

He heralds 'a new dawn of American leadership'

Photos by The Associated Press

President-elect Barack Obama hails a crowd of 125,000 at Chicago's Grant Park on Tuesday night. In his victory speech, he proclaimed "change has come to America."

SENATE

DAVE WEAVER/The Associated Press
Mike Johanns prepares to vote in Omaha on Tuesday.

Johanns headed for Washington

Story, 7A

DAVE WEAVER/The Associated Press
Lee Terry signals commuters Tuesday in Omaha.

HOUSE

■ **Terry wins in District 2**

■ **Fortenberry re-elected**

■ **Smith also victorious**

Stories, 7A

INITIATIVES

Affirmative action ban passes

Story, 7A

OTHER RACES

Legislature/8A
Regents/8A
County Board/9A

Sen. John McCain thanks his supporters for their efforts through a "long and difficult" campaign during a rally in Phoenix on Tuesday night. See story on Page 6A.

The Washington Post

WASHINGTON — Sen. Barack Obama of Illinois was elected the nation's 44th president Tuesday, riding a reformist message of change and an inspirational exhortation of hope to become the first African-American to ascend to the White House.

Obama, 47, the son of a Kenyan father and a white mother from Kansas, led a tide of Democratic victories across the nation in defeating Republican Sen. John McCain of Arizona, a 26-year veteran of Washington who could not overcome his connections to President Bush's increasingly unpopular administration.

"If there is anyone out there who still doubts that America is a place where all things are possible, who still wonders if the dream of our founders is alive in our time, who still questions the power of our democracy, tonight is your answer," Obama told a throng of supporters during a victory celebration in Chicago's Grant Park at midnight Eastern time.

He added: "Its been a long time coming, but tonight, because of what we did on this day, in this election, at this defining moment, change is coming to America."

Obama became the first Democrat since Jimmy Carter in 1976 to receive more than 50 percent of the popular vote, and made good on his pledge to transform the electoral map.

McCain congratulated Obama in a phone call shortly after 11 p.m. and then delivered a gracious concession to his supporters in Phoenix. "We have had and argued our differences," he said of his rival, "and he has prevailed."

Obama's victory also ushered in a new era of Democratic dominance in Congress, even though the party fell short of the 60 votes needed for a veto-proof majority in the Senate. In the House, Democrats made major

See OBAMA, Page 6A

Presidential win state by state

83% of precincts reporting

Projected results as of 12:45 a.m.

Number of electoral votes each state has.

*Two states, Maine and Nebraska, allow their votes to be split.

Presidential win county by county

Results as of 10:50 p.m.; not complete in all counties

KEY:

■ **McCAIN** ☐ **OBAMA** ☐ **RESULTS NOT COMPLETE**

	Popular vote	Percent	States	Electoral	
☐ **OBAMA**	56,198,518	52%	27	338	270 of the 538 electoral votes needed to win
■ **McCAIN**	51,200,845	47%	20	160	

Graphics by KIM STOLZER/
Lincoln Journal Star

ELECTION SCENE

See what our bloggers had to say about election events around Lincoln and the area online at Journal Star.com.

66 43
Details, 8B

Sports/1C: Pelini becoming more aware of the impact of his demeanor on the sidelines

CONTACT US

Delivery and
subscriptions473-7300
Newsroom473-7301
Classified ads473-7373
Retail ads473-7450
Toll-free......(800) 742-7315
Copyright 2008
Lee Enterprises Inc.
40 pages

MON547 75 cents

LAS VEGAS SUN
Sun's special access to the Obama
campaign helps us tell how he won
75 CENTS ONE DOLLAR

Obama **349** ELECTORAL VOTES 52%

McCain **147** ELECTORAL VOTES 47%

CONGRESS 3 **Dina Titus (D) 47%** Jon Porter (R) 42%
CONGRESS 2 **Dean Heller (R) 51%** Jill Derby (D) 42%
ST. SENATE 5 **Shirley Breeden (D) 47%** Joe Heck (R) 46%
ST. SENATE 6 **Allison Copening (D) 53%** Bob Beers (R) 47%
★★★a

WEDNESDAY, NOVEMBER 5, 2008

LAS VEGAS
REVIEW-JOURNAL

www.reviewjournal.com

'Change is coming to America'

Obama

- **Voters decide on ballot measures | 7A**
- **Titus defeats Porter for House seat | 1B**
- **Democrats take control of state Senate | 1B**
- **On the Web: lvrj.com/politics**

By MICHAEL D. SHEAR and ROBERT BARNES | THE WASHINGTON POST

Sen. Barack Obama of Illinois was elected the nation's 44th president Tuesday, riding a reformist message of change and an inspirational exhortation of hope to become the first African-American to ascend to the White House.

Obama, 47, the son of a Kenyan father and a white mother from Kansas, led a tide of Democratic victories across the na-

tion in defeating Republican Sen. John McCain of Arizona, a 26-year veteran of Washington who could not overcome his connections to President Bush's increasingly unpopular administration.

"If there is anyone out there who still doubts that America

► SEE **OBAMA** PAGE 9A

Democrats add five seats, possibly more, in Senate

By STEVE TETREAULT
and MOLLY BALL
REVIEW-JOURNAL

WASHINGTON — Democrats expanded their control of the Senate on Tuesday, adding at least five seats and strengthening the hand of Sen. Harry Reid, the majority leader from Nevada.

When Republicans rescued seats in Kentucky, Maine and Mississippi, it appeared unlikely that Democrats would be able to muster the 60 votes necessary to stave off filibusters on contentious issues.

Still, the Democrats' margin

was projected to be the largest the party has enjoyed since 1979, when they controlled 58 seats. Four seats currently held by Republicans were still undecided late Tuesday night.

Democrat Jeff Merkley was neck and neck in Oregon with incumbent Gordon Smith with less than half of the vote counted, and Republican Norm Coleman was virtually tied with challenger Al Franken in Minnesota with about 90 percent of the vote tallied there. Convicted Sen. Ted

► SEE **SENATE** PAGE 5A
Losses unsurprising, Ensign says

JOHN GURZINSKI/REVIEW-JOURNAL
Democrats, including Kevin and Sheila White, center, react to the announcement that Barack Obama has been elected president Tuesday night at the Rio.

Nevada Democrats win House, Assembly slots

By MOLLY BALL
REVIEW-JOURNAL

A Democratic tidal wave swept over Nevada on Tuesday, carrying Democrats to Congress, the statehouse and the Clark County Commission in the course of giving a majority of the state's votes to a Democratic presidential candidate for the first time since 1964.

Democratic presidential nominee Barack Obama carried by more than 120,000 votes a state that President Bush won by 20,000 votes four years ago, taking 56 percent of

the vote to Republican John McCain's 42 percent on the strength of a grass-roots organization of unprecedented scope, with most precincts reporting late Tuesday.

Three-term Rep. Jon Porter, R-Nev., was ousted by his Democratic challenger, state Sen. Dina Titus, in the suburban 3rd Congressional District, overpowered by the Democratic voter registration trend and the Obama campaign's operation.

Rep. Dean Heller, R-Nev.,

► SEE **NEVADA** PAGE 8A
Obama campaign aided Democrats

WEATHER | PAGE 23A
MOSTLY SUNNY **64/43**

© 2008, Stephens Media LLC
Vol. 104, No. 219, 96 pages

7 58551 00001 6

I didn't vote for him because he was black. I voted for him to get out of a war we never should have been in and to get the economy going.

THE CINCINNATI ENQUIRER

CINCINNATI.COM **WEDNESDAY, NOVEMBER 5, 2008** FNMO **75 CENTS**

★ ★ ★ ★ ★
YOUR 2008 VOTE

OBAMA TRIUMPHS

| Illinois senator becomes first African-American president | Ohio helps lift him over top amid economic worries |

Gannett News Service/Jack Gruber, USA Today

President-elect Barack Obama celebrates his victory over Republican nominee John McCain late Tuesday at Chicago's Grant Park, along with (from left) daughters, Sasha and Malia, and his wife, Michelle.

BY HOWARD WILKINSON ■ HWILKINSON@ENQUIRER.COM

One of the last barriers of American politics – one forged by more than two centuries of slavery and more than a century of struggle for equality – was broken Tuesday night with the election of Illinois Sen. Barack Obama as the 44th president of the United States.

And Ohio – the same state where Democratic primary voters eight months ago rejected him – helped make it possible for the 47-year-old son of a Kenyan father and a Kansan mother to win the presidency over Republican John McCain.

Obama's election set off celebrations across America – from a massive gathering in Chicago's Grant Park, where Obama appeared at midnight to claim his victory, to smaller but just as enthusiastic gatherings in downtown Cincinnati.

See **ELECTION**, Page **A13**

How it adds up: As of 12:30 a.m.

Based on early returns, here is a breakdown of which candidate won which states' electoral votes. A candidate needs 270 electoral votes to win the election.

CANDIDATE: | OBAMA ▨ | MCCAIN ▨ | UNDECIDED □
ELECTORAL VOTE: | 338 votes ▨ | 156 votes ▨ | 40 votes
(Note: Stripes indicate party change from 2004)

(Still voting)
Total National Precincts reporting: 73% Source: Enquirer research The Enquirer

INDEX

Five sections, 168th year, No. 210

Copyright, 2008, The Cincinnati Enquirer

Portions of today's Enquirer were printed on recycled paper

WEATHER

High 75°
Low 46°

Brilliant sunshine and very warm today; remaining warm with some sun Thursday.

DETAILS B10

INSIDE: 12 PAGES OF ELECTION COVERAGE

Congress, A4-5

1st District: Steve Driehaus (D) elected
2nd District: Rep. Jean Schmidt (R) re-elected
3rd District: Rep. Mike Turner (R) re-elected
8th District: Rep. John Boehner (R) re-elected
Ky. Senate: Sen. Mitch McConnell (R) re-elected

State races, A7

Issue 1: Petition deadline passed
Issue 2: Clean Ohio passed
Issue 3: Property rights passed
Issue 5: Payday lending passed
Issue 6: Casino failed
Attorney general: Richard Cordray (D) elected
Supreme Court: Maureen O'Connor (R) and Evelyn Stratton (R) re-elected

General Assembly, A8

Senate, 4th Dist.: Gary Cates (R) re-elected
Rep., 28th Dist: Too close to call
Rep., 30th Dist.: Bob Mecklenborg (R) re-elected
Rep., 31st Dist.: Denise Driehaus (D) elected
Rep., 34th Dist.: Peter Stautberg (R) elected

Our counties, A9-11

Many Hamilton County results are incomplete.

Hamilton County stopped counting votes with just more than 50 percent of the votes shortly after midnight.

A computer being used by election officials crashed. Another computer was delivered, and counting resumed after about an hour.

For updates on results today, go to Cincinnati.Com.

Cincinnati, Ohio

news.cincinnati.com

THE PLAIN DEALER ELECTION SPECIAL EDITION

WEDNESDAY, NOVEMBER 5, 2008

'CHANGE HAS COME'

Barack Obama elected first black president

Economic anxiety propels Democrat to electoral landslide

JAE C. HONG | ASSOCIATED PRESS

Barack Obama and his wife, Michelle, and daughters, Sasha, left, and Malia, acknowledge cheers at his victory rally in Chicago's Grant Park. Obama will be the 44th president of the United States.

Obama carries Ohio, other swing states to victory

ELIZABETH AUSTER AND MARK NAYMIK
The Plain Dealer

Illinois Sen. Barack Obama became the first black American in history to win the U.S. presidency Tuesday, riding a powerful wave of economic anxiety and frustration with the Bush administration that left Democrats in control of the White House and Congress for the first time in 14 years.

Ohio, which gave President Bush his margin of victory in 2004 and which Arizona Sen. John McCain deemed vital to his own success, once again played a crucial role in a presidential election, handing its 20 electoral votes to Obama earlier in the night than many had expected.

Tens of thousands of Obama supporters in Chicago's Grant Park broke out in cheers, and some in tears, as they heard the news that he was the winner about 11 p.m.

SEE OBAMA | X3

INSIDE

LOCAL REACTION | X4
Thousands gather to watch
historic electoral victory

CONGRESS | X6
Democrats pick up seats
in House and Senate

STATE ISSUES | X8
Voters reject casino plan,
approve cap on payday loans

STATE RACES | X9
Dems gain seats, but control
of state House in doubt

VOTING | X12
Few problems at polls,
but counting starts slowly

FORUM | X15
It's time to unite behind
Obama's message of hope

STEPHEN KOFF AND MARGARET BERNSTEIN | THE PLAIN DEALER

Forty-five years ago, the Rev. Dr. Martin Luther King Jr. stood on the marble steps of the Lincoln Memorial and in a baritone voice invoked a dream, of when people would not be judged by the color of their skin. Sen. Barack Obama, barely 2 years old then, realized that dream on Tuesday — more fully than many Americans could ever have imagined. § "We're watching the hinge of history swing," said Roger Wilkins, an assistant attorney general in President Lyndon Johnson's administration and a friend of King's. § "It's still unbelievable," said Louis Stokes, the former congressman from Cleveland whose brother, Carl, in 1967 was the first black man elected mayor of a major American city. "Not withstanding the fact that I believed in this country, to the degree that I believed that someday this country would rise up to the occasion of electing a qualified African-American to be its president, I did not expect to see it in my lifetime." § Obama, 47, defeated Sen. John McCain in one of the most gripping elections in modern history. Acknowledging the significance, he said in his victory speech in Chicago, "If there is anyone out there who still doubts that America is a place where all things are possible, who still wonders if the dream of our founders is alive in our time, who still questions the power of our democracy, tonight is your answer." § He will be sworn in on Jan. 20 as the 44th United States president. § SEE HISTORY | X16

GET UP-TO-THE-MINUTE LOCAL, STATE AND NATIONAL RESULTS AT CLEVELAND.COM/ELECTION

Cleveland, Ohio

www.cleveland.com/plaindealer

THE OKLAHOMAN

WEDNESDAY, NOVEMBER 5, 2008 · 50¢ · NEWSOK.COM · COVERING OKLAHOMA SINCE 1907

ELECTION 2008

ROTH UPSET
Republican Dana Murphy wins Corporation Commission race, defeating incumbent Jim Roth.
NEWS, 5A

WEATHER

STORMS POSSIBLE
Windy, cloudy
High: 77
Low: 46

STATE, 22A

HISTORIC ELECTION ENDS LONG, UP-AND-DOWN CAMPAIGN FOR 44TH CHIEF EXECUTIVE

'CHANGE HAS COME TO AMERICA'

President-elect Barack Obama takes the stage Tuesday night at his election night party in Chicago's Grant Park. AP PHOTO

Most incumbents do well in Oklahoma

FROM STAFF REPORTS

President: Republican John McCain carried Oklahoma. With 99 percent of precincts reporting, McCain had 66 percent of the vote. Democrat Barack Obama had 34 percent.

U.S. Senate: Incumbent Republican Jim Inhofe was declared the winner. Also with 99 percent of precincts reporting, Inhofe had 57 percent of the vote, defeating Democrat Andrew Rice and independent Stephen P. Wallace.

U.S. House: All five Oklahoma incumbents won. With 99 percent precincts reporting, Republican John Sullivan (District 1) had 66 percent of the vote, Democrat Dan Boren (District 2) had 70 percent, Republican Frank Lucas (District 3) had 70 percent, Republican Tom Cole (District 4) had 66 percent and Republican Mary Fallin (District 5) had 66 percent.

Corporation Commission: With 99 percent of precincts reporting, Republican incumbent Jeff Cloud defeated Democrat Charles Gray and Republican Dana Murphy defeated incumbent Jim Roth.

State Senate: Republicans picked up at least two seats to gain control of the Senate for the first time.

State questions: All four state questions were passing. They concerned tax exemptions for disabled veterans; filing for property tax exemptions; hunting rights; and the sale of local wines.

NEWSOK.COM

Video
Robert Jones, who was born in 1905, got a chance to vote for the first black president on Saturday. Watch his journey to the polls.

Photo
Check out photo galleries of the sights from Tuesday's election.

Comments
What was your experience on election day? Add your comments.

Blog
Recap Mark Green and Chris Casteel's live chat about the election.

ALL AT NEWSOK.COM/ELECTION

OBAMA WINS 12 STATES, MANY HISTORICALLY GOP STRONGHOLDS

Lorraine Lovelace, center, of Oklahoma City hugs Neva Hames of Norman during the Democratic watch party on Tuesday. PHOTO BY BRYAN TERRY, THE OKLAHOMAN

BY THE ASSOCIATED PRESS

[PAGE 3A] Barack Obama swept to victory as the nation's first black president Tuesday night in an electoral college landslide that overcame racial barriers as old as America itself. "Change has come," he declared to a huge throng of cheering supporters in Chicago.

The son of a black father from Kenya and a white mother from Kansas, the Democratic senator from Illinois sealed his historic triumph by defeating Republican Sen. John McCain in a string of wins in hard-fought battleground states — Ohio, Florida, Virginia and Iowa.

INSIDE

TURNOUT FALLS SHORT
Results show about 1.4 million Oklahomans voted in the general election, which is just shy of the 1.46 million who turned out for the 2004 Bush-Kerry election.
PAGE 4A

VOTERS VOICE CONCERNS
Six in 10 voters around the nation picked the economy as the most important issue facing the nation.
PAGE 2A

A LOOK AT LOCAL ISSUES
A roundup of the issues voted on by each county in Oklahoma on Tuesday.
PAGE 8, 9A

TODAY'S PRAYER
Let us celebrate You with our offerings, Lord. To You we give praise. Amen.

Advice	5E	Deaths	19A
Business	1B	Movies	4E
Classified	1F	Opinion	14A
Comics	8F	Sports	1C
Crossword	8F	TV	3E

PUPPY MAULING

Tulsa mom charged in fatal dog attack

[PAGE 17A] A mother was charged with second-degree manslaughter after the family dog attacked her 2-month-old boy. Linzy Leigh Earles, 18, left her son and the young Labrador retriever unattended for two hours. Earles was charged in Tulsa County, according to court papers filed Tuesday.

SHEILA STOGSDILL, STAFF WRITER

SPORTS

Lords of the rings in Boston

The Celtics are back to their winning ways and that's a good thing for the NBA and Oklahoma City.

SPORTS, 1C

WWW.TULSAWORLD.COM
WEDNESDAY
NOVEMBER 5, 2008

TULSA WORLD

■ LOCALLY OWNED SINCE 1905 ■

FINAL HOME EDITION
75¢

✓ **Sen. Barack Obama, (D) 51.4%**
Popular vote: 48,589,274 Okla. vote: 492,138

Sen. John McCain, (R) 47.2%
Popular vote: 45,152,711 Okla. vote: 936,100

YES HE DID

President-elect Barack Obama waves to the crowd after giving his victory speech at Grant Park in Chicago on Tuesday night. PABLO MARTINEZ MONSIVAIS/Associated Press

Obama's triumph is historic moment

BY DAVID ESPO
Associated Press

WASHINGTON — Barack Obama swept to victory as the country's first black president Tuesday night in an Electoral College landslide that overcame racial barriers as old as the United States itself.

"Change has come," he told a jubilant hometown Chicago crowd estimated at nearly a quarter-million people.

The son of a black father from Kenya and a white mother from Kansas, the Democratic senator from Illinois sealed his historic triumph by defeating Sen. John McCain, the Republican nominee, in a string of victories in hard-fought battleground states — Ohio, Florida, Iowa and more. He captured Virginia, too, making him the first candidate of his party in 44 years to do so.

On a night for Democrats to savor, they not only elected Obama as the 44th president but padded their majorities in the House and Senate. In January, they will control both the

John McCain

White House and Congress for the first time since 1994.

A survey of voters leaving polling places showed that the economy was by far the top Election Day issue. Six in 10 voters said so, and none of the other top issues — energy, Iraq, terrorism and health care — was picked by more than one in 10.

Obama's election capped a meteoric rise — from mere state senator to president-elect in four years.

Spontaneous celebrations erupted from Atlanta to New York and Philadelphia as word of Obama's victory spread. A big crowd filled Pennsylvania Avenue in front of the White House.

In his first speech as the victor, to an enor-

SEE **OBAMA** EE8

PRESIDENTIAL REACTION

Locals gleeful or dismayed

BY DENVER NICKS
World Staff Writer

Tulsans reacted with a range of emotions — from unbridled glee to disappointment to cautious optimism — to news that the United States had elected its first black president.

"I feel real good. You know the way I feel? Yeeea!" said Jacqueline Embray, leaping into the air at a watch party at the Greenwood Cultural Center.

"Tonight is a call to celebration," said Toni Wynes. "I'm so happy, I could fly. The dream has come true."

"I'm just thrilled to be on the same ballot (as Obama)," said Sally Frasier, an elector for the president-elect from Oklahoma.

"I'm sorry that I won't get to use my elector status in the state of Oklahoma, but I'm sure excited about the national scene, the U.S. Senate and the president's race," said Frasier.

SEE **LOCALS** EE8

CITY OF TULSA STREETS PACKAGE

Voters OK streets plan

BY BRIAN BARBER AND P.J. LASSEK
World Staff Writers

Tulsa voters paved the way Tuesday for the city to spend $451.6 million to fix the cracked and crumbling streets.

Both propositions that will provide funding for the five-year tax program were easily approved.

Proposition 1 — the sales tax portion — captured 61 percent of the votes and proposition 2 — the property tax portion — got 60 percent of the votes with 219 of 219 precincts reporting.

"We listened carefully to what the citizens wanted and that's what we put on the ballot," Mayor Kathy Taylor said after proclaiming victory at a watch party at the Tulsa Press Club.

Councilor G.T. Bynum, who pushed this pared-down program over a $2 billion, 12-year version, said voters approved it, even in tough economic times, because the

SEE **FIX** EE6

✦ tulsaworld.com
ONLINE
See the official results of Tuesday's election.
tulsaworld.com

Daily - 75 cents

Tulsa, Oklahoma
www.tulsaworld.com

WEDNESDAY • NOVEMBER 5, 2008 • PORTLAND, OREGON 75 CENTS • SUNRISE EDITION

The Oregonian

OREGONLIVE.COM/POLITICS

OBAMA'S TIME

America votes for historic change | A11

COMPREHENSIVE ELECTION COVERAGE | A11-20, B1-5

DOUG MILLS/THE NEW YORK TIMES

Copyright © 2008, Oregonian Publishing Co.
Vol. 158, No. 53,223, 56 pages

Key results For a complete list, see A11

Big gains in Congress
Democrats scored some
convincing victories in both
chambers, picking up Senate
seats in North Carolina, New
Hampshire and Virginia | **A18**

Crime measure wins
The Oregon Legislature's less-
costly alternative to Kevin Mannix's
anti-crime initiative will go into
effect, but a slew of other
measures fail | **A19**

Elephants win: Zoo bond passes
Portland-area voters approve a $125 million
bond measure that would provide more space
and more natural surroundings for the Oregon
Zoo's elephants, polar bears, chimps and other
animals | **B1**

Portland, Oregon

www.oregonlive.com/oregonian

Portland isn't known for its impromptu outpourings of national pride and patriotism. Yet on Election Night, jubilant people filled Pioneer Courthouse Square and sang the Star-Spangled Banner to celebrate the election of Democratic Sen. Barack Obama . . . What's next, American flags replacing the Tibetan prayer flags and anti-Bush signs?

Philadelphia, Pennsylvania
www.philly.com

Pittsburgh, Pennsylvania
www.post-gazette.com

In the cozy family room of his Penn Hills home, where family photos and African-American art adorn the walls, Ron Saunders danced. It wasn't anything elaborate. Just a little shimmy, a small celebration after MSNBC projected that Sen. Barack Obama had won Ohio, clearing the way for his sweeping election win.

– Monica Haynes and Deborah M. Todd, Pittsburgh Post-Gazette

The Greenville News

High: **70°**
Weather, 14A

GreenvilleOnline.com

Greenville,
South Carolina

WEDNESDAY, NOVEMBER 5, 2008 ■ FINAL EDITION

Obama wins

CONGRESS: Democrats increase majorities

HISTORY: Nation elects first black president

VICTORY KEY: Obama wins electoral landslide

PRESIDENT OF THE UNITED STATES
Precincts reporting: 76 percent
John McCain (R)
48,736,508 - 47.4%
Electoral votes: 141

✓ Barack Obama (D)
52,760,687 - 51.3%
Electoral votes: 338

UNITED STATES SENATE
2,105 of 2,291 precincts reporting
Bob Conley (D)
695,431 - 42%
✓ Lindsey Graham (R)(I)
963,053 - 58%

UNITED STATES HOUSE OF REPRESENTATIVES
4TH DISTRICT
274 of 274 precincts reporting
Paul Corden (D)
111,141 - 37%
✓ Bob Inglis (R)(I)
180,211 - 60%
C. Faye Walters (GRN)
7,193 - 2%

STATE SENATE
DISTRICT 7
27 of 27 precincts reporting
✓ Ralph Anderson (D)(I)
21,693 - 70%
Roan Garcia-Quintana (R)
8,251 - 27%
John Langville (CST)
958 - 3%

STATE SENATE
DISTRICT 13
54 of 54 precincts reporting
Jimmy Tobias (D)
11,868 - 32%
✓ Shane Martin (R)
25,111 - 68%

STATE HOUSE
DISTRICT 16
24 of 24 precincts reporting
Michael Turner Jr (D)
6,234 - 47%
✓ Mark N Willis (R)
7,078 - 53%

STATE HOUSE
DISTRICT 23
15 of 15 precincts reporting
✓ Chandra Dillard (D)
7,965 - 76%
Justin Alexander (R)
2,491 - 24%

STATE HOUSE
DISTRICT 25
15 of 15 precincts reporting
✓ Karl Allen (D)
9,876 - 77%
Rick Freeman (R)
2,977 - 23%

STATE HOUSE
DISTRICT 28
16 of 16 precincts reporting
Jonathan Smith (D)
7,260 - 39%
✓ Eric M. Bedingfield (R)
11,190 - 61%

AMENDMENT 1
2,105 of 2,291 precincts
✓ Yes, 791,681
No, 738,381

AMENDMENT 2
2,105 of 2,291 precincts
Yes, 642,213
✓ No, 904,160

AMENDMENT 3
2,105 of 2,291 precincts
Yes, 667,337
✓ No, 855,812

Barack Obama was elected the nation's first black president Tuesday night.

MICHAEL CONROY / The Associated Press

President-elect says first priority will be economy

By David Espo
THE ASSOCIATED PRESS

WASHINGTON — Barack Obama swept to victory as the nation's first black president Tuesday night in an Electoral College landslide that overcame racial barriers as old as America itself. "Change has come," he told to a huge throng of jubilant supporters.

The son of a black father from Kenya and a white mother from Kansas, the Democratic senator from Illinois sealed his historic triumph by defeating Republican Sen. John McCain in a string of wins in hard-fought battleground states — Ohio, Florida, Virginia, Iowa and more.

On a night for Democrats to savor, they not only elected Obama the nation's 44th president but

See **OBAMA** on page 3A

LATEST RESULTS
■ Get the results of late races, read election analyses, find out about all the local races and see Election-Day photo galleries at:

greenvilleonline.com

Graham re-elected to second term in Senate

Seneca Republican turns back challenge from Conley

By Dan Hoover
STAFF WRITER
dhoover@greenvillenews.com

U.S. Sen. Lindsey Graham overcame internal GOP discord and a Democratic voter registration surge to easily brush back a re-election challenge Tuesday from Bob Conley.

The Seneca Republican monitored returns from Phoenix where he was at the side of GOP presidential nominee John McCain as they watched returns.

In a telephone call to the state GOP's election night party at a downtown Columbia hotel, Graham, sounding tired and hoarse, said, "I'm going back to the Senate and say no to expanding government and spending more of your money."

With 2,105 of 2,291 precincts reporting, Graham had 963,053 votes, or 58 percent, and Conley, 695,431, or 42 percent.

Graham appeared to have mended fences in Greenville County, holding more than 60 percent of the votes with all 148 precincts reporting.

See **SENATE** on page 8A

Inglis retains 4th District seat

■ Details, Page 4A

By Tim Smith
CAPITAL BUREAU
tcsmith@greenvillenews.com

U.S. Rep. Bob Inglis of Travelers Rest was elected to a sixth term in Congress representing the 4th District on Tuesday.

With all 274 precincts reporting, Inglis led Democrat Paul Corden,

a retired businessman and first-time office seeker, 60 percent to 37 percent, according to unofficial results. Faye Walters, the Green Party nominee on her seventh try for the seat, had 2 percent of the vote.

"This is the hardest election cycle I've ever had," Inglis said about being elected to his sixth term. "I'm very grateful for this good result."

Voters face long lines to cast historic ballots

By David Dykes
STAFF WRITER
ddykes@greenvillenews.com

Some voters endured waiting times of more than three hours in Greenville County on Tuesday, and the elections director said many poll workers and polling places were swamped by the heavy turnout.

The biggest challenge, said Conway Belangia, Greenville County's director of elections, was "just resources, not having enough poll workers, enough space in some poll-

ing places, enough machines, enough part-time help to handle all the phone calls.

"It's just been quite overwhelming," he said.

According to election officials, 191,602 ballots were cast in Greenville County by 76.4 percent of the county's 250,778 registered voters, up sharply from the 165,778 ballots cast in the county in 2004 in the last presidential election.

See **VOTERS** on page 8A

INSIDE
■ GOP likely to claim extra County Council seat. Page 4A
■ Dems, GOP split wins in state House races. Page 4A
■ Results close in some special district races. Page 4A
■ Loftis returned as county sheriff. Page 4A
■ Anderson re-elected to state Senate. Page 4A
■ Mauldin OKs Sunday alcohol sales. Page 4A
■ Precinct-by-precinct voting results. Page 5A
■ Democrats expand control of Congress. Page 11A
■ Bush vows 'smooth transition'. Page 10A
■ N.C. elects its first female governor. Page 10A
■ Economic worries pushed state voters to McCain. Page 11A

Greenville incumbents keep school board seats

By Ron Barnett
STAFF WRITER
rbarnett@greenvillenews.com

Two incumbents easily turned back challengers, and a veteran educator won in a race for an open seat on the Greenville County school board on Tuesday.

Two other incumbents were re-elected without opposition.

With all 143 precincts reporting, incumbents Tommie Reece and Danna Edwards each had claimed 70 percent of the vote in

their contests to win in Districts 17 and 21, respectively.

Edwards bested her next-door neighbor, Darin Scheidly, 10,033 to 4,055.

In the Nicholtown area's District 23 seat vacated by Grady Butler, Glenda Morrison-Fair won over Yvonne Smith Reeder 2,666 to 2,302.

Leola Robinson-Simpson and Debi Bush were unopposed for re-election in the District 19 and 25 seats, respectively.

INSIDE
Abby 5D
Business 1B
Classifieds 1E
Comics 4-5D
Local News 2A
Obituaries 7A
Sports 1C
Taste 1D
Theaters 3D
U.S./World 10A
Voices 6A
Weather 14A

www.greenvilleonline.com
Circulation hot line
800-736-7136
Classified Ads 298-4221
© Copyright 2008
Greenville News-Piedmont Co.
A Gannett Newspaper · 131st year
No.260· 36pages

75¢

THE NEWS IS
PRINTED USING
RECYCLED PAPER

The Dallas Morning News

Texas' Leading Newspaper 75 cents Dallas, Texas, Wednesday, November 5, 2008 dallasnews.com

ELECTIONS '08 | Special Report, 14-27A

'Change has come'

Obama wins big, shatters White House color barrier

VERNON BRYANT/Staff Photographer

Barack Obama, with wife Michelle and daughters Sasha, 7, and Malia, 10, addressed a jubilant crowd at Chicago's Grant Park on Tuesday night after rival John McCain conceded the presidential election. Mr. Obama, whose victory capped the first-term U.S. senator's meteoric rise to the top of the political world, called on Americans to embrace "a new spirit of service."

DALLAS REACTION

For black residents, pride and optimism

**By SCOTT FARWELL
and JESSICA MEYERS**
Staff Writers

For a generation, black parents have told their children, "You can be anything you want in this world."

After Tuesday night, they can say it with confidence.

Barack Obama, a first-term senator from Illinois known for booming soliloquies and a cool-under-fire demeanor, was elected the nation's first black president.

The historic election was greeted with prayer and shouts of jubilation around the city, especially in southern Dallas, home to more than 500,000 black residents.

"Tonight, America is living up to its potential," said Ahtatcha Hendrix, a 32-year-old self-proclaimed political junkie from southern

See **CHEERING** Page 18A

Senator makes history; Dems expand majorities

**By TODD J. GILLMAN
and GROMER JEFFERS JR.**
Staff Writers

CHICAGO — Democrat Barack Obama smashed through the presidential color barrier Tuesday with a huge win propelled by economic malaise, war fatigue and an urgent demand for change.

"It's been a long time coming, but tonight, because of what we did on this day, in this election, at this defining moment, change has come to America," Mr. Obama told a jubilant crowd estimated at 240,000 in Grant Park after defeating Republican John McCain.

His stunning political rise — from Illinois state senator to president-elect in four years — marks an extraordinary moment for America, sending to the dustbin of history the Jim Crow legacy that persisted even when he was born

See **OBAMA** Page 19A

ANDREW HARRER/Bloomberg News

Mr. McCain, outside Phoenix's Biltmore Hotel, called on supporters to offer Mr. Obama "our good will and earnest effort to find ways to come together."

ANALYSIS

Walk the walk? He needs running start

By WAYNE SLATER
Senior Political Writer
wslater@dallasnews.com

AUSTIN — As mandates go, Barack Obama has been given the keys and a clear highway to steer the nation in a dramatically new direction.

From his first day in the White House, the new president will find himself as the country's crisis manager — facing the fierce urgency of huge expectations.

"He'll have to go and make things happen," said University of Texas professor Bruce Buchanan.

"He has a credible claim on tax cuts for the middle class and tax increases for the rich, for getting out of Iraq sooner rather than later and dealing in a new way with adversaries in the world," he said. "You still have to go out

See **NEW** Page 18A

Congress

House
+12

Dems get first back-to-back surge for the party since before World War II.

Senate
+5

Dems fattened majority control and were hoping for even greater gains.

President

Electoral votes by state, 270 needed to win

80% precincts reporting

Obama
338
52%
54,314,223
27 states
(including D.C.)

McCain
141
47%
49,740,554
18 states

58 electoral votes, 6 states undeclared

INSIDE

How Obama won, **15A**

Democrats build on majority in Congress. **20A**

Americans stormed to the polls in what could be record numbers, but problems were scattered and few. **22A**

CHAT LIVE WITH Wayne Slater about the presidential election and other results at 11 a.m. today. dallasnews.com

SEE OUR MAPS of Dallas County precinct results for the presidency, sheriff's race, and Parkland hospital bond. dallasnews.com/precinctresults

Forecast: **Showers**

Metro, back page

©2008, The Dallas Morning News

INSIDE			
Lottery	2A	Sports TV/Radio	2C
Texas	3A	NFL	6C
Nation	4-6A	Market Day	6-7D
World	8-13,29A	TV	9E
Editorials	30A	Movies	3E
Reg. Roundup	2B	Dear Abby	9E
Obituaries	4-6B	Comics	9-11E
NBA	1C	Horoscope	10E

83197 00001

III

U.S. SENATE

Cornyn wins re-election

Republican John Cornyn fended off Democrat Rick Noriega to win re-election to the U.S. Senate. **21A**

DALLAS COUNTY

New hospital approved

In Dallas County, voters overwhelmingly approved replacing aging Parkland Memorial Hospital with a larger, modern facility. **Sheriff race:** Voters chose incumbent Democrat Lupe Valdez over Lowell Cannaday. **22A**

TEXAS SENATE

Tarrant County adds more blue

In Tarrant County, Democrat Wendy Davis defeated Republican state Sen. Kim Brimer. **27A**

HOUSTON ★ CHRONICLE

WWW.CHRON.COM WEDNESDAY, NOVEMBER 5, 2008 ★ ★ ★ ··· VOL. 108 · NO. 23 · 75 CENTS

OBAMA: 'CHANGE HAS COME TO AMERICA'

JEWEL SAMAD : AFP/GETTY IMAGES

FIRST FAMILY: President-elect Barack Obama, with daughters Sasha and Malia and his wife, Michelle, greets a massive crowd Tuesday night in Chicago's Grant Park. "America, we have come so far, we have seen so much, but there is so much more to do," he told the jubilant supporters.

HARRIS COUNTY

New day dawning for Dems

■ Long-standing GOP hold broken by huge turnout

By ALAN BERNSTEIN
HOUSTON CHRONICLE

The political "perfect storm" sought by local Democrats shattered the Republican fortress that was Harris County on Tuesday, but left some GOP officeholders standing strong and many local voters emotionally drained.

With Barack Obama leading the way at the top of the local ballot, the most populous county in Texas elected a new sheriff, Democratic City Councilman Adrian Garcia. The election also wiped about 20 Republican state district judges out of the civil and criminal court houses.

But on a night of mixed verdicts, in which Tuesday's turnout fell far short of the early vote avalanche, Repub-
Please see COUNTY, Page A6

PRESIDENTIAL RESULTS

ELECTORAL VOTES

Obama 349
McCain 160
(Projected results as of 1:30 a.m. CST)

POPULAR VOTE

Obama 52% McCain 47%
58,177,203 52,571,445
(As of 1:30 a.m. CST)

TEXAS POPULAR VOTE

McCain 55% Obama 44%
4,380,975 3,471,542
(97% of precincts reporting)

Electoral votes needed to win: 270

■ McCain
■ Obama
■ Undecided

CHRONICLE

Results as of 1 a.m. CST

CONGRESS

CONGRESSIONAL DISTRICT 22

Lampson falls to GOP's Olson

Republican Pete Olson upends incumbent Nick Lampson to reclaim Tom DeLay's old seat for the GOP.

CONGRESSIONAL DISTRICT 7

Culberson fends off challenger

GOP incumbent John Culberson wins his fifth two-year term, defeating Democrat Michael Skelly.

U.S. SENATE

Cornyn claims second term

Incumbent John Cornyn, above, turns back Democratic challenger Rick Noriega of Houston to win his second six-year term.

John Cornyn, GOP (i)
4,545,077 — 57%
Rick Noriega, Dem
3,334,104 — 41%
(97% of precincts reporting)

COUNTY

JUDGE

Emmett holds off challenger

Republican incumbent Ed Emmett retains the county's top job, easily defeating Democrat David Mincberg.

DISTRICT ATTORNEY

Lykos leads in DA race

Republican Pat Lykos is edging former Houston police chief C.O. Bradford, a Democrat, in a tight race.

■ Senator to become first black president of the U.S.

■ Across nation, Democrats pad majorities in Congress

By RICHARD S. DUNHAM
WASHINGTON BUREAU

Nearly 150 years after Abraham Lincoln signed his Emancipation Proclamation, Barack Obama, a freshman senator from Lincoln's home state, became the first black to be elected president of the United States.

Obama, a 47-year-old Chicago Democrat who inspired millions with his soaring oratory and hopeful rhetoric, defeated Republican presidential nominee John McCain by a comfortable electoral vote margin. The Hawaii native, who spent much of the first decade of his life in Indonesia, rolled to victory by winning every state carried by Democrat John Kerry in 2004, then adding traditionally Republican states such as Virginia, Colorado, Nevada and Florida.

"If there is anyone out there who still doubts that America is a place where all things are possible, who still wonders if the dream of our founders is alive in our time, who still questions the power of our democracy, tonight is your an-
swer," the president-elect told more than 100,000 people who gathered for a moonlit victory celebration on a balmy Chicago night.

A country beset by a battered economy, an unpopular war and partisan sniping in Washington turned to a candidate unlike any of the nation's
Please see PRESIDENT, Page A6

TO OUR READERS

To bring you the most up-to-date election results, we pushed our deadlines later Tuesday night. This may have resulted in a delay in the delivery of your newspaper. We apologize for any inconvenience.

INSIDE

Business . . **D1**	Editorials **B16**
Comics . . **E10**	Lottery . . **A2**
Crossword **E9**	Movies. . . **E3**
Directory . **A8**	Obituaries **B14**

6 37953 11111 0

WE RECYCLE

The Burlington Free Press

Wednesday, November 5, 2008 *** *A Local Custom* • Serving Vermont for 182 years • www.burlingtonfreepress.com 75 cents

INSIDE: 14 PAGES OF LOCAL, STATE AND NATIONAL COVERAGE

BUSINESS NEWS

IBM lays off 100 contract workers, STORY 7C

Obama makes history

America elects first black president

■ **Vermont first state called for Obama** STORY 4A

■ **Democrats increase majorities in U.S. House, Senate** STORY 2A

■ **Turnout, troubles and scenes from Election Day** STORY 1C

Printed in the U.S.A.

Available for home or office delivery.
Call toll-free 1-800-427-3126

 WEATHER
Hi: 61 Low: 49

Mostly sunny, very warm.

INDEX

Vol. 181, No. 310

(c) 2008 The Burlington Free Press

For up-to-the-minute news, sports and entertainment, go to

www.burlingtonfreepress.com

Burlington, Vermont

www.burlingtonfreepress.com

Seattle Post-Intelligencer

CHANGE
HAS COME TO AMERICA

— PRESIDENT-ELECT BARACK OBAMA

EMMANUEL DUNAND / GETTY IMAGES

President-elect Barack Obama acknowledges a crowd of about 125,000 in Chicago's Grant Park after giving his acceptance speech Tuesday night. He swept to an Electoral College landslide over John McCain.

★ ELECTION 2008 ★

STATE RACES	BALLOT ISSUES

STATE RACES

COMMISSIONER OF PUBLIC LANDS

Doug Sutherland (R)	Peter Goldmark (D)
52%	48%

SUPT. OF PUBLIC INSTRUCTION

Randy Dorn	Terry Bergeson
51%	49%

SEATTLE'S 36th LEGISLATIVE DISTRICT

Reuven Carlyle (D)	John Burbank (D)
66%	34%

SEATTLE'S 46th LEGISLATIVE DISTRICT

Scott White (D)	Gerry Pollet (D)
73%	27%

BALLOT ISSUES

PROP. 1: TRANSPORTATION LEVY
PASSED
YES 62% NO 38%

PROP. 1: PIKE PLACE MARKET LEVY
PASSED
YES 59% NO 41%

PROP. 2: SEATTLE PARKS LEVY
PASSED
YES 57% NO 42%

INITIATIVE 1000: DEATH WITH DIGNITY
PASSED
YES 58% NO 42%

SEATTLEPI.COM
FOR LATEST
ELECTION UPDATES

FIRST AFRICAN-AMERICAN ELECTED PRESIDENT

BY ADAM NAGOURNEY
The New York Times

Barack Hussein Obama was elected the 44th president of the United States on Tuesday, sweeping away the last racial barrier in American politics with ease as the country chose him as its first black chief executive.

Obama's election amounted to a national catharsis – a repudiation of a historically unpopular Republican president and his economic and foreign policies, and an embrace of Obama's call for a change in the direction and the tone of the country. But it was just as much a strikingly symbolic moment in the evolution of the nation's fraught racial history, a breakthrough that would have seemed unthinkable just two years ago.

Obama, a 47-year-old first-term senator from Illinois, defeated Sen. John McCain of Arizona, 72, a former prisoner of war who was making his second bid for the presidency. To the very end, McCain's campaign was eclipsed by an opponent who was nothing short of a phenomenon, drawing huge crowds epitomized by the tens of thousands of people who turned out Tuesday night to hear Obama's victory speech in Grant Park in Chicago.

SEE PRESIDENT, A18

In mostly blue Seattle, jubilation

Big voter turnout boosts Obama, Gregoire, levies

BY VANESSA HO
P-I reporter

As Barack Obama was elected the nation's 44th president, Seattle reveled in a jubilant sea of blue Tuesday night, with Democrat Chris Gregoire declaring victory in a tight governor's race and thousands of people spilling into the streets for impromptu rallies on Capitol Hill and in downtown Seattle.

Drivers honked, people wept and strangers hugged. A crowd of 2,000 chanted, "Yes, we can" outside Pike Place Market. Laura Bennett, who is 24 and white and African-American, said, "This is the most gratifying feeling that I've ever experienced as an American. I've been crying all day."

The national Democratic wave boosted challenger Darcy Burner in the 8th Congressional District race, giving her a solid lead

SEE SEATTLE, A18

INDEX

TODAY'S WEATHER: Rain tonight. High 50. Low 46. **B8**

★★

The P-I and seattlepi.com reach 1.3 million readers a week in Western Washington, including three-quarters of a million Monday through Saturday. To subscribe, call 206-464-2121.
© 2008 SEATTLE POST-INTELLIGENCER

7 59423 15000 6

Hungry for change, steeped in discontent and economically embattled, voters turned to a candidate whose election would have been hard to envision in decades past, who was a political unknown five years ago, who defeated two entrenched political figures on his way to the White House . . . and who rewrote the campaign book getting there.

MILWAUKEE · WISCONSIN
JOURNAL SENTINEL

2008 PULITZER PRIZE WINNER FOR LOCAL REPORTING

ELECTION '08 ★ The voters decide

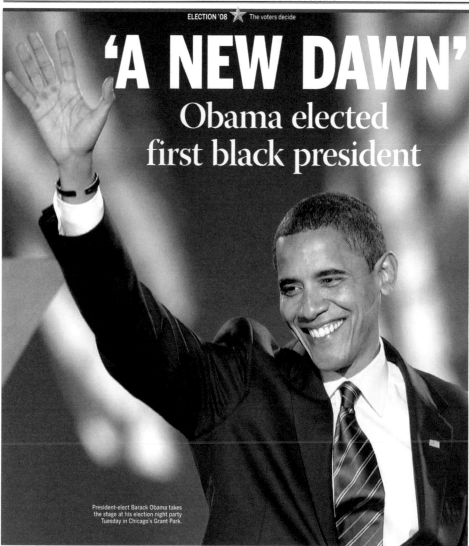

'A NEW DAWN'
Obama elected first black president

President-elect Barack Obama takes the stage at his election night party Tuesday in Chicago's Grant Park.

ASSOCIATED PRESS

ELECTION RESULTS

COVERAGE ON PAGES 3A-11A, 1B, 6B-8B; UPDATES AT JSONLINE.COM

U.S. CONGRESS

Kagen beats Gard

U.S. Rep Steve Kagen (D-Wis.) scores a narrow victory over challenger John Gard in the 8th Congressional District race. **1B**

JOE KOSHOLLEK/JOURNAL SENTINEL
Steve Kagen addresses supporters after defeating John Gard.

Democrats gain in House, Senate

With 29 of 35 Senate races called, Democrats are guaranteed at least a 56-44 majority, but they hope for even greater gains. In the House, Democrats are expected to gain upwards of 20 seats. **5A**

MILWAUKEE

Paid sick leave issue approved

City of Milwaukee residents overwhelmingly approve requiring private employers to provide paid sick leave for all their workers. **6B**

Sales tax may pass: A referendum on raising Milwaukee County's sales tax by 1 percentage point appears headed for approval. **6B**

WISCONSIN

Democrats hold state Senate, gain in Assembly

Democrats appear to keep control of the state Senate, but their margin depends on the outcomes of elections that are too close to call. Democrats make gains in the state Assembly, putting them in striking distance of taking control of the house for the first time in 14 years. **1B, 7B**

Candidate's call for change resonates around nation

By CRAIG GILBERT
cgilbert@journalsentinel.com

Illinois Sen. Barack Obama made history Tuesday, becoming the first African-American to win the presidency of the United States after an epic and exhaustive campaign that consumed Americans and captivated much of the world.

PRESIDENT U.S. results
151,906 of 187,088 units reporting
Barack Obama (D)....55,015,187
John McCain (R)....50,337,843
Wisconsin results
3,119 of 3,621 units reporting
Barack Obama (D)....1,380,528
John McCain (R)........1,047,037
For latest results go to www.jsonline.com

Hungry for change, steeped in discontent and economically embattled, voters turned to a candidate whose election would have been hard to envision in decades past, who was a political unknown five years ago, who defeated two entrenched political figures on his way to the White House in John McCain and Hillary Rodham Clinton, and who rewrote the campaign book getting there.

"It's been a long time coming, but tonight, because of what we did on this day, in this election, at this defining moment, change has come to America," Obama told a huge crowd of supporters in Chicago, saying a "new dawn of American leadership is at hand."

Addressing the world beyond America's shores, Oba-

Please see OBAMA, 9A

IT'S THE ECONOMY, POLLS SAY

Economy was on the majority of voters' minds. **6A**

▶ **More of Wisconsin votes blue in '08:** Youth, independents choose Obama. **11A**

▶ **Living to see the day:** Black Milwaukeeans celebrate. **4A**

▶ **Party in Kenya:** Obama's relatives celebrate. **4A**

A WORD **Elation** (ee LAY shuhn) A feeling of exultant joy or pride. n. **Page 9G**

INDEX
Comics 7G
Crossword 8G
Deaths 4B
Editorials 18A

Movies 9G
Stocks 4D
Sports on TV 7C
TV listings 9G

WEATHER
TODAY'S TMJ4
Map: Back of Sports

TODAY
53/71
Partly cloudy and unseasonably warm

TOMORROW
54/63
Mostly cloudy, showers and storms

50¢
CITY AND SUBURBS
$1.00 OR HIGHER ELSEWHERE

7 31544 10500 4

First place at stake
Marshall, ECU meet for control of East division
Sports / 1B

Mostly sunny and nice
7345

Weather / 10A

Leak causes evacuation
Artisan Avenue reopens after a chemical leak
Local / 3A

The Herald-Dispatch

Huntington, West Virginia www.herald-dispatch.com Home Edition 50¢

WEDNESDAY
November 5, 2008

WEST VIRGINIA

Rockefeller, Rahall win
Democratic incumbents U.S. Jay Rockefeller and U.S. Rep. Nick Rahall rolled to easy victories Tuesday. **Page 4A.**

Manchin wins big
Democratic incumbent Joe Manchin easily won re-election as governor of West Virginia. **Page 4A.**

McGraw leading
Attorney General Darrell McGraw was leading in a tight race with Republican Dan Greear. **Page 4A.**

Plymale wins again
West Virginia State Sen. Bob Plymale was re-elected to another term. **Page 4A**

House of Delegates
Incumbents Jim Morgan, Kevin Craig, Carole Miller, Doug Reynolds, Kelli Sobonya, Richard Thompson and Don Perdue won re-election in area state delegate races. **Page 4A**

Cabell sheriff
Democrat Tom McComas took a strong lead over Republican Jim Scheidler for the Cabell County Sheriff's Office. **Page 5A.**

Cabell commissioner
Incumbent Republican Nancy Cartmill beat Democrat Susan Hubbard for a seat on the Cabell County Board of Commissioners. **Page 5A.**

KENTUCKY

Lunsford, McConnell
Incumbent Republican Mitch McConnell edged out a victory in one of the nation's bitterest contests for the U.S. Senate. **Page 6A**

OHIO

Casino vote
Ohio voters defeated a plan to build the state's first casino gambling operation. **Page 6A.**

Index

© The Herald-Dispatch
Champion Publishing, Inc.
www.herald-dispatch.com
Huntington, West Virginia
Vol. 108 No. 310

0 40901 03506 0

OBAMA WINS

President-elect Barack Obama smiles as he gives his acceptance speech at Grant Park in Chicago Tuesday night. Obama made history by becoming the first black president of the United States.
The Associated Press

Senator triumphs, will be first black U.S. president

By DAVID ESPO
AP Special Correspondent

ELECTION 2008

WASHINGTON — Barack Obama swept to victory as the nation's first black president Tuesday night in an electoral college landslide that overcame racial barriers as old as America itself. "Change has come," he told a huge throng of jubilant supporters.

The son of a black father from Kenya and a white mother from Kansas, the Democratic senator from Illinois sealed his historic triumph by defeating Republican Sen. John McCain in a string of wins in hard-fought battleground states — Ohio, Florida, Virginia, Iowa and more.

On a night for Democrats to savor, they not only elected Obama the nation's 44th

Please see OBAMA/10A

Obama wins election

Presidential results by states won

■ McCain ■ Obama ■ Not called

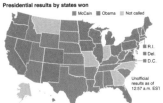

R.I.
Del.
D.C.

Unofficial results as of 12:57 a.m. ES1

Electoral votes		270 needed to win	
Obama			338
McCain		142	

AP

National issues drive voters to polls

By JEAN TARBETT HARDIMAN
The Herald-Dispatch
jeant@herald-dispatch.com

A number of exciting races took place across the Tri-State on Tuesday, but it was the presidential vote that ultimately drew many people to the polls for Election 2008.

Voters had some concerns in common, while other issues separated them. But the bottom line was they wanted their voices to be heard.

Riffe Rawls Mervine Campbell

In West Virginia and Kentucky, The Associated Press declared Sen. John McCain the winner, earning about 55 per- cent of the popular vote in each state. Sen. Barack Obama was declared the winner in Ohio, earning about 52 percent of the popular vote. No Republican has ever won the presidency without Ohio.

By early Wednesday morning, Obama was declared the victor with 51 percent of the popular vote and 338 Electoral College votes.

But a majority of Tri-State voters went for McCain, who won Cabell County 18,571 to 15,110, Lawrence County (Ohio) 15,055 to 10,956 and Boyd County

Please see VOTERS/5A

Ketchum tops court voting

Workman holds lead over Walker for the second spot on Supreme Court

By LAURA WILCOX
The Herald-Dispatch
lwilcox@herald-dispatch.com

Ketchum Workman

HUNTINGTON — Huntington Attorney and Democrat Menis Ketchum was gathering the most votes Tuesday night in a close race to become one of two new justices on the five-member West Virginia Supreme Court of Appeals.

"I'm just tickled to death. I'm the first Supreme Court Justice elected from Huntington, West Virginia, since the 1940s," Ketchum said.

While Ketchum seemed assured of election, Democrat and former

Supreme Court Justice Margaret Workman was in a tighter race for the second spot.

With 85 percent of precincts reporting, Ketchum had 310,068 votes, while Workman followed with 292,161 votes. Lone Republican Beth Walker had 284,789 votes.

Ketchum has been practicing law for almost 40 years. He said his personal campaign efforts paid off.

"I have very rarely been home in

the last year, and I never dreamed that personal contact through the 55 counties would pay off like this," he said.

Workman served as a circuit court judge from 1981 through 1988 and was the first woman elected to statewide office. She was elected to the Supreme Court in 1988 and served through 2000.

Each justice will get a full, 12-year term on West Virginia's only appeals court.

The candidates will take the seats held by Chief Justice Elliott "Spike" Maynard, who was defeated in the May primary, and Larry V. Starcher, who did not seek re-election.

All three candidates said restoring the Supreme Court's integrity was their main priority following questions of conflicts of interest involving the court in recent years.

Wolfe elected mayor

Republican beats incumbent Felinton

By BRYAN CHAMBERS
The Herald-Dispatch
bchambers@herald-dispatch.com

HUNTINGTON — Kim Wolfe will move from the Cabell County Courthouse to Huntington City Hall come January.

With all 40 city precincts reporting in Cabell and Wayne counties Tuesday night, unofficial returns show the Republican Cabell sheriff winning the mayor's race with a commanding 2,418-vote victory over Democratic incumbent David Felinton. Wolfe had 9,192 votes to Felinton's 6,774.

ELECTION COVERAGE
4A-7A, 7C-8C

ON 5A:
New faces ready to join City Council

Felinton, who was seeking a third term, was followed by independent candidates Tom McCallister with 726 votes and Robin Howell with 146 votes.

Wolfe, who started the night watching returns at the Cabell County Courthouse and then celebrating with family and supporters at the Pullman Plaza Hotel, said his victory shows that his message of making Huntington cleaner and safer struck a chord with voters.

"I said from the beginning that I didn't think anyone would outwork me," Wolfe said. "I'm sure a lot of my

Please see MAYOR/5A

Huntington's newly elected Republican Mayor Kim Wolfe reads the tally sheet with updates on the race at the Cabell County Courthouse on Tuesday.
Jeremy McKnight/For The Herald-Dispatch

DREAM FULFILLED A11

Analysis: Now Obama has to get down to business A11

WyomingTribuneEagle

WEDNESDAY, NOVEMBER 5, 2008 CHEYENNE, WYOMING WYOMINGNEWS.COM 75¢

Herbert: 4%
Trauner: 42%
Lummis: 53%

NEW U.S. REP: LUMMIS

Republican candidate for U.S. House of Representatives Cynthia Lummis celebrates after receiving a phone call informing her that she won her election bid over Gary Trauner Tuesday night at the Nagle-Warren Mansion. *Michael Smith/staff* **See story on page A13**

Mockler: 42%
Kaysen: 57%

NEW MAYOR: KAYSEN

From left, Dorothe Akes, Billie Miller, Rick Kaysen and Jim Murphy watch election returns on Tuesday night at the Plains Hotel just before Kaysen was elected to be the next mayor of the city of Cheyenne. *Larry Brinlee/staff*

By Jodi Rogstad
jrogstad@wyomingnews.com

CHEYENNE – Rick Kaysen easily coasted to victory to become the Capital City's next mayor, posting a strong lead from the early results until the last absentee ballot was counted.

Kaysen, 62, garnered 14,565 votes to state Sen. Jayne Mockler's 10,711.

"Needless to say, I'm very pleased, overwhelmed at the same time and relieved now that the citizens have had their voices heard," Kaysen said. "(I feel) pretty doggone good."

The former CEO of Cheyenne Light, Fuel and Power ran on a platform of reforming downtown, bringing better jobs to Cheyenne and keeping the progressive bent of Mayor Jack Spiker's administration.

"I think we're going to have a very strong council," Kaysen said.

All the incumbents won re-election, except Ward 1 Councilman Pete Laybourn.

"I think we can bring some strengths and talents to move the community forward."

See Kaysen, page A2

ELECTION 2008 ELECTION WINNERS

Full list of voting results Page A7
Stories on every winner Pages A6-A14

MIKE ENZI (R)
U.S. SENATOR

JOHN BARRASSO (R)
U.S. SENATOR

WAYNE JOHNSON (R)
SENATE DIST. 6

BRYAN PEDERSEN (R)
HOUSE DIST. 7

LORI MILLIN (D)
HOUSE DIST. 8

DAVE ZWONITZER (R)
HOUSE DIST. 9

PETE ANDERSON (R)
HOUSE DIST. 10

AMY EDMONDS (R)
HOUSE DIST. 12

KEN ESQUIBEL (D)
HOUSE DIST. 41

DAN ZWONITZER (R)
HOUSE DIST. 43

JAMES BYRD (D)
HOUSE DIST. 44

AMBER ASH
COUNCIL WARD 1

JIMMY VALDEZ
COUNCIL WARD 1

JACK SPIKER
COUNCIL WARD 2

PAT COLLINS
COUNCIL WARD 3

JIM BROWN
COUNCIL WARD 3

DON PIERSON
COUNCIL WARD 3

LCSD1 trustees (4-year)
Jan Stalcup
Bob Farwell
Glenn Garcia

LCSD1 trustees (2-year)
Hank Bailey

LCSD2 trustees (2-year)
Jeff Kirkbride

LCSD2 trustees (4-year)
Esther Davison (Area C)
Sue Anderson (Area D)
Julianne Randall (Area E)
Wynema Thompson (Area E)
Jack Bomhoff (Area F)

LCCC trustees
William "Bill" Dubois
John Kaiser
Tony Mendoza
Greg Thomas

Weather
Record: 70/4
Average: 50/26

Scattered snow showers are possible today as cold air settles over southeast Wyoming

4026

Colorado Lottery
Cash 5: 4, 16, 22, 23, 31

Index
Astrograph B9
Comics B8

Crossword B8
Dear Abby B9
Entertainment .. B7

Money C1
Obituaries ... A4-A5
Sudoku/Jumble . B9

6 85504 00300 1

Faces in the crowd during Barack Obama's election night address, Grant Park, Chicago. PHOTOGRAPH BY DAVID BURNETT

The Sydney Morning Herald

Thursday November 6, 2008

First published 1831 No. 53,390 **$1.30** (inc GST)

'THIS IS OUR TIME'

Americans embrace change and elect first black president

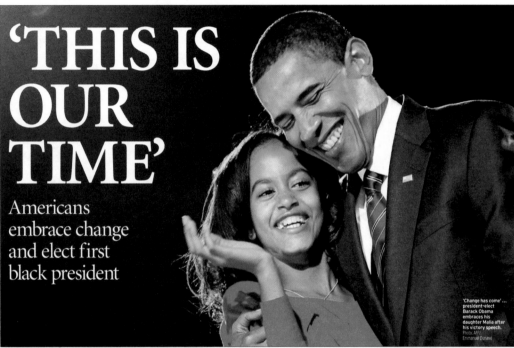

'Change has come' ... president-elect Barack Obama embraces his daughter Malia after his victory speech. Photo: AFP/Emmanuel Dunand

Fairytale unfolds in no-fly zone

YES, he could. What impossibly strange confluence of circumstance led to this moment, when a junior senator from Illinois, a man with a spindly public record leavened with a gift for oratory from God, stood in front of a quarter of a million hysterical people in his own home town and claimed his country's highest honour?

Something weird and magical hastened Barack Obama along this path.

That something bore him through the primaries, which at first he seemed comfortably destined to lose.

It gave him a hair's-breadth opportunity as the Democratic candidate, created between a desperately unpopular incumbent president and a nation at a genuine loss as to what should be done about its crumbling fortunes.

And it rendered him free enough of the past to escape recrimination, but full enough of the future to inspire blind faith.

Perhaps it was even responsible for suspending Chicago's standard November chill and making the post-election evening in the Windy City so unseasonably balmy the locals could barely believe it.

Bill Clinton, in unhappier times, said of Obama's campaign that it was "the biggest fairytale I've ever seen".

How will it translate into reality? It's impossible to say.

There aren't any aerial images of events in Grant Park.

We may never see what that gathering looked like from the air, because downtown Chicago was a no-fly zone all night.

Apart, that is, from the Secret Service choppers.

They loitered fretfully overhead as the 75,000 lucky ticketholders, freshly vetted by security, bolted down the slopes into the best positions like Christmas sales shoppers.

Their spotlights combed and recombed the park as - around at the media entrance – news crews wearily dismantled their cameras and laid the pieces out in rows on Continued Page 12

THE president-elect of the United States, Barack Obama, pledged to unite the nation across racial and partisan divides and to show the rest of the world that "America can change" as he made history by becoming its first African-American leader.

Before a huge and emotional crowd in Grant Park, Chicago and the streets beyond, the 47-year-old first-time Democratic senator from Illinois acknowledged the historic nature of his victory yesterday, Sydney time.

He also seized the mandate he had received to take America in a different direction, both economically and in its dealings with the rest of the world, and so to leave the Bush era behind.

"We are and always will be the

ANNE DAVIES IN CHICAGO

United States of America," he said. "It's been a long time coming, but tonight, because of what we did on this day, in this election, at this defining moment, change has come to America."

Many people in the crowd wept openly as Senator Obama honoured the civil rights activist Martin Luther King, who had forged the path towards racial equality, and such unsung heroes as Ann Nixon Cooper, a 106-year-

old African-American woman who voted on Tuesday and who was born just one generation after the end of slavery in America.

The transformative nature of Senator Obama's victory was acknowledged by his defeated rival, the Republican John McCain, who said Senator Obama had inspired the hopes of millions of Americans who had once wrongly believed that they had little at stake in the election of an American president.

"We both recognise that, though we have come a long way from the old injustices that once stained our nation's reputation and denied some Americans the full blessings of American citizenship, the memory of them still had the power to wound," he said.

ELECTORAL COLLEGE VOTES

OBAMA
338

McCAIN
163

Undecided: 37
Source: CNN.com

A NEW DAWN

In Australia, the Obama win will do a lot to sweep away the negativity and cynicism towards the United States that has built up during the Bush-Cheney years.
Editorial – Page 18

Even as Senator Obama delivered his victory speech, he warned that the climb for America "will be steep".

Americans face huge challenges, including two wars, a planet in peril and the worst financial crisis in a century, he said.

But he also told the American

people: "This is our moment. This is our time."

It was time "to put our people back to work", he said: "And open doors of opportunity for our kids; to restore prosperity and promote the cause of peace; to reclaim the American dream and reaffirm that fundamental truth that out of many, we are one; that

while we breathe, we hope; and where we are met with cynicism and doubt and those who tell us that we can't, we will respond with that timeless creed that sums up the spirit of a people: Yes, we can."

Hundreds of thousands of people in Grant Park echoed the campaign chant, "Yes, we can".

Addressing the rest of the world, Senator Obama promised that America would defeat those who threatened it but would help countries who pursued peace.

He said America would return to what it truly stands for: "democracy, liberty, opportunity and unyielding hope".

At home Senator Obama will now hold the best chance of delivering on his pledges since Bill

Clinton in the early years of his presidency because the Democrats control the White House, the Senate and the House of Representatives.

Top of his agenda will be expanding health care to cover the 47 million uninsured, reviving the economy, making the tax system fairer by giving middle-class Americans a tax cut, and working with the world towards a solution to climate change.

He is also likely to get the opportunity to reshape the Supreme Court with two appointments during his first term, which would tip the balance away from conservative justices.

Senator Obama's win was emphatic. Even before the polls Continued Page 12

WEATHER
Details – Page 28

● **Sydney city** fine 15°-28°
 Tomorrow chance shower 16°-24°
● **Liverpool** fine 11°-31°
 Tomorrow chance shower 12°-29°
● **Penrith** fine 13°-31°
 Tomorrow chance shower 12°-29°
● **Wollongong** fine 15°-25°
 Tomorrow chance shower 14°-22°

ISSN 0312-6315

9 770312 631049

Bye-bye billions: Swan stares into abyss

Phillip Coorey
Chief Political Correspondent

THE Federal Government has scrapped plans to streamline the income tax system and can no longer guarantee a host of post-election spending promises after revealing the global financial crisis will smash a $40 billion hole in the budget over four years.

With the midyear budget review forecasting a revenue slump, slashed surpluses and rising unemployment, the Treasurer,

BANKS CRY POOR

All four of the big banks have refused to pass on the full 0.75 percentage point cut to official interest rates. Page 9
Economists say the Treasury is being too optimistic. Page 8

Wayne Swan, said the only promise the Government could guarantee was next year's increased payments for pensioners.

Beyond that, spending on Labor core policy areas such as infrastructure, increased payments to the states for health, education and other services, and funding recommendations stemming from a swag of policy reviews, were at the mercy of unfolding global financial conditions.

"There's no point in trying to sugar-coat these figures. The global financial crisis has smashed a $40 billion hole in the budget," Mr Swan said. "There are difficult decisions to be made.

"We've got to go back and have a look at everything. We are going to have to cut our cloth to suit the circumstances."

The midyear budget review was the first detailed assessment by Treasury of the impact of the global financial crisis on the Australian economy.

In rosier-than-expected forecasts, Treasury predicted Australia would avoid a recession as growth for this financial year slipped from the 2.75 per cent forecast in the May budget to

2 per cent. The $10.4 billion spending the Government unveiled last month is worth between 0.5 and 1 percentage points of that growth figure.

Next financial year, growth is forecast to increase to 2.25 per cent; the original estimate was 3 per cent.

"This is slower growth, but it's solid growth given the international circumstances," Mr Swan said.

The surplus for this financial Continued Page 8

India rejects ban

Ricky Ponting fears India will name the banned batsman Gautam Gambhir (pictured) for the fourth Test in Nagpur today, and called on Cricket Australia to stand up to the powerful Indian board that has pushed cricket to the brink of a new crisis by refusing to accept the batsman's one-match suspension for elbowing Shane Watson. Sport – Page 42

CityRail damned as trains feel the strain

Sydney's ageing trains will not be replaced fast enough to cater for unprecedented demand, a scathing report by the NSW Auditor-General says, even though one in four carriages breaks down every month. Page 3

O GLOBO

IRINEU MARINHO (1876-1925) RIO DE JANEIRO, QUARTA-FEIRA, 5 DE NOVEMBRO DE 2008 • ANO LXXXIV • Nº 27.484 ROBERTO MARINHO (1904-2003)

ELEIÇÕES AMERICANAS

Presidente Barack Hussein Obama

Em votação histórica, EUA elegem o primeiro presidente negro, apenas 44 anos após o fim da segregação racial

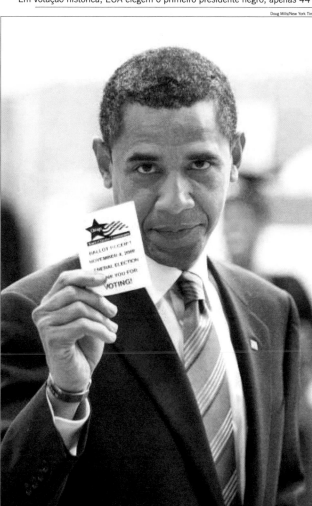

Doug Mills/New York Times

OBAMA, APÓS VOTAR EM CHICAGO: projeções indicavam que o democrata fora eleito ontem como o primeiro presidente negro dos EUA

● O senador democrata Barack Hussein Obama, de 47 anos, rompeu uma barreira histórica, ao tornar-se o primeiro negro a conquistar a Presidência dos Estados Unidos. Segundo a CNN e a Fox News, com 34 estados apurados mais o Distrito de Colúmbia, ele obteria 220 votos no Colégio Eleitoral, além dos 55 da Califórnia, superando assim os 270 necessários. A chegada de Obama à Casa Branca consagra a idéia do sonho americano e ocorre apenas 44 anos depois da assinatura do ato que proibiu a segregação racial no país pelo então presidente Lyndon Johnson. Em sua incansável campanha de 21 meses, Obama superou obstáculos como a acirrada disputa nas primárias com Hillary Clinton e ataques de republicanos que o tacharam de socialista, muçulmano e até terrorista. Filho de pai negro e queniano e de mãe branca e americana, Obama é cristão e prega a união e a superação de divisões partidárias entre democratas e republicanos e uma coalizão multirracial. Nenhum presidente da era moderna chegou ao poder sem ter sido testado, como Obama, que só ocupou cargos no Legislativo. Ele herdará um país com prestígio arruinado no mundo, numa profunda crise econômica e com duas guerras em andamento, resultado da desastrada gestão de George W. Bush. Em contraponto à impopularidade do atual presidente, o carisma de Obama o tornou uma celebridade nos EUA e no mundo. Atraídos pela possibilidade de elegê-lo, milhões de americanos esperaram ontem até cinco horas nas filas para votar em grande parte dos estados americanos, informam JOSÉ MEIRELLES PASSOS e MARÍLIA MARTINS, correspondentes nos EUA, e HELENA CELESTINO, enviada especial ao país **Páginas 28 a 33**

Internet e tecnologia revolucionam campanha	Filas se formaram para a celebração em Chicago
No Quênia, família faz uma festa antecipada	Os voluntários negros da eleição na Flórida

CHICO

— Tadinho do Schwarzenegger...

Conta de luz sobe em média 4,7%

● A partir de sexta-feira, a conta de luz da Light vai subir, em média, 4,7%. Os 3,5 milhões de consumidores residenciais da empresa vão arcar com alta de 3,29%. As indústrias vão pagar mais, até 7,4%. O aumento foi autorizado por causa da alta do dólar, que reajusta os valores da energia comprada em Itaipu. **Página 27**

Itaú Unibanco quer crescer no México e no Chile

Alvo serão clientes com fortunas acima de US$ 5 milhões

● O novo megabanco brasileiro formado pela fusão de Itaú e Unibanco já tem planos para crescer no exterior, principalmente na América Latina, e brigar com os concorrentes Santander, HSBC e Citibank. Os primeiros mercados que estão sendo cobiçados são México, Chile e Colômbia. Um dos principais objetivos é atuar no mercado de clientes de altíssima renda, com fortunas de mais de US$ 5 milhões. Pelas contas feitas por um executivo, a Itaúsa (holding que reúne os membros das famílias Setubal e Villela, donas do Itaú) ficará com 69,9% de todas as ações ordinárias (com direito a voto) do novo banco, enquanto a Unibanco Holding (da família Moreira Salles, do Unibanco) terá cerca de 30%. **Páginas 19 e 20**

Número de vans no Rio pode aumentar

● O novo responsável pelos transportes na cidade, Alexandre Sansão, admitiu ontem que as vans podem crescer e até ganhar cartão eletrônico. **Página 11**

SEGUNDO CADERNO

O diretor inglês Alan Parker fala de duas paixões: cinema e futebol brasileiro.

Guarda vai trabalhar até mais tarde

● Futuro secretário da Ordem Pública, Rodrigo Bethlem anunciou que a Guarda Municipal ficará na rua após as 18h para combater pequenos delitos. **Página 12**

CARRO*etc*

Um passeio ao volante do novo Fit. Modelo da Honda ganhou espaço e potência.

2ª Edição Metropolitana • Preço deste exemplar no Estado do Rio de Janeiro • **R$ 2,00** • Circulam com esta edição: Classificados, Segundo Caderno, Carro Etc: 110 páginas

THE GLOBE AND MAIL

CANADA'S NATIONAL NEWSPAPER

THE ROAD TO THE WHITE HOUSE

Yes he can Massive turnout delivers the most votes ever cast for a U.S. presidential candidate

Yes he can Key battlegrounds switch from red to blue, including Florida, Iowa, Ohio and Virginia

Yes he can Democrats expand their majority in the House and cement their grip on the Senate

Obama overcomes

Barack Obama takes the stage in Chicago last night with his wife, Michelle, and daughters, Malia and Sasha. 'Tonight,' the president-elect declared, 'change has come to America.' JOE RAEDLE/GETTY IMAGES

BY PAUL KORING CHICAGO

Americans overwhelmingly chose Barack Obama as their next president last night, sending the first African-American to the Oval Office in a historic election victory that also gave Democrats commanding control of Congress.

Mr. Obama, 47, defeated Republican Senator John McCain, 72, in a landslide triumph, winning more than 335 of the 538 Electoral College votes, in striking contrast to the wafer-thin victories that sent George W. Bush to Washington in 2000 and again four years later.

A tumultuous ovation greeted Mr. Obama and his family as the president-elect emerged to deliver a victory speech to a massive throng gathered in Grant Park on the Chicago lakefront.

"It's been a long time coming, but tonight because of what we did on this day in this election at this defining moment, change has come to America," he said.

He underscored the enormity of the challenge facing the nation. It was, he said, "the greatest of a lifetime ... with two wars, a planet in peril, the worst financial crisis in a century."

Mr. McCain was quick to concede defeat. "We have come to the end of a long journey," he told a crowd of hundreds of supporters beneath palm trees in Phoenix. "The American people have spoken and they have spoken clearly," he said, and paid tribute to his opponent for inspiring "hope in so many millions of Americans."

U.S. President George W. Bush called Mr. Obama to congratulate him.

In his speech, Mr. Obama also issued a grim threat to America's enemies and a promise to the rest of the world. "Our destiny is shared, and a new dawn of American leadership is at hand," he said, but warned "those who would tear the world down ... we will defeat you."

In record numbers, Americans, including an unprecedented number of young voters, turned out and voted. They opted for the youthful, charismatic Mr. Obama and his vague promises of sweeping "change."

His improbable win capped a remarkable two-year political odyssey; from inexperienced first-term Illinois senator and distant long shot into the most powerful person on the planet. In doing so, Mr. Obama not only ended eight years of Republican rule in the White House, he also wrenched loose the Clintons' supposedly iron grasp on the Democratic Party and – perhaps most impressively – dramatically proved the naysayers wrong by winning the votes of tens of millions of ordinary white voters.

The son of a black father from Kenya and a white mother from Kansas, Mr. Obama was raised in Indonesia and, later, in Hawaii. His maternal grandmother died only two days before he achieved what no other mixed-race American has ever done.

In Chicago, the swelling crowd, estimated at more than 100,000 – old and young, black and white – filled the vast lakeside park on a summer-like warm evening.

›› SEE 'ELECTION' PAGE 21
EDITORIAL, PAGE 22 ›

ELECTORAL COLLEGE

OBAMA	McCAIN
338	**159**

POPULAR VOTE

OBAMA	McCAIN
53%	**47**%

OBAMA'S COALITION

National support, according to exit polls, among the following groups:

BLACK
96%

YOUNG
66%

LOW-INCOME
60%

WOMEN
55%

RESULTS AS OF 1:45 A.M. (ET),
WITH 82% OF POLLS REPORTING

THE VIEW FROM CHICAGO

A dawn to savour, but a tough tomorrow

JOHN IBBITSON
jibbitson@globeandmail.com

CHICAGO

Barack Obama's convincing victory has redefined a fractured, troubled America. There have been few nights in the annals of this republic to equal the one we are waking from. The first true democracy, which survived its revolution and its civil war, defeated the dictators and reached the moon, last night elected a black president. Suddenly, "historic" seems too small a word.

Historic, also, are the challenges facing the man who will be the 44th president of the United States. The economy teeters on the abyss; foes and competitors test the restless giant on every front. And rarely has a president come to office with so little experience in rising to such challenges.

Yet Mr. Obama confronts this grim agenda with a powerful weapon not available to any of his recent predecessors: While previous presidential elections have revealed the cultural fissures that plagued America, last night was an act of union. The defining question of the coming years is whether he can hold that union together.

The president-elect harbours no doubt that he is the harbinger of yet another American renaissance.

"To all those who have wondered if America's beacon still burns as bright," he forewarned at his acceptance speech before an enthralled throng at Grant Park, "tonight we proved once more that the true strength of our nation comes not from the might of our arms or the scale of our wealth, but from the enduring power of our ideals: democracy, liberty, opportunity, and unyielding hope."

Mr. Obama's victory spanned the nation. He won in the grim cities of the decaying industrial Midwest, and the cockpit of segregation, Virginia. He owned the farm fields of Iowa and the desert and peaks of New Mexico.

He united the Atlantic with the Pacific with the Great Lakes with the Mississippi with the Gulf. He united passionately enthused African Americans with grudgingly accepting working-class whites.

›› SEE 'IBBITSON' PAGE 20

VOTER TURNOUT

U.S. presidential
election 1960: **63.1%**

Can.
'08
59.1%

135m
VOTERS

Nearly 70 million Americans catapulted Barack Obama to his convincing win, besting George W. Bush's 2004 result of 62 million votes. Mr. Obama won 43 per cent of the white vote and 67 per cent of the hispanic vote, according to exit polls. Turnout was set to be the second-highest of the modern era – with a record 132 million to 135 million people expected to have cast a ballot. PAGE 19 ›

Inside Obama's first 100 days, plus the parties in Chicago and Harlem. PAGES 16-21 ›

Online Globe Roundtable podcast, Globe Salon and John Ibbitson. GLOBEANDMAIL.COM ›

Barack Obama's convincing victory has redefined a fractured, troubled America. There have been few nights in the annals of this republic to equal the one we are waking from. The first true democracy, which survived its revolution and its civil war, defeated the dictators and reached the moon, last night elected a black president. Suddenly, "historic" seems too small a word.

Hong Kong, China

"Obama's American Dream"

www.scmp.com

Paris, France

"Obama and Us"

www.latribune.fr

Forty-five years ago, Martin Luther King had a dream. Now, Barack Obama has finally brought it to life. – *Greg Torode, South China Morning Post*

DIE WELT

Leser-Service: 0800 / 935 85 37 Donnerstag, 6. November 2008 D 1,60 Euro B welt.de

Finanzkrise: Die Last der geschlossenen Fonds Seite 22

Handel: Der Siegeszug des Haustier-Discounters Seite 16

Loriot: Die große Ausstellung zum 85. Geburtstag Seite 29

ZIPPERT *zappt*

Nach Ansicht von Zukunftsforschern wird Religion bald keine Rolle mehr spielen. Die Menschen glauben nicht mehr an Gott, sondern an die Familie. Das ist kein Wunder. Die Macht von Vater und Mutter erlebt jedes Kind am eigenen Leib, während Gott nur sehr selten in Erscheinung tritt, meistens in alten Büchern oder schlecht synchronisierten Filmen. Gott zu belügen oder zu hintergehen zieht kaum jemals eine Strafe nach sich. Eine verheimlichte Fünf in Mathe bringt kirchlich gesehen ein Jahr Fegefeuer, das aber durch eine Drei in Religion oder Latein wieder ausgeglichen werden kann. In der Familie drohen dagegen Taschengeld- und Liebesentzug sowie Stubenarrest. Wohlverhalten wie eine Zwei in Mathe bringt dagegen oft direkte Vorteile wie Sonderzahlungen und Sachprämien. An Weihnachten, wenn beide Religionen direkt aufeinanderprallen, erweist sich die Familie als überlegen. Die wunderbare Nahrungsvermehrung findet vor den Augen der Kinder statt, genauso wie eine reichliche Bescherung. Und wenn der Vater alt wird, kann das Kind ihn in ein Heim abschieben und selbst Gott werden. Eine Möglichkeit, die die Kirche nicht bietet.

Politik
Medwedjew droht Nato mit Raketen

Russland will wegen des geplanten US-Raketenabwehrschilds Kurzstreckenraketen in Königsberg (Kaliningrad) aufstellen. Das verkündete der Präsident in seiner ersten Rede zur Lage der Nation. Seiten 8, 10

Wirtschaft
Siemens erwartet Milliarden-Strafe

Für den Schlussstrich unter den Schmiergeldskandal rechnet der Konzern mit einer Strafe von einer Milliarde Euro. Seite 15

Sport
Bremen sucht neues Personal

Erschrocken von 0:3 gegen Athen, will Werders Manager Allofs schnellstens einige Spieler ersetzen. Seite 28

Feuilleton
„Schimanski hat mich geprägt"

Die ARD widmet dem „Tatort" heute eine Ratesendung. Einer der Kandidaten ist „Kommissar" Axel Prahl. Die WELT sprach mit dem Ermittler für Münster. Seite 29

Aus aller Welt
Ursache für Buskatastrophe unklar

Nach dem schrecklichen Busunglück auf der A 2 mit 20 Toten rätseln Experten über die Brandursache. Das Feuer begann offenbar in der Bordtoilette. Seite 32

Börsen
Obama-Euphorie bleibt aus

Die von vielen Anlegern erwartete Obama-Rallye an den Märkten fand nicht statt. Der Dax erlitt zum Schluss zwar leicht, blieb aber in der Verlustzone. Seite 19

DAX	EURO	DOW
16.45 Uhr	EZB-Kurs	11.45 Uhr NY
5238,36 Punkte	1,2870 US-$	9529,07 Punkte
-0,75%	**+0,39%**	**-1,00%**

WELT ONLINE

So lief Bayern Münchens Champions-League-Spiel beim AC Florenz:
welt.de/sport

Obama schreibt Geschichte

Der erste farbige Präsident beschwört Amerikas Traum – und spricht von harten Zeiten

WASHINGTON – 143 Jahre nach Abschaffung der Sklaverei in den USA wird erstmals ein Farbiger ins Weiße Haus einziehen. Mit seiner Botschaft des Wandels hat der 47-jährige Senator Barack Obama aus Illinois die Amerikaner überzeugt, ihn zum 44. Präsidenten zu wählen. Zusammen mit dem designierten Vizepräsidenten Joe Biden wird Obama am 20. Januar 2009 in Washington den Amtseid ablegen. Dann endet auch die achtjährige Regierungszeit des Republikaners George W. Bush.

„Change has come to America" (Der Wandel ist in Amerika angekommen), sagte der Wahlsieger in einer ersten Rede vor mehr als 100 000 Menschen in seiner Heimatstadt Chicago und bekräftigte: „Wenn es da draußen irgendjemand gibt, der noch zweifelt, dass Amerika ein Ort ist, wo alles möglich ist, der sich noch fragt, ob der Traum unserer Gründer heute lebendig ist, der Fragen zur Kraft unserer Demokratie aufwirft, dann hat er heute eine Antwort bekommen." Zugleich sei er sich der Herausforderungen klar, die vor seiner Präsidentschaft liegen: „Zwei Kriege, ein Planet in höchster Gefahr, die schwerste Finanzkrise in einem Jahrhundert."

Die Wahl des Sohns eines schwarzen Kenianers und einer Weißen aus Kansas ist ein bemerkenswerter Wendepunkt in der Geschichte eines Landes, das noch vor wenigen Jahrzehnten vielen schwarzen Amerikanern das Wahlrecht verweigerte. Diese historische Dimension erkannten auch Obamas unterlegener Rivale John McCain und George W. Bush an. Beide Republikaner gratulierten Obama und sicherten ihm „volle Zusammenarbeit" dabei zu, die USA aus den schwierigen Zeiten herauszuführen.

Mit seinem unerwartet deutlichen Sieg hat Barack Obama die politische Landkarte der USA von Grund auf verändert. Er gewann in mindestens 28 US-Staaten, darunter auch in einst sicheren Hochburgen der Republikaner, und sammelte so knapp 350 Wahlmännerstimmen. McCain konnte rund 20 Staaten gewinnen, was ihm etwa 145 Wahlmännerstimmen brachte. Nicht ganz so deutlich fiel das landesweite Stimmenverhältnis aus. Hier erreichte Obama einen Anteil von 52 Prozent, McCain folgte mit 46 Prozent. Dadurch kann sich der neue Präsident auf eine komfortable Mehrheit in beiden Häusern des Kongresses stützen. Die Demokraten gewannen die absolute Mehrheit im Senat und bauten ihren Vorsprung im Repräsentantenhaus weiter aus. Bemerkenswert ist auch die Wahlbeteiligung: Der

Die Umarmung mit „dem Fels unserer Familie, der Liebe meines Lebens, der nächsten First Lady der Nation, Michelle Obama"

Website RealClearPolitics zufolge war diese so hoch wie seit 100 Jahren nicht mehr und lag damit höher als bei der Wahl des Demokraten John F. Kennedy zum US-Präsidenten im Jahr 1960.

Bundeskanzlerin Angela Merkel setzt auf enge Zusammenarbeit mit den künftigen US-Präsidenten bei bisher strittigen Themen wie Klimaschutz und Finanzreform. Sie gratulierte Obama zu seinem „historischen Sieg" bei der Präsidentschaftswahl und lud ihn nach Deutschland ein. Bundespräsident Horst Köhler äußerte die Hoffnung auf eine „kooperative Weltpolitik" der USA. DW

Amerika hat gewählt

WELT ONLINE

Das große Dossier zum teuersten Wahlkampf der Geschichte: welt.de/us-wahl

Kommentar

Barack Obama und das amerikanische Wunder

Von Thomas Schmid

Die Vereinigten Staaten sind das Land der Freiheit. In Abstoßung von den engen Obrigkeitsstaaten Europas sind sie entstanden und begriffen sich von Anfang an als Hort universeller Werte. Das macht ihre bis heute tragende Stärke und das Selbstbewusstsein ihrer Bürger aus. Amerika wurde zum Schmelztiegel, zu dem großen Integrationsunternehmen, das aus lauter Fremden Bürger macht, die sich vor Gleich zu Gleich begegnen: E pluribus unum, aus Vielen Eins. Protestanten, Katholiken, Hindus, Muslime, Engländer, Deutsche, Italiener, Iren, Polen, Russen, Chinesen: Alle hatten die Chance, in der Mitte der amerikanischen Gesellschaft anzukommen. Nur die Schwarzen nicht.

Im Umgang mit ihnen ist Amerika sich selbst nicht gerecht geworden. Das gesellschaftliche Elend der Schwarzen hat das Land der Freiheit beschädigt, entstellt, verwundet. Die Schwarzen gehörten nie wirklich dazu, die Mitte war ihnen verwehrt. Und lange sah es so aus, als würden sie selbst nicht die Kraft aufbringen, sich aus dieser Stigmatisierung – aus der im Zug der Jahrhunderte auch Selbststigmatisierung geworden war – zu befreien.

Dass das nicht das Ende des amerikanischen Liedes ist: Das hat der Wahlsieg Barack Obamas wunderbar bewiesen. Der kommende Präsident hat sich in seinem fast zwei Jahre dauernden Wahlkampf zwar nie auf seine Herkunft berufen. Und doch ist allein das Faktum, dass ein Schwarzer dies Amt erobert hat, von ungeheurer historischer Bedeutung. John McCain, der Verlierer, besaß im Moment der Niederlage die Größe, genau dies zu würdigen.

Ein schwarzer Präsident: Von der bloßen Tatsache könnte – nicht muss – ein Impuls zur inneren Befriedung der USA ausgehen. Barack Obama hat in der Wahlnacht gezeigt, dass er es gut versteht, auch in die Rolle des strengen, fürsorglichen Vaters zu schlüpfen. Davon mag eine Überzeugungskraft auf die große Zahl jener ausgehen, in denen ein Rest des alten Rassenvorbehalts noch brodelt oder glimmt, denen aber die amerikanische Gleichheits- und Freiheitsmelodie vertraut und lieb ist. Wer in der Wahlnacht den vor Freude weinenden ehemaligen schwarzen Präsidentschaftskandidaten Jesse Jackson sah, der weiß, was da geschehen ist.

Barack Obama ist bisher sehr wolkig geblieben. Auch das hat viele Europäer veranlasst, in ihm einen Gleichgesinnten zu sehen: einer wie wir. Hinter dieser Eingemeindung des kommenden Präsidenten in die Diskurs-, Empfindungs- und Friedensgemeinschaft des Alten Kontinents verbirgt sich ein oft beschriebenes Missverständnis, das schon bald offenkundig werden wird. Obama ist Amerikaner, und die Interessen Amerikas vertreten und dabei George W. Bush sehr viel näherstehen als – sagen wir – Heidemarie Wieczorek-Zeul. Und gerade weil Europa ihn so mag, wird es sehr verwundert sein, wenn der neue Herr Obama, ganz Multilateralist, die Europäer zu mehr Engagement, auch militärisch, da und dort in der Welt auffordern wird.

Und doch ist die Begeisterung, die Obama in fast allen Teilen der Welt entgegenschlägt, auch ein Pfund. Amerika, das Europa und Deutschland mindestens dreimal aus schwerer Not geholfen hat, ist nicht beliebt und wird verkannt. Dass Obama zum Präsidenten gewählt worden ist, könnte helfen, darum sein mag die Augen zu öffnen, die beharrlich Amerikas innere Größe und Attraktivität übersehen haben. Mit Obama als Präsident wird sich der Antiamerikanismus neu sortieren müssen.

Zur bewundernswerten Kühnheit Barack Obamas gehört auch eine Portion Anmaßung. Wandel, Erneuerung, Reform und gute Gesellschaft: Das ist in den Staaten des Westens ein Kampf, der seit eh und je geführt wird – erfolgreich, verlustreich. Auch wenn er wahlkämpfend so tat: Obama hat kein Monopol auf change. Denn der Wandel ist das Bewegungsgesetz freier Gesellschaften. Die Party, als die der kommende Präsident seine Kampagne inszeniert hat, ist vorbei. Der Ernst, den es in der Wahlnacht zeigte, wird der Normalfall werden. Obama ist als Inkarnation eines Gefühls gewählt worden. Was er wirklich will – wir wissen es nicht. Er muss nun Träume in Regierungsprosa übersetzen. Wird der ihn ins Weiße Haus trug, könnte der mächtigste Mann der Welt auch international ein Erneuerer werden. Er hat eine Chance, die kaum ein Präsident vor ihm hatte.

thomas.schmid@welt.de

Kein Bahn-Börsengang mehr vor Bundestagswahl 2009

BERLIN – Die Deutsche Bahn wird wohl nicht mehr in dieser Legislaturperiode an die Börse gehen. Es wäre „nicht verantwortlich", den Börsengang zu einem Zeitpunkt in Gang zu setzen, zu dem das Marktumfeld ungünstig sei, sagte Bundesfinanzminister Peer Steinbrück (SPD). Deshalb seien im Bundeshaushalt 2009 auch keine Mittel aus dem geplanten Börsengang eingeplant. Regierungssprecher Ulrich Wilhelm betonte, eine vernünftige Erlössituation sei auf absehbare Zeit nicht zu erkennen und man wolle hier „kein Vermögen verschleudern". Bahn-Aufsichtsratschef Werner Müller äußerte Verständnis für die vorläufige Absage des Börsengangs und kündigte neue Gespräche nach der Bundestagswahl 2009 an.

Im Streit über Bonuszahlungen für Bahn-Manager beim Börsengang haben sich Steinbrück und Wirtschaftsminister Michael Glos (CSU) hinter Verkehrsminister Wolfgang Tiefensee (SPD) gestellt. „Wenn es zum Börsengang kommt, wird es eine solche Regelung nicht geben", sagte Steinbrück. Glos bezeichnete die Prämie als „relativ geschmacklos". Tiefensee sieht sich damit bestätigt. DW

Seite 10: Kommentar
Seite 13: Bericht

Steinbrück rechnet mit weniger Steuereinnahmen für den Bund

BERLIN – Die Bundesregierung muss im nächsten Jahr mit 2,2 Milliarden Euro weniger Steuereinnahmen auskommen als noch im Mai gedacht. Dies ergab am Mittwoch eine neue Steuerschätzung. Die Finanz- und Wirtschaftskrise schlägt nach der neuen Prognose der Steuerschätzer jedoch weniger stark auf die Staatskassen durch als befürchtet.

In diesem und im nächsten Jahr werden Mehreinnahmen für Bund, Länder und Gemeinden von rund 8,3 Milliarden Euro erwartet als bei der bisherigen Annahmen erwartet. Der Großteil davon entfällt mit 7,4 Milliarden Euro allerdings auf dieses Jahr mit einer gut laufenden Konjunktur. Insbesondere die Kommunen profitieren von den Mehreinnahmen.

Die neue Prognose der Steuerschätzer könnte aber bald überholt sein. Denn das Milliarden-Konjunkturpaket der Bundesregierung, das gestern beschlossen wurde und das zusätzliche Steuerausfälle zur Folge haben wird und die öffentlichen Haushalte in den nächsten vier Jahren mit insgesamt 23 Milliarden Euro belastet, ist bei der Vorhersage noch nicht berücksichtigt. DW

Seite 13: Berichte, Kommentar

Axel Springer 24-Stunden-Service:
01805 6 300 30 (14ct/min aus dt. Festnetz)

welt.de
mobil.welt.de
E-Mail: redaktion@welt.de

Kostenloses Probeabo:
Tel. 0800 / 935 85 37
Fax 0800 / 935 87 37

DIE WELT, Axel-Springer-Straße 65, 10888 Berlin, Redaktion: Brieffach 2410
Täglich weltweit in über 130 Ländern verbreitet. Pflichtblatt an allen deutschen Wertpapierbörsen.
Redaktion: Tel. 030/25910, Fax 030/25917606, E-Mail: redaktion@welt.de; Anzeigen: 030/585890, Fax 030/585891, E-Mail: anzeigen@welt.de
Leserservice: DIE WELT, Briefach 2440, 10867 Berlin, Tel. 0800/9 35 85 37, Fax 0800/9 35 87 37, E-Mail: leser@welt.de

ISSN 0173-8437 261-45 ZKZ 7109

B 2,30 € / 90 cdv / 22 dkr / P 2,50 € (Cont.) / F 2,70 € / 735 FT / GR 3,00 € / CYP 3,20 € / NL 2,30 € / E/C. 2,70 € / 24 KN / 1,270 € / L 2,30 € / 38 skr /
E 2,50 € / A 2,30 € / 2,40 GBP / FIN 3,20 € / IRL 3,20 € / 13 PLN / 42 SEK / 4,10 sfr / SIT 640 / 2,70 / SK 96,50 SKK / 3,20 € / 7,00 YTL / TD 4,70 / MLT 3,20 €

In a country long divided, Obama
had a singular appeal: He is biracial
and a graduate of top universities;
a stirring speaker who plays basketball
and quotes the theologian Reinhold
Niebuhr; a politician who grooves
to the rapper Jay-Z and loves the
lyricism of the cellist Yo-Yo Ma;
a man of remarkable control and
startling boldness.

INTERNATIONAL
Herald Tribune
THE GLOBAL EDITION OF THE NEW YORK TIMES

THURSDAY, NOVEMBER 6, 2008

iht.com

Big victory, bigger challenges

U.S. voters leap beyond long, bitter racial divide

By Rachel L. Swarns

WASHINGTON: Even during the darkest hours of his presidential campaign, Barack Obama held on to his improbable, unshakable conviction that America was ready to step across the color line.

On Tuesday, America leaped. Millions of voters — white and black, Hispanic and Asian, biracial and multiracial — put their faith and the future of their country into the hands of a 47-year-old son of a black father and a white mother, a man who made history both because of his race and in spite of it.

Black Americans wept and danced in the streets, declaring that a once-reluctant nation had finally lived up to its democratic promise. White voters marveled at what they had wrought in turning a page on the country's bitter racial history. Strangers of all colors exulted in small towns and big cities.

"It brought tears to my eyes to see the lines," said Bob Haskins, a black maintenance worker at an Atlanta church where scores of college students voted. "For these young folks, this is a calling. Everything that Martin Luther King talked about is coming true today."

Tobey Benas, a retired teacher who voted for Obama in Chicago, also savored the moment: "I can't believe how far we've come," said Benas, who is white. "This goes very deep for me."

In a country long divided, Obama had a singular appeal: He is biracial and a graduate of top universities; a stirring speaker who plays basketball and quotes the theologian Reinhold Niebuhr; a politician who grooves to the rapper Jay-Z and loves the lyricism of the cellist Yo-Yo Ma; a man of remarkable control and startling boldness.

He was also something completely new: a black presidential aspirant without a race-based agenda. His message of unity and his promise of a new way of thinking seemed to inspire — or least offer some reassurance — to a country staggered by two wars, a convulsing economy and sometimes bewildering global change.

Americans, of course, have not suddenly become colorblind or forgotten old wounds. But millions of white citizens clearly decided Obama was preferable to the alternative, even if some might have had to swallow hard when they walked into the voting booth.

"In difficult economic times, people find the price of prejudice is just a little bit too high," said Governor Michael Easley of North Carolina, a white Democrat. "They're saying, 'We don't care what your race is. If you can make things better, we're for you.'"

Easley said he knew big changes were coming when he passed a pickup on the

RACE, Continued on Page 9

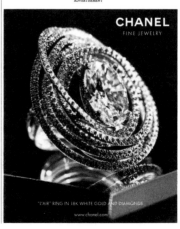

Barack Obama took the stage to address his supporters at an election night victory rally in Grant Park in Chicago.
Damon Winter/The New York Times

From Day One, crises await Obama on all fronts

By Peter Baker

No president since before Barack Obama was born has ascended to the Oval Office confronted by the accumulation of seismic challenges awaiting him. Historians grasping for parallels point to Abraham Lincoln taking office as the nation was collapsing into Civil War, or Franklin D. Roosevelt arriving in Washington in the throes of the Great Depression.

The task facing the first African-American to capture the presidency perhaps does not rise to those levels, but that these are the comparisons most often cited sobers even Democrats rejoicing at their return to power. On the shoulders of a 47-year-old first-term senator, with the power of inspiration yet no real executive experience, now falls the responsibility of prosecuting two wars, protecting his nation from terrorist threat and stitching back together a shredded economy.

Within hours of his victory, Russia and Afghanistan provided glimpses of the weighty challenges ahead. In Moscow, President Dmitri Medvedev, in a speech Wednesday laced with anti-American rhetoric, threatened to station missiles near Poland to counter the U.S. antimissile system to be based there. In Afghanistan, President Hamid Karzai wasted no time in urging Obama to stop the killing of innocents as U.S.-led troops pursue the Taliban as unconfirmed reports said dozens of civilians had been killed in an airstrike. (Pages 2 and 4)

In Chicago, Obama largely stayed out of sight the morning after his joyous victory rally in Grant Park, but he began moving to build a new administration to sweep aside eight years of Republican rule.

A close friend and fellow Illinois politician, Representative Rahm Emanuel, was offered the post of White House chief of staff and is widely expected to accept, said Democrats close to the process. Obama also tapped another hard-hitting Clinton veteran, former chief of staff John Podesta, to lead his transition team, along with Valerie Jarrett, a longtime adviser, and Pete Rouse, his Senate chief of staff.

Obama's advisers say they anticipate nominating the secretaries of state and the Treasury by Thanksgiving, on Nov. 27.

Given the issues facing him, Obama has little room to maneuver. "You better damn well do the tough stuff up front, because if you think you can delay the tough decisions and tiptoe past the graveyard, you're in for a lot of trouble. Make the decisions that involve pain and sacrifice up front."

The sweep of Obama's victory and the high turnout — at 136.6 million, or 64.1 percent, the highest rate since 1908 — may help him push through difficult steps. He won at least 349 Electoral College votes, far more than the 270 he needed, and led his party to sharp gains in Congress. (Page 8)

How Obama will lead and what kind of decision maker he will be remains unclear even to many of his supporters. Will he be willing to use his political capital and act boldly, or will he move cautiously and risk being paralyzed by competing demands from within his own party? His performance under the harsh lights of the campaign trail suggests a figure with remarkable coolness and confidence under enormous pressure, yet also one who rarely veers off a methodical path.

While Roosevelt refused to get involved in

OBAMA, Continued on Page 9

POPULAR VOTE

Obama	McCain
52.3%	46.4%

ELECTORAL VOTE

Obama	McCain
349	162

270 needed to win
27 not yet assigned

VOTER TURNOUT **64%**

The highest turnout since 1908 and the first time since Jimmy Carter in 1976 that a Democrat has received more than 50% of the vote.

Voting results as of 1940 GMT.

INSIDE

■ THE OVERVIEW

Barriers shattered in Democrat surge

The election of Barack Hussein Obama as president of the United States swept away the last racial barrier in U.S. politics and amounted to a repudiation of a historically unpopular Republican president: George W. Bush. *Page 8*

■ HOW OBAMA WON

Never wavering from initial plan

The disciplined and nimble Obama team marched through a presidential contest of historic intensity, learning to exploit opponents' weaknesses and making remarkably few errors. The Democratic campaign was, even in the view of many of the rivals that it defeated, almost flawless. *Page 8*

CURRENCIES *New York*

		Previous
Wednesday, 2 p.m.		
€1=	$1.3027	$1.2980
£1=	$1.6049	$1.6044
$1=	¥98.915	¥100.335
$1=	SF1.1591	SF1.1629

Full currency rates | *Page 22*

OIL *New York, Wednesday, 2 p.m.*

Light sweet crude	$66.60	▼ $3.53

STOCK INDEXES *Wednesday*

The Dow 2 p.m.	9,309.80	▼	3.28%
FTSE 100 close	4,530.73	▼	2.34%
Nikkei 225 close	9,521.24	▲	4.46%

IN THIS ISSUE

No 39,085

NEWSSTAND PRICES

France € 2.50

Books	19
Culture & More	25
Health & Science	25
Opinion	14
Business with REUTERS	16-22

AlgeriaDin 175	Réunion.........€ 3.50
Andorra...........€ 2.50	Antilles..........€ 3.60
Cameroon .CFA 2,200	Senegal....CFA 2,200
Gabon.......CFA 2,200	Tunisia......Din 3,000
Ivory Coast..CFA 2,200	

For information on delivery, or to subscribe in France, call toll-free:

00 800 44 48 78 27

or e-mail us at subs@iht.com
or visit subs.iht.com

MORE COVERAGE

■ U.S. CONGRESS

Democrats post gains

Democrats gained five Senate seats but fell short of a filibuster-proof goal of 60. The party also expanded its numbers in the House of Representatives. *Page 10*

■ THE VOTING

Melting pot was pivotal

Barack Obama drew support from a broad range of demographic groups that included majorities of women, African-Americans, Hispanics and younger voters. *Page 6*

■ Instead of congratulations, a warning from Russia. *Page 4*

■ Afghan leader asks president-elect to end civilian strikes. *Page 2*

ONLINE AT IHT.COM

■ Photographs Slide shows depict Americans voting, and reactions of people around the world.

■ Video See McCain's concession speech and Obama's acceptance speech, plus global reaction.

■ Discussions Express your views on the change the results of the election will bring.

Global wonder and relief
But expectations are vast for U.S. victor

By Ethan Bronner

GAZA: From far away, this is how it looks: There is a country out there where tens of millions of white Christians, voting freely, select as their leader a black man of modest origin, the son of a Muslim. There is a place on Earth — call it America — where such a thing happens.

Even where the United States is held in special contempt, like here in this benighted Palestinian coastal strip, the "glorious epic of Barack Obama," as the leftist French editor Jean Daniel calls it, makes America — the idea as much as the actual place — stand again, perhaps only fleetingly, for limitless possibility.

"It allows us all to dream a little," said Oswaldo Calvo, 58, a Venezuelan political activist in Caracas, in a comment echoed to correspondents of The New York Times on four continents in the days leading up to the election.

Tristram Hunt, a British historian, put it this way: Obama "brings the narrative that everyone wants to return to — that America is the land of extraordinary opportunity and possibility, where miracles happen."

But wonder is almost overwhelmed by relief. Obama's election offers most non-Americans a sense that the imperial power capable of doing such good and such harm — a country that, they complain, preached justice but tortured its captives, initiated a disastrous war in Iraq, turned its back on the environment and greedily dragged the world into economic chaos — saw the errors of its ways over the past eight years and shifted course.

REACTION, Continued on Page 9

Residents of Obama, Japan, paying homage to the winner's Hawaiian roots.
Itsuo Inouye/AP

Americans voted their country back into reckoning as the leader of the free world when they elected Barack Obama the 44th President of the US last night in a turnout that set a record.

The Telegraph

44 PAGES CALCUTTA THURSDAY 6 NOVEMBER 2008 Rs2.00 CE www.telegraphindia.com

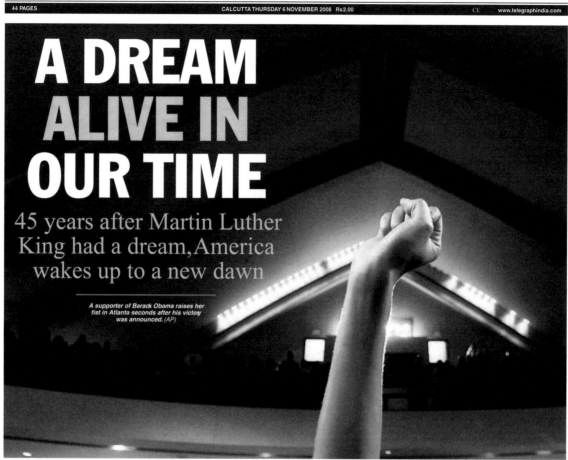

A DREAM ALIVE IN OUR TIME

45 years after Martin Luther King had a dream, America wakes up to a new dawn

A supporter of Barack Obama raises her fist in Atlanta seconds after his victory was announced. (AP)

TTMARKETS

INDEX		CHANGE
BSE SENSEX	10120.01 ▼	511.11
NSE NIFTY	2994.95 ▼	147.15
RS/$	47.46	-0.28
GOLD*	12205	+75

*Calcutta 24ct pure
For complete stocks turn to BUSINESS

INBRIEF

Human baits die on Bengal road

■ Robbers tied six occupants of a Mahindra Bolero to the car in the middle of a highway in Bishnupur to force other vehicles to stop but a truck rammed into the human baits and killed three of them. Two of the killed were brothers. **BENGAL P7**

BR Chopra dead

■ B.R. Chopra, the filmmaker who produced the TV serial *Mahabharat* that mesmerised most of India, died on Wednesday. He was 94. **PAGE 6 & T2**

Crichton passes away

■ Michael Crichton, author of *Jurassic Park*, has died in Los Angeles. He was 66.

❝ Change has come to America ❞
BARACK OBAMA

Obama reaches out to world

K.P. NAYAR

Washington, Nov. 5: Americans voted their country back into reckoning as the leader of the free world when they elected Barack Obama the 44th President of the US last night in a turnout that set a record in 48 years.

With the counting of provisional and absentee ballots still going on across America, 64 per cent of eligible voters cast their votes, braving the elements, long queues and snags at polling stations.

The last time Americans turned out in similar numbers to elect their commander-in-chief was when they voted in John F. Kennedy.

If the percentage is much higher than the figure given at the time going to the press, yesterday's voting statistics could set a record in 100 years for a country that is notorious for its indifference to exercising adult franchise. Obama won at least 349 electoral college votes — 270 such votes are needed to assume the presidency — with two states still too close to call.

The 63 million-plus popular votes polled for Obama, a nearly seven million lead over John McCain, represented a comprehensive rejection of eight years of Republican unilateralism that made the US government an object of re-

Barack Obama at the victory rally in Chicago. (Reuters)

vulsion in virtually every country in the world.

An hour after McCain conceded defeat, Obama sought to assure the world that he would turn his back on policies which have made people around the world lose faith in America and turn against it.

"To all those watching tonight from beyond our shores, from parliaments and palaces to those who are huddled around radios in the forgotten corners of our world — our stories are singular, but our destiny is shared, and a new dawn of American leadership is at hand," the President-elect said in an acceptance speech at midnight before a raucous audience estimated at 200,000 in his home town of Chicago.

"And to all those who have wondered if America's beacon still burns as bright — tonight we proved once more that the true strength of our nation comes not from the might of our arms or the scale of our wealth, but from the enduring power of our ideals: democracy, liberty, opportunity and unyielding hope," Obama said.

Today, with only 76 days left for his swearing-in, Obama immediately set about assembling his presidency, but he made a point of taking his two daughters, 10-year-old Malia and 7-year-old Sasha, to school in the knowledge that he cannot do that regularly any more after January 20.

From tomorrow itself, intelligence officials will begin

to give him top-secret daily briefings and share critical overnight intelligence reports as if he is already in the White House. Obama will also begin a practice of daily briefings to the media on Thursday

Obama is expected to immediately name Illinois Congressman Rahm Emanuel as his White House chief of staff. Emanuel was political and policy adviser to Bill Clinton.

In another move that will bring Clinton's top aides back into the White House, Obama is also expected to name John Podesta, who was Clinton's chief of staff, to head his transition team.

A group of Americans has begun an online petition drive through an open letter to the next President to draft Fareed Zakaria as the next secretary of state. Zakaria is an Indian-born American journalist. It is an effort that is unlikely to go very far in view of his earlier support for the policies of President George W. Bush.

The Democratic Party establishment is said to be pressing for recruiting Senator John Kerry for the job.

The victory sparked celebrations across the US. A few thousand marched to the White House and claimed that the American people had retaken the presidential mast. CNN quoted Secret Service officers as saying that they had never seen anything like it before.

THE DAY YOU WILL WANT TO PRESERVE FOR YOUR GRANDCHILDREN

| **LONG AND HARD VOYAGE** PAGE 2 | **WHAT BUSH AND KARAT SAID** PAGE 3 | **THE MOOD AMONG TECHIES** PAGE 4 | **SPEECH THAT MADE JESSE CRY** PAGE 5 | **AMARTYA SEN SPEAKS** PAGE 6 | **COMMENT** PAGE 8 / **GUEST COLUMNS** PAGES 2 & 4 |

For Love Quotes
SMS DIL to 56569

ভারতে সর্বাধিক প্রচারিত প্রথম শ্রেণির বাংলা দৈনিক

আনন্দবাজার পত্রিকা

10.5% p.a
for 890 days deposit
IDBI BANK

www.anandabazar.com

কলকাতা ২০ কার্তিক ১৪১৫ বৃহস্পতিবার ৬ নভেম্বর ২০০৮ শহর সংস্করণ ৩ টাকা

১২ পাতা CE

প্রেসিডেন্ট (ইলেকটোরাল কলেজ ৫৩৮)			সেনেট (মোট আসন ১০০)		প্রতিনিধিসভা (মোট আসন ৪৩৫)	
৩৪৯		১৬৩	৫৬	৪০	২৫৩	১৭২
ওবামা	জিততে প্রয়োজন ২৭০	ম্যাকেন	ডেমোক্র্যাট	রিপাবলিকান	ডেমোক্র্যাট	রিপাবলিকান

অমীমাংসিত
ডেমোক্র্যাট
রিপাবলিকান

হ্যাঁ, পাল্টালেন ওবামাই

রঙের ভেদাভেদ মুছে দিয়ে ইতিহাসের স্বপ্নপূরণ

দিন বদলের দিন। মহাজয়ের পর জনতাকে অভিনন্দন জানাচ্ছেন বারাক ওবামা, সপরিবার। শিকাগোর গ্রান্ট পার্কে। এ এ পি-র তোলা ছবি

মার্টিন লুথার কিং

আমার একটা স্বপ্ন আছে। এক দিন আমার চার ছেলেমেয়ে এমন এক দেশে বাস করবে, যেখানে গায়ের রং নয়, চরিত্র দেখেই তাদের বিচার করা হবে।
২৮ অগস্ট, ১৯৬৩

বারাক হুসেন ওবামা

অনেক সময় লাগল ঠিকই, কিন্তু আজ, এই নির্বাচনে, এই নির্ণায়ক মুহূর্তে আমরা যা করলাম, তার পরিণামে আমেরিকায় পরিবর্তন এল।
৪ নভেম্বর, ২০০৮

নিজস্ব প্রতিবেদন, ৫ নভেম্বর: আমেরিকায় একটা এসএমএসেস সারা দিন ধরে এ হাত থেকে ও হাতে ঘুরছে। "রোজা (পার্ক) বসেছিলেন বলে মার্টিন (লুথার কিং) হাঁটতে পেরেছিলেন। মার্টিন হাঁটলেন বলে বারাক (ওবামা) ছুটতে পেরেছেন। আর বারাক ছুটছেন বলে আমাদের ছেলেমেয়েরা উড়তে পারবে।"

আমেরিকার প্রথম কৃষ্ণাঙ্গ প্রেসিডেন্ট পদে নিপুল জয় পেয়ে ৪৭ বছরের বারাক ওবামা শুধু নতুন ইতিহাস রচনাই করলেন না, পুরনো ইতিহাসকে নতুন করে মনে করিয়ে দিলেন প্রতি মুহূর্তে। "একটা পরিবর্তনের আগামী অনেক দিন ধরে সৃষ্টি হচ্ছিল। কিন্তু আজ যে নির্ণায়ক মুহূর্তে আমরা এসে দাঁড়ালাম, সেই পরিবর্তন শেষ পর্যন্ত ঘটিয়ে তুলল।"

ওবামা মঞ্চে দিয়েই এই 'ইতিহাস' তৈরি হওয়ার মুহূর্তটাকে সঙ্গী করে নেয় মানুষের ঢল ঝাপিয়ে পড়া জল, চোখের আদরে, টেলিভিশন পর্দায় তখন তুলে ধরা হচ্ছিল জটিল, ঘনঘট আর বিষাদ করতে চাওয়া একটা স্লোগান, 'ইয়েস উই কুড'।

ভিতরের পাতায়

অপেক্ষা করছে কঠিন সময়

ওয়াশিংটন, ৫ নভেম্বর: আব্রাহাম লিঙ্কন, ম্যাডলিন কডলেনে এবং বারাক।

আপনার মত

ওবামার জয় কি এনডিএসএর অবনেতের পথ প্রশস্ত করল?

শাসনবিরোধী হাওয়া খুব জোরে বইছে কি না ৯৮%

পুলিশ এখনও স্পষ্ট নয় ২%

CORRIERE DELLA SERA

Milano, Via Solferino 28
Tel. 02 6339

Fondato nel 1876 • www.corriere.it

Roma, Piazza Venezia 5
Tel. 06 688281

Salari e contratti
La Cgil va avanti da sola: pronti allo sciopero generale
di **Enrico Marro**
a pagina 33

Alta velocità e esercito
Linea dura di Berlusconi: Tav anche con la forza
di **Luca Angelini**
a pagina 25

Concorsi e bilanci
Università, il governo decide di varare il decreto
di **Giulio Benedetti**
a pagina 20

Le elezioni della svolta

Obama: cambierò l'America

L'omaggio del mondo e di McCain al nuovo presidente democratico

UNA SOCIETÀ APERTA

di **ANGELO PANEBIANCO**

Nessuno oggi può sapere che cosa farà il nuovo presidente, che cosa diventeranno gli Stati Uniti nell'era di Barack Obama. Ma tutti, persino i tanti nemici dell'America sparsi per il mondo, sono costretti a riconoscere che la democrazia americana continua ancora oggi a disporre di doti che nessun'altra comunità politica possiede. «Se qualcuno pensava che l'America non fosse il Paese ove tutto è possibile...». Le parole con cui Obama ha iniziato il suo patriottico discorso di ringraziamento alla nazione che lo aveva appena eletto rendono perfettamente il senso di ciò che è accaduto.

Un giovane senatore afro-americano, di poca esperienza politica, con un passato di simpatie radicali e un background da outsider si è dapprima imposto contro un establishment democratico che gli era ostile, sconfiggendo alle primarie un cavallo di razza come Hillary Clinton, e ha poi conquistato la Casa Bianca contro un avversa-

rio di grande valore come John McCain (il cui spessore politico e la cui tempra morale, per inciso, tutti, anche quelli che gli erano ostili, hanno potuto misurare ascoltando il bellissimo discorso con cui ha riconosciuto la vittoria di Obama, e ha invitato i repubblicani a stringersi intorno al nuovo presidente).

È vero in generale che in tempi di crisi le personalità carismatiche hanno più probabilità di affermarsi. E, senza dubbio, la gravissima crisi finanziaria, con i suoi pesantissimi effetti sull'economia americana, ha favorito l'outsider Obama. Il successo del suo stile profetico e l'entusiasmo che ha suscitato in una parte così ampia degli Stati Uniti non sarebbero stati possibili senza il senso di smarrimento e la paura per il futuro che attanagliavano la società americana già prima che (sono passate solo poche settimane) la crisi rivelasse tutta la sua gravità con i fallimenti bancari e il crollo di Wall Street.

CONTINUA A PAGINA 44

I discorsi

IL VINCITORE
«Qui tutto è possibile»
di **BARACK OBAMA**
ALLE PAGINE 8 E 9

LO SCONFITTO
«Ora giusto aiutarlo»
di **JOHN McCAIN**
ALLE PAGINE 14 E 15

Giannelli

Tutti i servizi sull'elezione del 44° presidente degli Stati Uniti DA PAGINA 2 A PAGINA 19

I protagonisti e le storie

IL RACCONTO
Quando era lecito linciare i neri
di **GIAN ANTONIO STELLA**
La lunga storia di schiavitù, dolore torture e morte dei neri americani.
A PAGINA 11

IL REPORTAGE
Alabama, tra i vinti al bar dei bianchi
di **ALDO CAZZULLO**
BIRMINGHAM — Nell'Alabama «bianca»: «Persa di nuovo la guerra civile».
ALLE PAGINE 10 E 11

BARACK E I SUOI
Il padre poligamo e la madre giramondo
di **PAOLO VALENTINO**
CHICAGO — Le origini di Obama, un incrocio che ha cambiato la storia.
A PAGINA 5

LA FIRST LADY
Michelle la dura, astronauta mancata
di **MARIA LAURA RODOTÀ**
SAN FRANCISCO — La donna che ha stupito (e terrorizzato) gli americani.
A PAGINA 6

Da «Jurassic Park» alla serie «E.R.»
Addio a Crichton maestro di thriller e fantascienza
di **ENNIO CARETTO**

È stato l'apostolo del *techno thriller*, il giallo scientifico, e ha fatto la fortuna di George Clooney con lo sceneggiato tv *E.R.* Ha tenuto dotte conferenze come a Milano, dove cercò di smitizzare l'effetto serra.

E' morto lo scrittore Michael Crichton. Aveva 66 anni. A PAGINA 47 Farkas

CONTINUA A PAGINA 47

It was a special day for students
of Obama's former school SDN
Menteng 01, Central Jakarta,
who gathered at the school's hall
to watch the final results pour
in. Several pictures of Obama
during his school years there
were prominently displayed. A
15-minute silence has been held
here every day since Monday
to allow the students to pray for
Obama's victory.

Ex-lawmakers admit to receiving BI money
Page 9

Sangeh: Bali's popular monkey forest preserve
Page 16

Garcia aiming for No. 2 ranking
Page 22

BARRY'S DONE IT!

Douglas Birch and Steven R. Hurst
Associated Press/Washington

American voters broke with the nation's history of racial divisions and overwhelmingly elected Barack Obama as the U.S.'s first black president, turning to an inspiring young Democratic senator to lead a country weary from war, economic turmoil and eight years of Republican rule.

Obama, embracing a message of change, tore up the U.S. political map as he defeated John McCain, the veteran Republican senator who struggled in vain to distance himself from George W. Bush's presidency, which had grown as unpopular at home as it is abroad.

The election of Obama, the son of black man from Kenya and a white woman from Kansas, marked a turning point for a nation haunted by a legacy of slavery and legal segregation of the races.

"If there is anyone out there who still doubts that America is a place where all things are possible; who still wonders if the dream of our founders is alive in our time; who still questions the power of our democracy, tonight is your answer," Obama told a crowd of about 240,000 supporters in Chicago's Grant Park.

"Change has come to America," he said.

Preparations for an Obama presidency were already underway Wednesday. With just 76 days until the inauguration, Obama is expected to move quickly to begin assembling a White House staff and selecting Cabinet nominees.

When Obama takes office Jan. 20 as the 44th U.S. president, he may face more difficult challenges both at home and abroad than any new U.S. president since the Great Depression.

But he will do so with many allies in Congress, as his Democratic Party expanded its majorities in both chambers. And he will take office with broad popular support.

He scored a decisive win in the electoral vote, the state-by-state tally that determines the winner.

Obama needed only 270 votes to claim the presidency, but sailed to victory with 349 to McCain's 147, with three states still too close to call. Voter turnout, still being counted, was expected to shatter records.

Obama's supporters cheered, screamed and waved flags, welcoming his election in a delirious victory celebration in his hometown. Many, including civil rights leader and two-time presidential candidate Jesse Jackson, had tears in their eyes.

In cities around the country, drivers honked horns through the night. In New York City's Harlem neighborhood, the roar of thousands of people gathered in a plaza near the legendary Apollo Theater could be heard blocks away.

Obama's victory marked the rise of a new generation of American leadership, after 16 years of presidents who came of age during the Vietnam War era. Obama, 47, was still a child when U.S. troops came home.

It was also Americans' final, symbolic rejection of Bush's presidency. Bush's popularity soared after the Sept. 11, 2001, terrorist attacks, then collapsed with his administration's bungled response to Hurricane Katrina in 2005, the war in Iraq, and to the regulatory lapses that many think led to the U.S. financial crisis.

The race was the longest, most expensive and most riveting in memory. Both Obama and McCain had been on the campaign train for almost two years.

McCain called his former rival to concede defeat - and mark the end of his own 10-year quest for the White House. "The American people have spoken, and spoken clearly," McCain told disappointed supporters in Arizona.

"This is an historic election, and I recognize the special significance it has for African-Americans and the special pride that must be theirs tonight," he said. "These are difficult times for our country. And I pledge to him tonight to do all in my power to help him lead us through the many challenges we face."

Bush added his congratulations from the White House and promised a smooth transition. "What an awesome night for you," he told Obama shortly after the race was decided.

An Obama presidency offers the prospect of a new style and tone in American foreign policy.

Obama has said he will try to withdraw U.S. troops from Iraq in 16 months and has called for a new opening to U.S. adversaries, such as Iran and Cuba. He has urged the closing of the Guantanamo Bay prison and favors cap-and-trade systems to reduce global warming.

Internationally, Obama is hugely popular - a sharp contrast to Bush. Part of his appeal is his personal story that highlights American multiculturalism: Besides his Kenyan father, he has a half-sister who is the daughter of an Indonesian.

In his campaign, Obama mined a deep vein of national discontent, promising Americans hope and change throughout a nearly flawless 21-month campaign for the White House.

He first soared into the national spotlight with his electrifying speech at the 2004 Democratic National Convention, when he made his first run for the Senate. He offered a message of unity to a country mired in partisan anger.
More stories on Pages 3, 11,12

DEFINING MOMENT: U.S. president-elect Barack Obama *(right)* hugs his wife Michelle as U.S. vice president-elect Joe Biden embraces his wife Jill on stage during their election night party before 240,000 electrified supporters in Chicago's Grant Park on Tuesday (Wednesday morning in Jakarta).
Reuters/John Gress

U.S. ELECTION RESULTS

Democrat Barack Obama is elected the first black U.S. president on Tuesday

Republican — Democrat

270 to win

Electoral votes *(TV networks projections)*
John McCain **173** — **349** Barack Obama

Popular votes *(96% of precincts reporting)*
(46%) 55,652,513 (52%)

Situation as of 1445 GMT

States with proportional allocation of electoral votes

States won
Number of Electoral College votes in bold

REUTERS — Source: MSNBC

PRODIGAL SON: Students of state primary school SDN Menteng 01 in Central Jakarta, where Barack Obama studied during his brief stay in Indonesia in the late-1960s, cheer the U.S. president-elect after learning Wednesday of his victory in Tuesday's historic vote.
JP/J. Adiguna

Jakarta celebrates the Menteng Kid's victory

The Jakarta Post
Jakarta

Jakarta shared the anxiety and the joy of the U.S presidential election won by new Indonesian darling Barack Hussein Obama on Wednesday.

It was a special day for students of Obama's former school SDN Menteng 01, Central Jakarta, who gathered at the school's hall to watch the final results pour in. Several pictures of Obama during his school years there were prominently displayed.

A 15-minute silence has been held here every day since Monday to allow the students to pray for Obama's victory.

"Every day we have something different to pray for, but since Monday we have prayed for him," said principal Kuwadiyanto.

Obama, or Barry as he was affectionately called during his time in Indonesia, enrolled in the school — then named SD Besuki — as a third-grader in 1968. He previously attended the Fransiskus Asisi Catholic School, also in Central Jakarta.

Obama's historic election as the next U.S. president was a dream come true for his supporters in Indonesia.

"I think it's good motivation for the children to study hard and set their dreams high," Kuwadiyanto said.

Israella Dharmawan, Barry's former teacher at Fransiskus Asisi and an avid follower of the U.S. election, said she was proud and touched by Barry's win.

"I hope to see him become a good president and keep his campaign promises," she said, adding he was good, cheerful and easygoing as a young boy.

"I remember he once wrote two stories titled 'My mother, my idol' and 'I want to be a president'," she said. Obama's former classmates at SDN Menteng 01 also recalled the times they spent at Café Pisa, Menteng, with the now U.S. president-elect.

Obama moved to Indonesia at the age of six with his mother Ann Dunham and his Indonesian stepfather Lolo Soetoro. He lived in Jakarta from 1967 to 1971.

In the rest of the capital, Jakartans cheered the election of *Anak Menteng* (the Menteng Kid) as America's first black president.

"Though I am not an American, I am very happy to hear that a child who studied in Menteng will be the next U.S. president," Sugiyono, a taxi driver, said after hearing radio reports of Obama's win.

The U.S. Embassy and USINDO organized a U.S. Election Day event at the InterContinental Hotel's Grand Ballroom. Most of the guests were non-Americans.

"It's no longer a U.S. election," one guest said. "It looks like an international election. People all over the world are eagerly awaiting the outcome of the election."

Among U.S. Ambassador Cameron R. Hume's invited guests were presidential spokesmen Dino Patti Djalal and Andi Mallarangeng, former ministers Emil Salim and Alwi Shihab, members of the House of Representatives, scholars, journalists and diplomats.

Despite their busy schedules, the British, Swiss, German, Austrian, Brazilian, Mexican, Jordanian, Tunisian, Palestinian and Singaporean ambassadors turned up to witness the historic moment.

Enda Nasution, who chairs the Obama for Indonesia society, celebrated Obama's victory with 300 members of the group, which was founded over the Internet.

"It's great to be part of history. No one thought Obama would win the U.S. presidency," Enda said.

Mulyani's bosses annul Bakrie suspension lift

Aditya Suharmoko and Rendi A. Witular
The Jakarta Post/Jakarta

The government annulled a decision Wednesday by the Indonesia Stock Exchange (IDX) to lift a trading suspension on PT Bumi Resources, in a move experts say is aimed at keeping the interests of the influential Bakrie family intact.

Before morning trading, the IDX said in a statement it would lift the Bumi suspension after hearing PT Bakrie & Brothers' explanation about a deal to sell its 35 percent stake in Bumi to Northstar Pacific.

The decision was believed to be supported by Finance Minister Sri Mulyani Indrawati, whose ministry oversees the Capital Market Supervisory and Financial Institutions Agency (Bapepam-LK).

However, the IDX scrapped its decision an hour later after a request from the government.

"After considering a request from the government, the exchange decided to delay lifting the suspension until further notice," the IDX said in a statement.

IDX president director Erry Firmansyah refused to explain the reason behind the request.

"It's the government who wanted it, the government of the Republic of Indonesia," he said, refusing to identify which institution had demanded the suspension.

A source at the Finance Ministry said the request was not from the ministry, and Mulyani did not comment on the issue.

"It was a request from an office higher than that run by Mulyani," the source said.

Presidential spokesman Andi Mallarangeng dismissed speculation President Susilo Bambang Yudhoyono was behind the intervention, saying the Bakrie mess was not the President's concern.

Capital market analyst Yanuar Rizky said the government's shocking intercession had diluted its own credibility as the referee of the capital market.

"This move proves there are conflicts of interest among factions within the government to protect certain ruling elites," he said.

Trading in shares of Bakrie & Brothers, Bumi and PT Energi Mega Persada — all part of the Bakrie Group of companies — have been suspended by the IDX since Oct. 7, following sharp falls in share prices due to reports Bakrie was having trouble with debt repayments.

Bakrie & Brothers, the nation's largest publicly listed investment firm, announced on Nov. 1 that Northstar, a local unit of U.S. buyout giant Texas Pacific Group, had agreed to pay US$1.3 billion for its 35 percent stake in Bumi.

Northstar, believed to be teaming up with state mining firms, must wrap up the deal within 28 days.

Analysts say a lifting of the suspension would have harmed the deal, with the Bumi stake expected to be heavily devaluated as investors promptly sell them over worries the stake could drop further due to uncertainties over Bakrie's debt arrangements.

Help from the government will mean a lot for the Bakrie family, headed by Coordinating Minister for the People's Welfare Aburizal Bakrie, following its role as a key financier of Yudhoyono's 2004 presidential campaign. **(hwa)**
San Miguel — Page 13

"نهار الشباب" مع هذا العدد

النهار

AN-NAHAR

الخميس 6 تشرين الثاني 2008 - السنة 76 - العدد 23520

Jeudi 6 Novembre 2008 - 76 ème Année - No 23520

24 صفحة/2000 ليرة

غير مخصص للبيع

نقسم بالله العظيم مسلمين ومسيحيين أن نبقى موحّدين إلى أبد الآبدين دفاعاً عن لبنان العظيم

جبران تويني

الحوار - 2: لا اتفاق ولا انتكاسة وتأجيل 47 يوماً

تصوّر عون "كارثي" للغالبية و "مدروس جيداً" للمعارضة

الاستراتيجية الدفاعية. واشار الى ان المجتمعين "استعملوا الى تصوّر للمعاد ميشال عون" في موضوع الاستراتيجية الدفاعية. ولخّصت النقاط التي تم التوافق عليها وابرزها "الانفتاح في المجال لمزيد من الاتصالات والمشاورات التي يجريها رئيس الجمهورية لتقريب وجهات النظر، والتزام الاستمرار في تعزيز التعددية السياسية والاعلامية وتشجيع المصالحة، واستكمال البحث في موضوع الاستراتيجية الدفاعية.

وحدد البيان 22 كانون الاول موعداً للجولة الثالثة للحوار.

وعلمت "النهار" ان رئيس الجمهورية ميشال سليمان افتتح الجلسة بكلمة مرتجلة ركّز فيها على اهمية المصالحة وتعددة الاجماع الحواري، مشدداً على ضرورة تنفيذ ما اتفق عليه في مؤتمر الحوار الوطني والمسائل التي لا تزال في حاجة الى مزيد من التشاور والجهد. كما لفت الى ان الدعم الخارجي الذي لمسه في جولاته واتفاق له مسيرة الحوار الوطني في لبنان، داعياً الى توظيفه ايجابياً والافادة منها. وقال للمشاركين في الحوار:

لم تخرج حصيلة الجولة الثانية التي انعقدت امس في قصر بعبدا بعيداً عن التوقعات التي سبقتها. فلم تحرز تقدماً ملموساً ولم تصطدم بانتكاسة، الامر الذي يعني ان المراوحة ستستمر حتى الجولة المقبلة على الأقل تحت سقف القرار السياسي الواضح لجميع القوى والمشاركين من الحفاظ على التعددية السياسية والاعلامية.

وكان المؤتمر الصحافي الذي تلا بأحد الاركان الـ14 للحوار الثائب حسن تويني وبواحد نقله الى مستشفى الجامعة كان لافتاً احياناً وبعدما من، بعد الجلسة. اذ لفظ اعلامياً واساساً، فإن البيان الذي قرأه تويني للجلسة كانت انتهت عملياً لدى اصاغة البيان بالمعارض ووضع نص البيان الختامي وعرض بعدما يجتمع المتحاورون ليتسنى لهم قراءته والتدقيق فيه.

وعكس البيان المضي قدماً في اجواء التهدئة، وان من دون التوصل الى نتيجة ملموسة. وتحدث عن مناقشة المتحاورين "امكان توسيع طاولة الحوار من حيث العدد والمعايير وموضوع

الرئيس ميشال سليمان والاركان الـ14 للحوار الوطني في قاعة 22 تشرين الثاني بقصر بعبدا امس.

(دلاتي ونهرا)

أوباما يبدأ البحث في تعيين مساعديه مؤكداً أن الطريق طويل

سوريا وإيران تريان في انتخابه رغبة في التغيير وإسرائيل متفائلة به

واشنطن - من هشام ملحم:

بعد انتصاره التاريخي الذي كان من الصعب تخيله عندما بدأ مسيرته نحو البيت الابيض قبل 21 شهراً، يواجه الرئيس الاميركي المنتخب باراك اوباما تحديات داخلية وخارجية تاريخية ستتطلب معالجتها ما اظهره خلال مسيرته المضنية من حكمة وصبر وبصيرة وقدرة تنظيمية خارقة، والكثير من الحظ، الان ما سيرثه من تركة الرئيس جورج بوش يمثل في خطورته وجسامة التحديات التي واجهها عدد محدود من الرؤساء الاميركيين كان آخرهم فرانكلين ديلانو روزفلت الذي قاد البلاد واخرجها من احلك ازمانها الاقتصادية في الثلاثينات من القرن الماضي، ليخوض حربا عالمية بعد منها اميركا "القوة العظمى" التي عرفها العالم لاحقاً. ورحب العالم بانتخاب اوباما، مبدياً الاستعداد للتعاون معه من الصين الى اوروبا. فيما تراءى سوريا وايران في انتخابه يظهر ميلا اميركيا الى التغيير، اما اسرائيل فأكدت ان مستقبل العلاقة مع الولايات المتحدة سيكون مشرقاً.

(راجع ص 10)

ويواجه اوباما اليوم ازمة اقتصادية هي الأخطر منذ الركود الاقتصادي الكبير، وحربين مكلفتين في العراق وافغانستان لا يبدو ان اميركا قادرة على الانتصار فيهما قريباً او ان تشكل حربا كما فعلت في الحرب العالمية الثانية، ومكانة دولية تعرضت للنكسات والتراجع، ومجتمع يساوره القلق على حاضره والوجوم.

الرئيس الاميركي المنتخب باراك اوباما، ونائب الرئيس جو بايدن وزوجته الحشود فيحيون وزوجته ميشيل اوباما، اليسار، الى اليسار، بشيكاغو حيث القى اوباما خطاب النصر ليل الثلاثاء - الاربعاء.

(أ ف ب)

شرطي اسرائيلي في مكان سقوط صاروخ فلسطيني جنوب مدينة عسقلان امس.

(رويترز)

أصعب اختبار للتهدئة في قطاع غزة

بعد مقتل 6 فلسطينيين بغارات إسرائيلية

رام الله - من محمد هواش:

غزة - الوكالات:

اطلقت حركة المقاومة الاسلامية "حماس" والفصائل المسلحة الاخرى عشرات من الصواريخ على اسرائيل، بعدما قتلت القوات الاسرائيلية ستة ناشطين فلسطينيين في تفجر للعنف بدء التهدئة المستمرة منذ اربعة اشهر على حدود قطاع غزة. ومع ذلك، افادت مصادر في "حماس" التي تسيطر على

قطاع غزة، ان التهدئة قد تعود إذا لم تواصل اسرائيل التصعيد، فيما اشار رئيس الدفاع الاسرائيلي ايهود باراك ايضا الى ان اسرائيل لا تريد انهيار التهدئة. ومن شأن انهيار التهدئة التي توسطت فيها مصر أن يمثل تحديا آخر للجهود الاميركية للتوصل الى اتفاق سلام بين اسرائيل والفلسطينيين والتي تعارضها "حماس". وتعمل مصر على تمديد التهدئة بعد انقضاء فترة الاشهر الستة المتفق عليها.

حملا واشنطن تبعة الأزمة المالية العالمية

ميدفيديف ينشر صواريخ "اسكندر" رداً على نظام الدفاع الأميركي

اتهم الرئيس الروسي دميتري ميدفيديف، امس، الولايات المتحدة بالتسبب بالازمة المالية العالمية والحرب في جورجيا واعلان نشر صواريخ في كالينينغراد ردا على نظام الدفاع الصاروخي الاميركي.

واشار في خطابه السنوي الاول للامة الى اختيار "الادارة الاميركية الجديدة" في علاقات جيدة" مع روسيا، من غير ان يذكر الثلاثاء باراك اوباما الذي انتخب الرئيس الرابع والاربعين للولايات المتحدة.

وتعهد الرئيس الروسي تحسين المعايير المنتخبة وتخفيض الشخصيات الروسية، وممثل المشروع الاميركي، الرد على مكونات المشروع الاميركي في اوروبا الشرقية.

الرئيس الروسي دميتري ميدفيديف موجهاً خطابه السنوي الاول للامة عند الضرورة في ابطال نظام الدفاع الصاروخي.

(أ ب)

ידיעות אחרונות

רכישת מנוי: 3778* | שירות מנויים: 3773*

| העורך לשעבר: ד"ר ח. רוזנבלום ז"ל | יו"ר ההנהלה הראשון: יהודה מוזס ז"ל | העורך האחראי הראשון: נח מוזס ז"ל | העורך האחראי: ארנון מוזס | עורך: שילה דה-בר | משנה לעורך: רון ירון | דפוס גלעד רח' מוזס 2, תל אביב | Yedioth Ahronoth יריעות אחרונות | יום ה', ח' בחשוון, תשס"ט 6.11.2008 גליון מס' 24965 | 4.80 ש"ח (כולל מע"מ) 4.20 ש"ח (ללא מע"מ) |

אובאמה, נשיא שחור ראשון בבית הלבן

הרגע הגדול בחייו: אובאמה ובתו מאליה בת ה-10 אחרי ההכרזה הרשמית על נצחונו (צילום: אבאקה)

התקווה של אמריקה

The New Zealand Herald

Yes we can

Americans make history by voting for a new future . . . and Barack Obama's campaign slogan comes true

Less than an hour after becoming the next President of the United States, Barack Obama stepped on to the stage with wife Michelle, holding the hands of their two daughters, at an enormous victory rally in Chicago.

"If there is anyone out there who still doubts that America is a place where all things are possible, who still wonders if the dream of our founders is alive in our time, who still questions the power of our democracy, tonight is your answer," he told the cheering thousands in downtown Grant Park.

The Democrat has written his name into the pages of American history by engineering a social and political upheaval to become the first black president-elect in a runaway victory over Republican John McCain.

The President-elect spoke warmly of the 72-year-old Arizona senator who was his rival in the longest and most expensive presidential campaign in US history.

After Mr McCain had called Mr Obama to concede victory, he spoke graciously of the victor at an outdoor rally in Arizona, commending him on his win and saying he understood its importance to African-Americans.

Mr Obama, a 47-year-old Illinois senator and son of a white mother from Kansas and a Kenyan father, mined a deep vein of national discontent, promising Americans hope and change throughout a 21-month campaign for the White House.

The election brought voters out in record numbers — polling booth figures and projections show 136.6 million Americans, or 64.1 per cent of those eligible, cast votes.

Analyst Michael McDonald, of George Mason University in Virginia, said this was the highest figure since the 65.7 per cent of 1908, when Republican William Howard Taft beat Democrat William Jennings Bryan.

Mr Obama will be sworn in as President on January 20, only 43 years after the United States passed the Voting Rights Act, a civil rights law banning denial of the vote to blacks in many Southern states where poll taxes and literacy tests were common.

Cautioning Americans that the nation's problems were manifest, Mr Obama said: "The road ahead will be long. Our climb will be steep. We may not get there in one year or even one term, but America, I have never been more hopeful than I am tonight that we will get there. I promise you we as a people will get there."

Up to 100,000 Obama supporters, cheering, screaming and waving flags, welcomed his election in a delirious hometown victory celebration.

Civil rights leader Jesse Jackson, beaten for the Democrat nomination in 1984 and 1985, stood with tears flowing down his cheeks; talkshow host and Obama backer Oprah Winfrey hugged people around her.

Watching the results on a jumbo TV screen, the crowd erupted in cheers each time another state went into the Obama victory column.

The jubilant supporters were treated to one of Mr Obama's most uplifting speeches.

"To those who would tear this world down, we will defeat you," he said. "To those who seek peace and security, we support you.

"And to all those who have won-

dered if America's beacon still burns as bright tonight, we proved once more that the true strength of our nation comes not from the might of our arms or the scale of our wealth but from the enduring power of our ideals — democracy, liberty, opportunity and unyielding hope.

"This election had many firsts and many stories that will be told for generations. But one that's on my mind tonight is about a woman who cast her ballot in Atlanta.

"She's a lot like the millions of others who stood in line to make their voice heard in this election, except for one thing: Ann Nixon Cooper is 106 years old.

"She was born just a generation past slavery, a time when there were no cars on the road or planes in the sky, when someone like her couldn't vote for two reasons — because she was a woman and because of the colour of her skin.

"And tonight, I think about all that she's seen throughout her century in America — the heartache and the hope, the struggle and the progress, the times we were told that we can't, and the people who pressed on with that American creed, 'Yes we can'.

"At a time when women's voices were silenced and their hopes dismissed, she lived to see them stand up and speak out and reach for the ballot. Yes we can.

■ **Continued on A2**

HISTORIC VICTORY

BARACK OBAMA	52%

349 electoral college votes

Won the key swing states of Virginia, Florida, Colorado, Pennsylvania and Ohio

JOHN McCAIN	47%

163 electoral college votes

■ Missouri and North Carolina yet to be decided last night.
■ 270 electoral college votes needed to win.

Source: RealClearPolitics.com

■ World reaction	– A2
■ McCain's concession speech	– A2
■ America's clean slate	– EDITORIAL, A10
■ The lone traveller	– WORLD, A13

THE CHALLENGES

■ Foreign policy	– A15
■ The economy	– A16
■ Climate change and energy	– A17
■ More election news and analysis	– A19-A22, A28
■ Obama's win gives sharemarkets a boost	– BUSINESS, B1

See also: nzherald.co.nz

FIRST COUPLE: A quiet moment for Barack Obama and his wife, Michelle, in front of thousands of cheering supporters in Grant Park. PICTURES / AP

Dziś | **Stypendia krajowe i zagraniczne**
Terminy składania wniosków, jakie warunki trzeba spełnić – **s. 30-31**

Zmiany w spadkach i darowiznach
Uwaga! Nowe terminy na zgłaszanie ich fiskusowi – **s. 39**

CZWARTEK
6 listopada 2008
NR 260. 5870
NAKŁAD 432 TYS. | 3

1,50 zł
w tym 7% VAT

REDAKTOR PROWADZĄCY
ZBIGNIEW PENDEL
WYDAJE AGORA SA
NUMER INDEKSU

www.wyborcza.pl

NAM NIE JEST WSZYSTKO JEDNO

gazeta
WYBORCZA.PL

REUTERS

OBAMERYKA!

40 lat temu, gdy biały zamachowiec zabił Martina Luthera Kinga, byłam w brzuchu mamy.
Strasznie się bała, wybuchały zamieszki. A teraz... Barack Obama, Murzyn, prezydentem! Ledwie 40 lat!

MARCIN BOSACKI, CHICAGO

••

- Nie mogę uwierzyć, nie mogę w to uwierzyć! O Boże, Boże wszechmogący!!! - krzyczała stojąca obok mnie Micheline Head, 40-letnia Murzynka z zachodniego Chicago, gdy na wielkim telebimie ogłoszono, że Barack Obama, 47-letni senator z Illinois, zostanie 44. prezydentem USA.

Staliśmy w dwustutysięcznym tłumie w parku Granta w Chicago, obok nas ludzie krzyczeli, machali flagami, rzucali sobie w objęcia.

- Dziś cały dzień się modliłam, cały dzień się trzęsłam, nie wierzyłam, że to się może stać, a jednak! Widzi pan, 40 lat temu, gdy biały zamachowiec zabił Martina Luthera Kinga, byłam w brzuchu mamy. W całym kraju wybuchały zamieszki, mama strasznie się bała. A teraz... Obama, Murzyn, prezydentem! Ledwie 40 lat! - ekscytowała się Micheline.

W tym momencie zaczęła płakać. Kiedy się ciut uspokoiła, wyszeptała:
- To jest Ameryka... To jest Ameryka...

Gdy Obama zaczął przemawiać nad ranem czasu polskiego, Micheline z tysiącami ludzi zaczęła krzyczeć główne hasło jego kampanii: "Yes, we can!" (Tak, damy radę!).

Nowy prezydent USA, który zostanie zaprzysiężony 20 stycznia, mówił:
- Jeśli ktoś wciąż wątpi, czy Ameryka jest miejscem, w którym wszystko jest

możliwe, jeśli ktoś kwestionuje żywotność naszej demokracji, to dziś otrzymał odpowiedź! To odpowiedź udzielona przez młodych i starych, bogatych i biednych, demokratów i republikanów, czarnych, białych, Latynosów, Azjatów i rdzennych mieszkańców tej ziemi, homo- i heteroseksualistów, niepełnosprawnych i zdrowych. Słowem - Amerykanów, którzy wysłali w świat przesłanie, że nigdy nie byliśmy tylko zlepkiem stanów republikańskich i stanów demokratycznych. Jesteśmy i zawsze będziemy Stanami Zjednoczonymi Ameryki!

Gdy Obama skupiony, może nawet spięty, mówił, że "do Ameryki nadeszła zmiana", wielu ludzi płakało. Ten młody polityk, cztery lata temu zupełnie nieznany Ameryce, nie dość, że został pierwszym Afroamerykaninem, który wygrał wybory prezydenckie, to jeszcze zrobił to bardzo zdecydowanie - pokonał republikanina Johna McCaina 53 do 46 proc. W liczbie elektorów, którzy formalnie wybiorą prezydenta USA, jego przewaga jest ogromna - demokrata zdobył prawdopodobnie 364 głosy, republikanin - 174 (wczoraj liczono jesz-

cze głosy w dwóch stanach). Obama zwyciężył w kilku bardzo konserwatywnych stanach, gdzie demokrata nie wygrał od 40 lat.

Obama pokonał McCaina, bo potrafił przekonać wyborców, że lepiej poradzi sobie z kryzysem gospodarczym. Gospodarka była głównym kryterium dla prawie dwóch trzecich Amerykanów, walka z terrorem i wojna w Iraku - tylko dla mniej więcej 10 proc. Dla połowy wyborców bardzo ważne było - "zerwanie z polityką Busha" - głosowali na demokratę.

Co dla Ameryki może najważniejsze, rasa Obamy nie grała negatywnej roli. Dostał głosy 43 proc. białych wyborców - więcej wśród demokratów miał tylko Jimmy Carter w 1976 r., tyle samo Bill Clinton w 1992 r. Wśród białych wyborców wygrał jednak McCain. Ale Obama dostał aż 95 proc. głosów Afroamerykanów i 66 proc. Latynosów.

Co prawda 20 proc. głosujących stwierdziło, że rasa była dla nich ważna, ale większość z nich - i czarnych, i białych - widziała w niej atut Obamy.

W mowie zwycięstwa Obama mówił o 106-letniej Ann Nixon Cooper, która głosowała w Atlancie: - Gdy Ann się rodziła, nie mogła głosować z dwóch powodów - bo była kobietą i była czarnoskóra. Na tym polega prawdziwy geniusz Ameryki - że Ameryka potrafi się zmieniać.

Gdy Obama to mówił, Micheline znów płakała. I mówiła cicho: - To jest Ameryka. To jest Ameryka. ●

SONDAŻ „GAZETY": POLACY ZA OBAMĄ

Czy cieszysz się, że Barack Obama wygrał wybory prezydenckie w USA?

Tak	**52** proc.
Nie	**14** proc.

WYBORY 2008

Czy Barack Obama będzie lepszym, czy gorszym prezydentem niż Bush dla...

...USA:	
Lepszym	**73** proc
Gorszym	**7** proc.

...Europy:	
Lepszym	**60** proc
Gorszym	**15** proc.

...Polski:	
Lepszym	**54** proc
Gorszym	**20** proc.

Czy to dobrze, czy źle, że prezydentem światowego mocarstwa został...

...polityk, który chce zerwać z polityką Busha:	
Dobrze	**73** proc.
Źle	**11** proc.

...człowiek stosunkowo młody:	
Dobrze	**87** proc.
Źle	**9** proc.

...polityk ciemnoskóry:	
Dobrze	**70** proc.
Źle	**11** proc.

PBS DGA dla „Gazety", 5 listopada, badanie telefoniczne, próba reprezentatywna 500 osób. Pominięto odpowiedzi „trudno powiedzieć"

THURSDAY

November 6, 2008 | Dhu Al Qa'da 8, 1429

THE END OF INFAMOUS
AMERICAN CIVIL WAR?
OPINION P14

DEAR
MR OBAMA,
YES YOU CAN
GULF NEWS SAYS P12

McCAIN
GRACIOUS
IN DEFEAT
PAGE 5

TEARS OF JOY
FROM JESSE
JACKSON
PAGE 3

OPRAH'S
CAMPAIGN
OF EMOTION
PAGE 3

GULF NEWS

AL NISR PUBLISHING

www.gulfnews.com E-mail: editor@gulfnews.com
© 2008 Al Nisr Publishing LLC All rights reserved. Dubai Tel: +97143447100

★★ LATE EDITION

30 Years

GGICO
A Journey of Success. Since 1973.

CHANGE HAS COME

It's been a long time coming, but tonight, because of what we did on this day, in this election, at this defining moment, change has come to America ... And to all those watching tonight from beyond our shores, from parliaments and palaces to those who are huddled around radios in the forgotten corners of our world — our stories are singular, but our destiny is shared, and a new dawn of American leadership is at hand. To those who would tear this world down — we will defeat you. To those who seek peace and security — we support you. And to all those who have wondered if America's beacon still burns as bright — tonight we proved once more that the true strength of our nation comes not from the might of our arms or the scale of our wealth, but from the enduring power of our ideals: democracy, liberty, opportunity, and unyielding hope."

Barack Obama, US President-Elect
VICTORY SPEECH DELIVERED ON NOVEMBER 4, 2008

بسم الله الرحمن الرحيم
٥٢
صفحة
٣
الطبعة
الرياض
جريدة يومية تصدر عن مؤسسة اليمامة الصحفية
AL RIYADH - 14745 - 45th Year - THURSDAY-6 -11-2008
الخميس ٨ ذي القعدة ١٤٢٩هـ - ٦ نوفمبر ٢٠٠٨م - العدد ١٤٧٤٥ - السنة الخامسة والأربعون

أناب سمو ولي العهد لإدارة شؤون الدولة
خادم الحرمين يصل إلى المغرب في طريقه إلى أمريكا

الدار البيضاء، الرياض - (و.أ.س)

• وصل - بحفظ الله ورعايته - خادم الحرمين الشريفين الملك عبدالله بن عبدالعزيز آل سعود الى الدار البيضاء مساء أمس قادماً من الرياض. وكان خادم الحرمين قد غادر في وقت سابق من يوم أمس الرياض، الى المغرب في طريقه إلى الولايات المتحدة للمشاركة في اجتماع القمة في الأمم المتحدة حول الحوار بين الأديان والثقافات وكذلك المشاركة في القمة الاقتصادية لمجموعة العشرين التي ستعقد في الولايات المتحدة منتصف الشهر الحالي. وقد صدر أمس أمر ملكي بإنابة صاحب السمو الملكي الأمير سلطان بن عبدالعزيز ولي العهد في إدارة شؤون الدولة ورعاية مصالح الشعب خلال فترة غياب خادم الحرمين عن المملكة.

(التفاصيل: ص٢)

الملك عبدالله لدى مغادرته مطار قاعدة الرياض حيث كان في وداعه سمو نائب الملك والأمير سلمان وكبار المسؤولين. (و.أ.س)

القيادة تهنئ الرئيس المنتخب وتؤكد حرصها على تعزيز العلاقات وتطلعها لتحقيق السلام الدولي
.. وانتصر «الحلم»: أوباما رئيساً لأمريكا

مشاعر البهجة والارتياح تعم عواصم العالم بفوز نهج «التغيير» وسقوط دعاة الحرب في الانتخابات الأمريكية

أوباما يحيي أنصاره في خطابه خلال الاحتفال بالانتصار التاريخي. (أب)

واشنطن - أحمد حسين الياسي ود. فوزي الأسمر:

• سادت مشاعر البهجة والأمل عواصم العالم أمس بعد إعلان فوز باراك أوباما التاريخي برئاسة الولايات المتحدة كأول رئيس أمريكي من أصل أفريقي، ما جسّد «حلم» داعية الحقوق المدنية الأمريكية الأسود مارتن لوثر كينغ الذي اغتيل برصاص الحقد العنصري قبل أكثر من نصف قرن عندما كان الأمريكي الأسود يعامل باحتقار ويُمنع من ركوب حافلات البيض وارتياد كنائسهم وأنديتهم ومحالهم.

وقد هنأ خادم الحرمين الشريفين الملك عبدالله بن عبدالعزيز وسمو ولي العهد الأمير سلطان بن عبدالعزيز أوباما وأكدا حرصهما على تعزيز العلاقات التاريخية الوثيقة بين البلدين الصديقين وتطلعهما لتحقيق السلام والعدالة في المنطقة والعالم أجمع.

وقال الرئيس الأمريكي المنتخب أوباما، في كلمة الفوز الذي ألقاه أمام مناصريه في حديقة «غرانت»، بمدينة شيكاغو إن التغيير جاء إلى أمريكا، مشدداً على أن القوة الحقيقية للأمة الأمريكية «لا تأتي من قوة سلاحها أو حجم ثروتها بل من قوة الثقافة المتمسكة بقيمها».

وقال الرئيس الأمريكي الرابع والأربعون والأول من أصل أفريقي في تاريخ أمريكا «إننا لسنا مجموعة من الولايات الحمراء والزرقاء.. نحن نشكل الولايات المتحدة. وسنبقى دائماً».

وعن الأزمة المالية قال أوباما «إذا علمتنا الأزمة المالية شيئاً فهو أنه لا يمكن لوول ستريت أن يزدهر فيما الآخرون يعانون.. نحن نزدهر أو نندثر كأمة واحدة.. كشعب واحد».

وتوجه «إلى الذين يريدون تدمير العالم سندمركم، والذين يسعون للسلام والأمن سنقف إلى جانبكم».

وقد فاز أوباما بـ ٣٣٨ صوتاً من أصوات المجمع الانتخابي، فيما حصل ماكين على ١٥٦.

وأقر السيناتور الجمهوري جون ماكين بهزيمته وهنأ منافسه معرباً عن إعجابه الشديد به.

حتى النصر.

وعزز الديمقراطيون في الانتخابات سيطرتهم على الكونغرس وأصبحوا في وضع يمكنهم من التحرك سريعاً للبت في كثير من القضايا التي تتضمنها الأجندة الطموحة للرئيس المنتخب من انعقاد الكونغرس الجديد في يناير (كانون الثاني) المقبل.

وهذا الفوز التاريخي لأوباما بوصفه أول أمريكي ينحدر من أصول أفريقية يتولى أرفع منصب في البلاد سيغير من صورة أمريكا عالمياً بعد أن شوهت سياسات جورج بوش الصغير وحروبه صورة القوة العظمى في العالم. وكان أوباما المرشح المفضل في معظم بلاد العالم.. وقد أقيمت احتفالات في شتى أنحاء العالم ابتهاجاً بفوزه وفي مقدمة هذه الدول كينيا البلد الأصلي لوالد الراحل.. وهنأ قادة العالم الرئيس أوباما.

وانتابت الفرحة الغامرة مدينة الصيد اليابانية النائية «أوباما» حيث تجمع السكان المحليون للاحتفال بفوز باراك أوباما الذي يتشاركه في الاسم مع البلدة.. وارتدى البعض زياً خاصاً برقصة الهولا المميزة في هاواي حيث ولد أوباما وقال المميزة «أنا أحب أوباما وقال آخرون فحمساتنا كتب تكريماً له. وارتدى أوباما.

(تغطية وافية: ص٢، ٣، ٤، ٥، ٦)

ابتسامة عريضة ترتسم في محيا منية أوباما الكينية في أنصاره في أفريقيا. الصناتور ماكين يطالب بمشاعر الهزيمة أمام أوباما يخاطب أنصاره في لوس أنجليس. (أي بي - أي) (أب - أي)

ستة شهداء في توغل إسرائيلي مدرع جنوب غزة
انهيار التهدئة.. عشية حوار القاهرة

غزة - مها أبوعويمر:

• استشهد ستة مقاومين فلسطينيين ليل الثلاثاء - الاربعاء خلال عملية توغل جنوب قطاع غزة ردت عليها المقاومة الفلسطينية بقصف عشرات الصواريخ في أخطر خرق للتهدئة منذ حزيران (يونيو) الماضي.

وقالت مصادر طبية إن خمسة نشطاء استشهدوا في غارتين على شرق بلدة القرارة جنوب قطاع غزة واستشهد السادس خلال عملية توغل شرق دير البلح جنوب قطاع غزة.

وأصيب أربعة جنود تأتي قبل أيام من بدء إسرائيليين بجروح خلال الحوار الفلسطيني برعاية عملية التوغل المدرع التي مصرية في القاهرة.

الفلسطينيون يبكون الشهداء أثناء تشييع جثامينهم في خان يونس أمس. (رويترز)

مواطنون خليجيون يرحبون بفوز أوباما:
نتوقع تغييراً في السياسة الأمريكية بنسبة ٨٠٪!

دبي - علي خليل، (أ.ف.ب):

• رحب مواطنون خليجيون أمس بفوز المرشح الديمقراطي باراك أوباما في الانتخابات الرئاسية الأمريكية معربين عن الامل في تغيير سياسات واشنطن إزاء القضايا العربية والإسلامية بسبب ما يرون أنه من جذور إسلامية.

وقال الخارجي «ان فوز أوباما يؤكد ان الولايات المتحدة ليست عنصرية وشعبها كذلك الشعب الأمريكي اختار أوباما بالرغم من أنه أفريقي في رفضه لسياسات المحافظين في الإدارة الأمريكية الحالية.

وأضاف الخارجي ان فوز أوباما «بوضح للمشددين في عالمنا العربي والإسلامي ان «لا خلاف مع أمريكا ليس له أبعاد عرقية ودينية».

وقال أحمد عزام من قطر «انا متفائل بانتخاب باراك أوباما وأنتظر تغييرات جذرية في طريقة تعاطي البيت الابيض مع قضايا المنطقة». اعتبر المهندس القطري «ان الإصلاحات التي سيطبقها أوباما ستركز على الداخل الأمريكي.. الا أن السياسة الخارجية لن تكون مندفعة ولا عنيفة في عكس ادارة بوش.

وفي البحرين، أبدى مندوب الاعلانات عادل شمس (٣٨ عاما) تفاؤلا كبيرا إزاء فوز أوباما قائلا انه يتوقع «تغييرا بنسبة ٨٠٪ في السياسة الأمريكية».

من جهته، اشاد رجل الأعمال السعودي الخارجي بالديمقراطية الأمريكية التي سمحت لرجل أسود والده مسلم بالوصول الى البيت الأبيض.

وقال المواطن السعودي عبدالله البكري في أحد مراكز التسوق الكبرى في دبي والده مسلم على ما اظن. اكيد سيكون هناك تغيير في السياسة تجاه قضايا العرب والمسلمين.

وأضاف البكري «ان شاء الله سيكون رئيسا افضل، خصوصا ان اول نقطة قالها هي انه سيسبب

Riyadh, Saudi Arabia
"The Dream Wins: Obama President of the USA"
www.alriyadh.com

ПОЛИТИКА

Београд, четвртак 6. новембар 2008.
Број 34124 година CV

Основана 1904. године
Оснивач Владислав Рибникар

Примерак 30 динара
СРБИЈА

Рен: Србија могући кандидат од 2009.
Босна најпроблематичнија.
– Владавина права изазов за Црну Гору.
– Македонија није испунила политичке критеријуме за чланство у ЕУ стр. 2

Скупљи и кредити у динарима
Банкари очекују повећање камате за два процентна поена због веће референтне стопе НБС стр. 13

Шминка по Правилу службе
Нова војна регулатива дозвољава синдикално организовање, али не и право на штрајк.
– Јутарње вежбање тек после доручка, поздрав руком и без шлема на глави стр. 8

Исповест инсајдера: Како сам открио друмску мафију и добио отказ

Горан Милошевић, бивши инкасант „Путева Србије" који је радио на једној наплатној рампи на аутопуту Београд-Лесковац, није могао ни да слути да ће од радника који је покушао да се избори за стално радно место постати човек који ће раскринкати „друмску мафију" и кључни сведок у процесу који се води пред Специјалним судом. Међутим, уместо похвала које би по логици ствари могао да очекује у земљи у којој у овој деценији није било владе који борба против корупције и криминала није била један од приоритета, Милошевић је остао без посла прошавши при

Горан Милошевић, бивши радник „Путева Србије" и један од кључних сведока у процесу „друмској мафији", каже да је три године без посла, док су неки од оптужених враћени на посао

том кроз праву голготу у настојању да докаже да је у праву.

Милошевићев ход по мукама почео је оног тренутка када му је додељено да у недоглед ради на одређено време уз неизвесност да ће му уговор бити продужен.

– Обратио сам се инспектору рада у Смедереву, јер сам био убеђен да не могу да ми тако продужавају уговор до пензије. Кад сам, међутим, код њега дошао први пут он ми је рекао 'слушај, дечко, ево, ређи ти ту нешто искрено – ту фирму држе београдски мангупи, ради колико радиш и гурај даље'. Мени је то било страшно – прича Милошевић у разговору за „Политику".

То га, ипак, није обесхрабрило. На форуму интернет-сајта Скупштине Србије почео је да пише о својим проблемима, али не наводећи о којој фирми се ради, а све у нади да ће његов случај заинтересовати некога од посланика. То се, међутим, није десило. Реаговао је само „обичан" свет. Истовремено, Милошевић је све отвореније о томе почео да прича са колегама из Ирака, па би почетком 2006. године добио отказ са образложењем да је престала потреба за његовим ангажовањем. **страна 7**

Ново лице историје

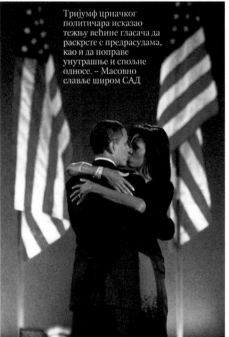

Остварен амерички сан: Барак и Мишел Обама Фото АФП

Тријумф црначког политичара исказао тежњу већине гласача да раскрсте с предрасудама, као и да поправе унутрашње и спољне односе. – Масовно слављe широм САД

Од нашег сталног дописника

Вашингтон, 5. новембра – Играло се на улицама. Скакало по столовима. Колоне одушевљених су закрчивале саобраћај. Седиште шефа државе су окружиле хиљаде манифестаната узвикујући „готов си". Орила се ведра музика. Штипало се да се провери из Образе да се провери. Проливале су се сузе-радоснице. Клицало се – битној промени и поретку, који је дуго, повремено сурово, мењао друге.

Овакве сцене синоћ су се виделе широм Америке: у незапамћеном масовном слављу поводом изборног резултата, којим је јуче ова земља први пут изабрала црначко – демократског сенатора из Илиноиса Барака Обаму (47) – за свог, 44. по реду, председника. На тренутке је изгледало да нација прославља своје „поновно рођење", да мења своје биће, у мери коју већина земаља није спремна да на себи примени или да припадника расне, или друге, мањине уздигне на чело извршне власти.

Да ли је могуће да је то она иста Америка која је два пута изабрала Џорџа Буша за председника да би јој он једнострaним потезима смањио самопоштовање и спољно уважавање, питали су се посматрачи. Јесте, одговарају истрајни истраживачи оваквог карактера, с чијим је одликама и изразита способност за преображавање, у складу са битним чињеницама, поготову кад их занемаре носиоци врховне власти.

Обама је просто слистио републиканског ривала Џона Мекејна (72) надмашивши га у „електорима" (који посредно одлучују о томе ко је изабран за председника), направивши разлику у своју корист, вишеструко, у апсолутном износу и процентуално, већу (338:161) од оне којом га је супарник надмашивао у годинама. На питање зашто, следи низ више одговора: 1. Демократа је боље осетио незадовољство грађана, од којих чак девет десетина тврди да се земља креће у погрешном правцу; 2. Апсолутно се одрекао „бушизма" (а супарника окарактерисао као следбеника тог „катастрофалног курса"); 3. Предложио је орочено повлачење трупа из Ирака, с преусмеравањем војних операција на обрачун са талибанима и Ал Каидом у авганистанско-пакистанском подручју, а новац са ратишта у побољшање здравства, школства… **страна 5**

„Делта" мерка „Меркатор"

Компанија Мирослава Мишковића ће учествовати на међународном тендеру за продају највећег словеначког ланца

„Делта холдинг" ће учествовати на међународном тендеру за продају словеначког „Меркатора", саопштено је јуче у овој компанији. „Делта" ће обавити и званичне разговоре са акционаром „Пивоварна Лашко" и обавестити будућу владу Словеније о својим намерама.

„Делта холдинг" планира наставак регионалног ширења у земљама југоисточне Европе и куповина 'Меркатора' знатно би допринела бржем остваривању овог циља. На тај начин створили бисмо компанију која би заузела значајно место међу водећим малопродајним ланцима у Европи", наводи се у саопштењу.

„Делта холдинг" је имао више неуспелих покушаја да изађе на тржиште Словеније. Још 2002. године са тамошњим званичницима успоставили су контакти око изласка ланца супермаркета „Макси" у Словенију. Званично су представљени планови и затражено је пет локација за изградњу објеката. Словеначка страна је најпре одуговлачила са одговором, потом су понуђене локације, али неодговарајуће у том послу.

Три године касније „Делта" је дала конкретну понуду за куповину „Фруктала" из Ајдовшчине, у тренутку када је ова компанија пословала са губитком и када је изгубила велики део тржишта на простору бивше Југославије. На састанку у Љубљани договорено је да у року од седам дана власници „Фруктала" одговоре на понуду.

Уместо писаног одговора, до „Делте" је стигла усмена порука да „Фруктал" није спреман да сарађује са српском компанијом.

Годину дана касније појавила се информација да „Делта" жели да на берзи купи акције „Меркатора", што је изазвало бурну реакцију целокупне словеначке јавности. **страна 13**

Партијски кадрови гуше општине

Питање је и да ли би уопште људи гласали за неке који сада седе у Скупштини Србије, а да су се на изборима појавили именом и презименом

ИНТЕРВЈУ
Милан Марковић, министар за државну управу и локалну самоуправу

Број запослених у локалној самоуправи у року од четири године од ступања на снагу новог закона, којим ће бити решено питање статуса запослених у локалној самоуправи, требало би да буде смањен са 22.000 на 12.000. Милан Марковић, министар за државну управу и локалну самоуправу, нада се да ће тај закон бити усвојен у току наредне године. **стране 6 и 7**

www.politika.rs
redakcija@politika.rs

 ДАНАС 8°/23° СУТРА 13°/18°

ISSN 0350 - 4395
ЦРНА ГОРА 0,50 EUR; РЕПУБЛИКА СРПСКА 0.70 KM; ХРВАТСКА 8,00 KH; МАКЕДОНИЈА 30,00 ДЕН; СЛОВЕНИЈА 0,80 EUR; ФБ.БиХ 0,70 KM; САД 1,50 $; НЕМАЧКА 1,15 EUR; АУСТРИЈА 1,30 EUR; ФРАНЦУСКА 1,40 EUR; ГРЧКА 1,00 EUR; ШВАЈЦАРСКА 3,00 CHF; ШВЕДСКА 14,00 SEK

Сутра у ТВ РЕВИЈИ

Радмила Раденовић:
Без провокације по сваку цену
Горан Султановић: Нећу да се трујем
Дејан Ђуровић: Адвокат озбиљне музике
Поли Вокер: Лепа и смртоносна Римљанка
Нови филм Срђана Кољевића:
Жена са сломљеним носом
Дајан Лејн: Наследница Грејс Кели

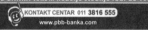
Beograd, Serbia
"A New Face in History"
www.politika.rs

Tokyo, Japan

"Obama Wins Election . . . Time for Change Has Come!"

www.asahi.com/english

Johannesburg, South Africa

www.thetimes.co.za

There had never been any doubt that, if the rest of the world had been eligible to vote in the US presidential election, Obama's victory would have been virtually absolute.

– Dominic Mahlangu and Jackie May,
The Times (Johannesburg)

Here is something that may be
hard for foreigners to understand:
Americans desperately want to
believe their country stands for
fairness, for equality, for democracy.
After the mistakes made in Iraq
and Guantanamo, the terrible
financial crisis, the embarrassment
of Hurricane Katrina, a vote for Mr
Obama allowed Americans to believe,
once again, that the United States is
still a virtuous nation.

SOUVENIR EDITION

The Daily Telegraph

ELECTION

Thursday, November 6, 2008 No 47,721 **BRITAIN'S BEST-SELLING QUALITY DAILY**

The dream comes true

America's first black President completes an epic journey begun by Martin Luther King

Anne Applebaum

THE maps on the television screens started turning blue as soon as the polls had closed on the East Coast; by midnight, John McCain had conceded the presidency to Barack Obama. But I had known the election result many hours before. I did not have special access to internal campaign data, or an early glimpse of the exit polls. I simply had one conversation, and one email exchange, which together told me everything I needed to know.

The conversation was with my sister, who lives in Florida, a bitterly contested battleground state. Florida was split down the middle in 2000, went for George W Bush in 2004, and was considered a possible McCain state this year. But as election day dawned, my sister told me that even though a huge percentage of Floridians had taken advantage of early voting, there were still queues – everywhere – and many of those standing in them were black. Clearly, those waiting, sometimes for hours, were not waiting to vote for Mr McCain.

The subsequent email exchange was with an old friend, a staunch Republican who is married to an even stauncher Republican – a rather famous one too. Despite this family circumstance she had, she confessed, just voted for Mr Obama. Though she had had her doubts, she suddenly found, on election day, that the decision was easy.

More than easy: uplifting. When she emerged from the polling booth, she had a spring in her step, because she had just voted for the first black president. "And that's no small thing," she wrote. "Maybe even worth some higher taxes."

And that was how, by about 10am, East Coast time, before the polls had opened in much of the country, I knew two extremely important pieces of information.

Number one: black Americans were, for the first time in recent history, already voting in high numbers. Really high numbers. If the image of the 2000 election was that of lawyers flocking to Florida to dispute the result, 2008 will be remembered for those first-time voters, patiently waiting their turn to mark a ballot or pull a lever. The Obama campaign had identified and steadily lobbied some 600,000 Florida blacks who registered to vote but did not show up in the past. Their efforts paid off, in Florida and everywhere else.

Number two: not just Democrats, not just independents, not just "swing voters" but actual, hard-core Republicans were so moved by the prospect of a black president – and so disgusted by the Bush administration – that they switched sides and voted for Mr Obama. This happened despite accusations that Mr Obama was a socialist, a Marxist, a secret Muslim, a

radical. None of those epithets really stuck. In the end his inclusive, centrist, bipartisan rhetoric proved more powerful than even the hard evidence of his solid, Left-liberal voting record.

He repeated some of it again in his acceptance speech, after quoting Abraham Lincoln, who was a Republican: "I may not have won your vote tonight," he told Mr McCain's electorate, "but I hear your voices, I want your help and I will be your president too."

As a rule, I dislike the word "historic" when used to describe elections: all elections are "historic", after all. Despite the rhetoric, this election is not "historic" in the sense that it presented the American people with some kind of monumental choice between presidents who would have had vastly different policies.

Let us be clear: whoever walks into the White House on inauguration day has limited choices, narrow possibilities, and almost no room for manoeuvre. Left, Right, Democratic or Republican, it does not matter: the new

president still has to make sure that banks continue to lend money, the housing market continues to function, Afghanistan and Iraq do not deteriorate into chaos. I have no doubt that President McCain would have made many of the same decisions as will President Obama.

Nevertheless, this was a completely different election and it has produced a kind of euphoria that I have never seen in American politics before. "Change" did not seem like much of a slogan, when Obama supporters held it up on signs during rallies. "Yes, We Can" did not seem like much of a clarion call.

But when the first black President-elect took the podium, with the black First Lady in waiting beside him, it was impossible not to feel that something profound really had just changed. If nothing else, the worst chapter of the American story – a chapter that began more than three centuries ago, when the first slave ships docked in Britain's North American colonies – had just come to an end.

Early yesterday, black Americans were sending a text

The moment of truth: America's President-Elect Barack Obama kisses his wife Michelle after his victory speech to a cheering crowd in Chicago yesterday

MATT

PLEASE DO NOT WALK ON THE WATER

message to one another: "Rosa sat so Martin could walk. Martin walked so Barack could run. Barack is running so our children can fly." Rosa was Rosa Parks, who refused to give up her seat to a white man on an Alabama bus. Martin was Martin Luther King, who marched on Washington and quoted the Declaration of Independence back at Americans: "We hold these truths to be self-evident, that

all men are created equal." Mr Obama is their inheritor – and he knew it. "If there is anyone out there who still doubts that America is a place where all things are possible," he told a cheering, weeping Chicago crowd; and if anyone "still wonders if the dream of our founders is alive in our time – tonight is your answer".

Mr McCain knew it too. In a gracious concession speech, he praised Mr Obama for "inspiring the hopes of so many millions of Americans who had once wrongly believed that they had little at stake or little influence in the election of an American president".

A century ago, he reminded his audience, President Theodore Roosevelt, was condemned for inviting the black educator Booker T Washington to dinner at the White House. "America today is a world away from the cruel and frightful bigotry of that time. There is no better evidence of this than the election of an African American to the presidency of the United States."

I am convinced it was not, in the end, a disadvantage for Mr Obama to be black. His race

was an enormous attraction for many white Americans, even – or perhaps especially – some white Republicans.

Here is something that may be hard for foreigners to understand: Americans desperately want to believe their country stands for fairness, for equality, for democracy. After the mistakes made in Iraq and Guantanamo, the terrible financial crisis, the embarrassment of Hurricane Katrina, a vote for Mr Obama allowed Americans to believe, once again, that the United States is still a virtuous nation.

It is not just about being liked abroad, though being liked is nice: it is about being certain that we still are, as we have often told ourselves, an example to other nations, a "city on a hill".

Americans stood in line for that certainty, they crossed party lines to vote for it, they donated record amounts of money to the Obama campaign in search of it.

In, the end, it comes down to this: all Americans are told, as children, that "anyone can grow up to be president of the United States." And now, once again, we know that it is true.

The victory address

> **If there is anyone out there who still doubts that America is a place where all things are possible, who still wonders if the dream of our founders is alive in our time, who still questions the power of our democracy – *tonight is your answer***

Inside

News
The long road to the White House:
13 pages of in-depth news and analysis
PAGES 2-14

Comment
The best writing: Iain Martin, Simon Heffer, David Frum, Irwin Stelzer and Bryony

Gordon, plus Editorial Comment
PAGES 25-27

Business
What an Obama win means for the economy: Ambrose Evans Pritchard, Tom Stevenson and Damian Reece
PAGES B1,B3 & B5

ISSN 0307-1235

£0.80

Thursday 06.11.08

Published
in London and
Manchester

guardian.co.uk

theguardian

Obama's new America

President-elect Barack Obama and his daughter Sasha salute supporters in Grant Park, Chicago Photograph: Eric Thayer/Getty Images

First black leader to hail 'birth of freedom' at inauguration

Ewen MacAskill
Suzanne Goldenberg Washington

Barack Obama will pay homage to Abraham Lincoln when he takes the oath of office as America's next president in January, urging his fellow citizens to unite in "a new birth of freedom".

Obama, who chose to launch his election campaign last year at the spot in Illinois where Lincoln began his, will express a hope that as the 44th president he too will usher in a new American era.

The Democratic president-elect, enjoying messages of congratulations from leaders round the world, spent the day closeted with his advisers in Chicago planning the team that will move into the west wing and executive office as President George Bush prepares to move out.

Bush, in offering his congratulations, promised full cooperation with the incoming administration, and hailed the historic nature of Obama's victory. "No matter how they cast their ballots, all Americans can be proud of the history that was made yesterday," Bush said in remarks delivered from the White House rose garden.

"This moment is especially uplifting for a generation of Americans who witnessed the struggle for civil rights with their own eyes – and four decades later see their dream fulfilled".

He said he had invited Obama and his wife, Michelle, to the White House before the inauguration on January 20. Although that is 75 days away, Obama's team demonstrated urgency yesterday by opening a transition office on Capitol Hill.

The Democrat's aides are expected to begin moving into key departments such as the Treasury within days to work with the outgoing administration. The priority is to get an economic stimulus package in place as quickly as possible.

As America celebrated yesterday, the stockmarkets suffered another difficult day; the Dow Jones index dropped by 3% because of recession fears.

In an another indication of the shift in power, Obama is to begin receiving intelligence briefings from the CIA from today. "He will see the full range of capabilities we deploy for the United States," the CIA director, Michael Hayden, said in a letter to employees.

Obama's sweeping victory to become the first black president elicited emotion across the political spectrum yesterday. The Republican former secretary of state Colin Powell, who watched the results come in from Hong Kong, was brought to tears. "The fact that he's also black just has turned America on," Powell told reporters. He paused for a few seconds, before adding: "Very emotional."

Bush's current secretary of state, Condoleezza Rice, also noted the historic nature of the result, saying American

Continued on page 3 »

Journey of generations that passed in a moment

Gary Younge
Chicago

There are times when the usually glacial pace of social progress accelerates to such a degree that you feel you are experiencing it in real time. Stand in the present and history comes rushing towards you, making you feel lightheaded.

The second that Ohio fell to Barack Obama on Tuesday evening, effectively handing him the keys to the White House, was one of those dizzying moments. A man born three years before African-Americans had secured their right to vote had risen by popular acclaim to the highest office in the land before he reached 50.

A political journey that should take generations felt as though it had occurred in a moment.

At the President's Lounge, a bar in Chicago's black southside, the soundtrack to that moment gave voice to decades of thwarted dreams. First they crooned soulfully to Sam Cooke's Change is Gonna Come. Then they bellowed boisterously to McFadden and Whitehead's Ain't No Stoppin' Us Now: "If you've ever been held down before, I know that you refuse to be held down any more."

Outside car horns beeped and Chicago police shouted Obama's name at passers by through loudspeakers. They were cheering for their native son, but the festivities were not bound by geography or race. Tens of thousands across the country took to the streets to celebrate. In Harlem, subway trains erupted into spontaneous applause. In Detroit, the home of Motown, they danced in the street.

Like Joe Louis's defeat of Max Schmeling back in the 30s, this was black America's gift to a grateful if not always gracious nation. "It was vindication," wrote Maya Angelou of Louis's win. "Some black mother's son, some black father's son, was the strongest man in the world."

Now Obama is the most powerful man in the world. Only he is the son of some white Kansan mother and some black Kenyan father – a biracial man with a Muslim name in a country at war in the Gulf. No matter how long one pores over the electoral map, his victory still seems unlikely if not implausible.

But the very things Republicans hoped would alienate him from the average American apparently made him appealing to some.

As the campaign gathered pace, it seemed as though there was a little bit of Obama for everyone: the immigrant, the midwesterner, the Hawaiian, the

Continued on page 2 »

guardian.co.uk »

Full results and analysis
The story of a historic victory from our unrivalled team in the US

Interactive
Click-through to the best of the Guardian's coverage: top stories, blogs, videos

Debate
Martin Kettle: After the triumph, holding on to the support through to 2012

London, England (UK)

www.guardian.co.uk

Now Obama is the most powerful man in the world. Only he is the son of some white Kansan mother and some black Kenyan father – a biracial man with a Muslim name in a country at war in the Gulf. No matter how long one pores over the electoral map, his victory still seems unlikely if not implausible.

www.iHNed.cz

HOSPODÁŘSKÉ NOVINY

SPOLEČNOST, EKONOMIKA A POLITIKA V SOUVISLOSTECH

John McCain	162		349	Barack Obama
	Počet voličů *(Průběžné výsledky)*			
	(46,3%) 56 021 694		63 364 275 (52,4%)	
	Počet hlasů *(bez dvou posledních států)*			

Senát — Dříve 49 · 49 — Nyní 54 · 40
Sněmovna — Dříve 236 · 199 — Nyní 254 · 173
Pozn.: průběžné výsledky

Cena 18 Kč ◆ Deník vydavatelství **Economia** čtvrtek / 6. listopadu 2008 ◆ Číslo 218

Změna jménem Obama

CENA HN V ZAHRANIČÍ
Slovensko 28 Sk (0,93 EUR);
Germany, Belgium 1,80 EUR

08218
9 770862 958320

Změna pro USA

Američané mají před sebou vidinu dlouhé hospodářské recese a bojují ve dvou válkách. Od svého nového prezidenta čekají, že nalezne řešení těchto hlavních problémů.

1. Krize

Od Obamy se očekává, že zastaví propad ekonomiky a prosadí opatření, která opět nastartují růst. Strašák opakování Velké deprese ze třicátých let zastiňuje všechna ostatní témata.

2. Rasismus

Od prvního černošského prezidenta se čeká, že 143 let po zrušení otroctví odsune definitivně do historie přízrak rasové nenávisti. Současně Američané doufají, že se nestane obětí atentátu.

3. Zdraví

Nový prezident stojí před úkolem zavést co nejširší zdravotní pojištění. Vůbec žádné nemá 46 milionů Američanů, tedy patnáct procent obyvatel, což je nejvíce z vyspělých zemí.

4. Irák

Většina voličů očekává, že Obama stáhne vojáky z Iráku, ale zároveň povede úspěšně válku proti islamismu v Afghánistánu a v nejlepším případě chytne Usámu bin Ládina.

5. Ropa

Obama se bude muset pokusit snížit závislost americké ekonomiky na dodávkách ropy a zajistit snížení cen pohonných hmot.

Změna pro svět

Pro svět se Obama stává miláčkem, který má vylepšit obraz USA v zahraničí. Očekávání se ale v jednotlivých zemích a světadílech přece jen liší.

1. Vztah s EU

Evropané si slibují, že se s nimi bude více radit o světových záležitostech, nebude bez spojenců zahajovat války, postaví se do čela boje proti klimatickým změnám a nebude ustupovat Rusku.

2. Terorismus

Mnoho spojenců i odpůrců USA doufá, že Obama zavře vězení, v němž jsou drženy stovky údajných teroristů, na základně Guantánamo.

3. »Osa zla«

Západ věří, že Obama bude s Teheránem jednat o jaderném programu, ale nepošle na Írán bombardéry; že bude tvrdý vůči Severní Koreji a že pohlídá, aby se pákistánské jaderné zbraně nedostaly do rukou islamistů.

4. Muslimové

Arabský svět chce, aby nový prezident víc naslouchal jeho hlasu a zasadil se o vznik palestinského státu a nepodporoval Izrael.

5. Česko

Větší část Čechů podle průzkumů doufá, že Obama zruší program protiraketové obrany, menšina naopak doufá že USA radar v Brdech postaví.

Muž, který přepsal bílé dějiny Ameriky

Daniel Anýž
www.ihned.cz/anyz

/Od našeho zpravodaje v USA/

Barack Obama, sedmačtyřicetiletý černoch, který vychodil střední školu na Havaji a své místo v Americe si složitě hledal v prostředí Chicaga. Muž, který vyrůstal bez otce a částečně i bez matky, s prarodiči, kteří suplovali jejich místo.

Relativně nezkušený politik, který nemusel ještě řešit žádnou skutečně vážnou krizi. Demokrat, který v kampani otevřeně řekl, že přišel čas na silnější roli federální vlády a že bohatí se musejí o část svých zisků podělit se zbytkem společnosti.

V úterý si jej Američané vybrali za svého nového prezidenta.

První černoch v historii, který stane v čele Spojených států, dostal nejvíce hlasů bílých mužů ze všech dosavadních demokratických kandidátů. Získal mladé, získal menšiny, získal bílé vysokoškoláky, kteří dosud vždy většinově volili republikány. Protestant Obama získal více katolíků než před čtyřmi roky katolík John Kerry. A získal dokonce i ty, kterým »slíbil« zdanění: majetnou vrstvu s příjmy nad 200 000 dolarů.

V roce 1980 republikán Ronald Reagan obdobně široce oslovil Američany a nadlouho předurčil budoucnost. V úterý se tato kapitola stala minulostí. »Pokud někdo ještě může pochybovat, že Amerika je místem, kde je vše možné, tak dnešní noc je odpovědí,« pronesl Obama na konci dlouhého volebního dne.

Pokračování na straně 2

JAM-E-JAM Vol.9, No.2422. THU. Nov.6.2008

پنجشنبه ۱۶ آبان ۱۳۸۷ / ۷ ذی القعده ۱۴۲۹ / ۶ نوامبر ۲۰۰۸ / سال نهم / شماره ۲۴۲۲ / قیمت ۱۰۰ تومان

ضمیمه امروز

رسانه ها

گفت و گو

رویای سفر در زمان ۲۱

ما و تبلیغات ما ۹
نگاهی به تبلیغات پخش شده از شبکه‌های سیما

علیدوستی: ما عاشق و معشوق بودیم ۷
با پدر نوجوانان قهرمان آسیا

روزنامه فرهنگی - اجتماعی صبح ایران ۲۰ صفحه + سیب ۱۶ صفحه + ضمیمه نیازمندی‌ها ویژه استان تهران در ۱۲ صفحه

www.jamejamonline.ir

هشدار نظامی ایران به ارتش آمریکا

گروه سیاسی، ستاد کل نیروهای مسلح با انتشار اطلاعیه‌ای به فرماندهان ارتش آمریکا در عراق اخطار داد که در صورت هر گونه تجاوز به مرزها با کشورمان مواجه خواهند شد...

ادامه در صفحه ۲

افزایش مدت معافیت مشمولان شرایط ویژه

گروه جامعه، سنوات مجاز معافیت تحصیلی مشمولان خدمت وظیفه عمومی در دانشگاه‌ها و موسسات آموزش عالی کشور...

ادامه در صفحه ۱۷

نمایندگان مجلس تصویب کردند فوق لیسانس؛ حداقل سواد برای نامزدهای ریاست جمهوری

گروه سیاسی، نمایندگان مجلس شورای اسلامی مقرر کردند که داوطلبان حضور در انتخابات ریاست جمهوری علاوه بر شرایط مندرج در قانون، دارای تحصیلات کارشناسی ارشد بالاتر...

ادامه در صفحه

رئیس جمهور سیاه در کاخ سفید

اوباما سوار بر موج نارضایتی از عملکرد دوران ۸ ساله بوش به سادگی توانست رقیب خود را از میدان خارج کند

استقبال جهانی از پیروزی اوباما

رهبر معظم انقلاب: حج سفر تفریحی نیست غنیمت بشمارید

گروه سیاسی، حضرت آیت‌الله خامنه‌ای، رهبر معظم انقلاب اسلامی در دیدار با کارگزاران اجرایی و فرهنگی حج، حج را فریضه‌ای مهم و مختص برای حجاج دانستند و تاکید کردند...

ادامه در صفحه ۲

دیدار اول

اوباما شیفته‌گی!

محسن ماندگاری

همان طور که پیش‌بینی می‌شد باراک اوباما به شمار کلیدی دنبر دموکرات‌ها به عنوان چهل و چهارمین رئیس جمهور آمریکا و نخستین رئیس جمهور سیاه‌پوست این کشور انتخاب شد...

ادامه در صفحه ۲

Teheran, Iran

"A Black President in the White House"

www.jamejamonline.ir

STARS AND STRIPES.

Volume 67, No. 203 ©SS 2008 G THURSDAY, NOVEMBER 7, 2008 50¢

With a historic victory behind him, President-elect

BARACK OBAMA

builds his team and prepares for the challenges ahead

Complete election coverage on Pages 3-12

PABLO MARTINEZ MONSIVAIS/AP

Washington, D.C.

(published for US armed forces overseas)

www.stripes.com

President-elect Obama hugs his daughter Malia after his victory address in Grant Park.
PHOTOGRAPH BY DAVID BURNETT

The Big Picture: Barack Obama is sworn in as the 44th president of the United States by the Chief Justice of the Supreme Court, John Roberts, on the west steps of the U.S. Capitol in Washington, D.C., on Tuesday, January 20, 2009.

PHOTOGRAPH BY J.M. EDDINS JR./THE WASHINGTON TIMES

Inauguration Speech

The United States Capitol
Washington, D.C.
January 20, 2009

I stand here today humbled by the task before us, grateful for the trust you have bestowed, mindful of the sacrifices borne by our ancestors. I thank President Bush for his service to our nation, as well as the generosity and cooperation he has shown throughout this transition.

Forty-four Americans have now taken the presidential oath. The words have been spoken during rising tides of prosperity and the still waters of peace. Yet every so often the oath is taken amidst gathering clouds and raging storms. At these moments, America has carried on, not simply because of the skill or vision of those in high office, but because we, the people, have remained faithful to the ideals of our forebears, and true to our founding documents.

So it has been. So it must be with this generation of Americans.

promise

Michelle Obama holds the Bible used at President Abraham Lincoln's 1861 inauguration while her husband, Barack Obama, recites the oath of office. PHOTOGRAPH BY J.M. EDDINS JR./THE WASHINGTON TIMES

That we are in the midst of crisis is now well understood. Our nation is at war against a far-reaching network of violence and hatred. Our economy is badly weakened, a consequence of greed and irresponsibility on the part of some, but also our collective failure to make hard choices and prepare the nation for a new age. Homes have been lost; jobs shed; businesses shuttered. Our health care is too costly; our schools fail too many; and each day brings further evidence that the ways we use energy strengthen our adversaries and threaten our planet.

These are the indicators of crisis, subject to data and statistics. Less measurable but no less profound is a sapping of confidence across our land − a nagging fear that America's decline is inevitable, and that the next generation must lower its sights.

Today I say to you that the challenges we face are real. They are serious and they are many. They will not be met easily or in a short span of time. But know this, America − they will be met.

On this day, we gather because we have chosen hope over fear, unity of purpose over conflict and discord.

On this day, we come to proclaim an end to the petty grievances and false promises, the recriminations and worn-out dogmas, that for far too long have strangled our politics.

We remain a young nation, but in the words of Scripture, the time has come to set aside childish things. The time has come to reaffirm our enduring spirit; to choose our better history; to carry forward that precious gift, that noble idea, passed on from generation to generation: the God-given promise that all are equal, all are free, and all deserve a chance to pursue their full measure of happiness.

In reaffirming the greatness of our nation, we understand that greatness is never a given. It must be earned. Our journey has never been one of shortcuts or settling for less. It has not been the path for the faint-hearted, for those who prefer leisure over work, or seek only the pleasures of riches and fame. Rather, it has been the risk-takers, the doers, the makers of things — some celebrated, but more often men and women obscure in their labor — who have carried us up the long, rugged path towards prosperity and freedom.

For us, they packed up their few worldly possessions and traveled across oceans in search of a new life.

For us, they toiled in sweatshops and settled the West; endured the lash of the whip and plowed the hard earth.

For us, they fought and died, in places like Concord and Gettysburg; Normandy and Khe Sanh.

Time and again these men and women struggled and sacrificed and worked till their hands were raw so that we might live a better life. They saw America as bigger than the sum of our individual ambitions; greater than all the differences of birth or wealth or faction.

This is the journey we continue today. We remain the most prosperous, powerful nation on Earth. Our workers are no less productive than when this crisis began. Our minds are no less inventive, our goods and services no less needed than they were last week or last month or last year. Our capacity remains undiminished. But our time of standing pat, of protecting narrow interests and putting off unpleasant decisions, that time has surely passed. **Starting today, we must pick ourselves up, dust ourselves off, and begin again the work of remaking America.**

For everywhere we look, there is work to be done. The state of our economy calls for action, bold and swift, and we will act − not only to create new jobs, but to lay a new foundation for growth. We will build the roads and bridges, the electric grids and digital lines that feed our commerce and bind us together. We will restore science to its rightful place, and wield technology's wonders to raise health care's quality and lower its cost. We will harness the sun and the winds and the soil to fuel our cars and run our factories. And we will transform our schools and colleges and universities to meet the demands of a new age. All this we can do. All this we will do.

Now, there are some who question the scale of our ambitions, who suggest that our system cannot tolerate too many big plans. Their memories are short. For they have forgotten what this country has already done, what free men and women can achieve when imagination is joined to common purpose and necessity to courage.

What the cynics fail to understand is that the ground has shifted beneath them, that the stale political arguments that have consumed us for so long no longer apply. The question we ask today is not whether our government is too big or too small, but whether it works − whether it helps families find jobs at a decent wage, care they can afford, a retirement that is dignified. Where the answer is yes, we intend to move forward. Where the answer is no, programs will end. And those of us who manage the public's dollars will be held to account − to spend wisely, reform bad habits, and do our business in the light of day − because only then can we restore the vital trust between a people and their government.

Nor is the question before us whether the market is a force for good or ill. Its power to generate wealth and expand freedom is unmatched, but this crisis has reminded us that without a watchful eye, the market can spin out of

control. The nation cannot prosper long when it favors only the prosperous. The success of our economy has always depended not just on the size of our gross domestic product, but on the reach of our prosperity, on the ability to extend opportunity to every willing heart – not out of charity, but because it is the surest route to our common good.

As for our common defense, **we reject as false the choice between our safety and our ideals.** Our Founding Fathers, faced with perils that we can scarcely imagine, drafted a charter to assure the rule of law and the rights of man, a charter expanded by the blood of generations. Those ideals still light the world, and we will not give them up for expedience sake. And so to all the other peoples and governments who are watching today, from the grandest capitals to the small village where my father was born: know that America is a friend of each nation and every man, woman, and child who seeks a future of peace and dignity, and we are ready to lead once more.

Recall that earlier generations faced down fascism and communism not just with missiles and tanks, but with the sturdy alliances and enduring convictions. They understood that our power alone cannot protect us, nor does it entitle us to do as we please. Instead, they knew that **our power grows through its prudent use; our security emanates from the justness of our cause, the force of our example, the tempering qualities of humility and restraint.**

We are the keepers of this legacy. Guided by these principles once more, we can meet those new threats that demand even greater effort – even greater cooperation and understanding between nations. We will begin to responsibly leave Iraq to its people, and forge a hard-earned peace in Afghanistan. With old friends and former foes, we will work tirelessly to lessen the nuclear threat and roll back the specter of a warming planet. We will not apologize for our way of

life, nor will we waver in its defense, and **for those who seek to advance their aims by inducing terror and slaughtering innocents, we say to you now that our spirit is stronger and cannot be broken. You cannot outlast us, and we will defeat you.**

For we know that our patchwork heritage is a strength, not a weakness. We are a nation of Christians and Muslims, Jews and Hindus and non-believers. We are shaped by every language and culture, drawn from every end of this Earth; and because we have tasted the bitter swill of civil war and segregation and emerged from that dark chapter stronger and more united, we cannot help but believe that the old hatreds shall someday pass; that the lines of tribe shall soon dissolve; that as the world grows smaller, our common humanity shall reveal itself; and that America must play its role in ushering in a new era of peace.

To the Muslim world, we seek a new way forward based on mutual interest and mutual respect. **To those leaders around the globe who seek to sow conflict or blame their society's ills on the West, know that your people will judge you on what you can build, not what you destroy.** To those who cling to power through corruption and deceit and the silencing of dissent, know that you are on the wrong side of history, but that we will extend a hand if you are willing to unclench your fist.

To the people of poor nations, we pledge to work alongside you to make your farms flourish and let clean waters flow; to nourish starved bodies and feed hungry minds. And to those nations like ours that enjoy relative plenty, we say we can no longer afford indifference to the suffering outside our borders; nor can we consume the world's resources without regard to effect. For the world has changed, and we must change with it.

As we consider the road that unfolds before us, we remember with humble gratitude those brave Americans who, at this very hour, patrol far-off deserts and distant mountains. They have something to tell us today, just as the fallen heroes who lie in Arlington whisper through the ages. We honor them not only because they are guardians of our liberty, but because they embody the spirit of service — a willingness to find meaning in something greater than themselves. And yet, at this moment — a moment that will define a generation — it is precisely this spirit that must inhabit us all.

For as much as government can do and must do, it is ultimately the faith and determination of the American people upon which this nation relies. It is the kindness to take in a stranger when the levees break, the selflessness of workers who would rather cut their hours than see a friend lose their job, which sees us through our darkest hours. It is the firefighter's courage to storm a stairway filled with smoke, but also a parent's willingness to nurture a child, that finally decides our fate.

Our challenges may be new. The instruments with which we meet them may be new. But those values upon which our success depends — honesty and hard work, courage and fair play, tolerance and curiosity, loyalty and patriotism — these things are old. These things are true. They have been the quiet force of progress throughout our history. What is demanded then is a return to these truths. What is required of us now is a new era of responsibility, a recognition on the part of every American that we have duties to ourselves, our nation, and the world, duties that we do not grudgingly accept but rather seize gladly, firm in the knowledge that there is nothing so satisfying to the spirit, so defining of our character, than giving our all to a difficult task.

This is the price and the promise of citizenship. This is the source of our confidence – the knowledge that God calls on us to shape an uncertain destiny.

This is the meaning of our liberty and our creed, why men and women and children of every race and every faith can join in celebration across this magnificent Mall, and why a man whose father less than 60 years ago might not have been served at a local restaurant can now stand before you to take a most sacred oath.

So let us mark this day with remembrance, of who we are and how far we have traveled. In the year of America's birth, in the coldest of months, a small band of patriots huddled by dying campfires on the shores of an icy river. The capital was abandoned. The enemy was advancing. The snow was stained with blood. At a moment when the outcome of our revolution was most in doubt, the father of our nation ordered these words be read to the people:

"Let it be told to the future world . . . that in the depth of winter, when nothing but hope and virtue could survive . . . that the city and the country, alarmed at one common danger, came forth to meet [it]."

America, in the face of our common dangers, in this winter of our hardship, let us remember these timeless words. With hope and virtue, let us brave once more the icy currents, and endure what storms may come. **Let it be said by our children's children that when we were tested, we refused to let this journey end; that we did not turn back, nor did we falter; and with eyes fixed on the horizon and God's grace upon us, we carried forth that great gift of freedom and delivered it safely to future generations.**

Thank you, God bless you, and God bless the United States of America. ★

The newly inaugurated 44th president of the United States addresses a crowd estimated at 1.5 million. PHOTOGRAPH BY DIRCK HALSTEAD/THE DIGITAL JOURNALIST/ZUMA PRESS

Arizona Daily Star

COMMEMORATIVE INAUGURATION SECTION • WEDNESDAY, JANUARY 21, 2009

CHUCK KENNEDY / MCT

THE INAUGURATION OF THE 44TH PRESIDENT

BARACK OBAMA

On an extraordinary day in the life of America, more than a million people waited for hours in frigid temperatures to witness an African-American man take command of a nation founded by slaveholders. It was a scene watched in fascination by many millions — perhaps billions — around the world.

To his countrymen Barack Obama urged, "What is required of us now is a new era of responsibility — a recognition, on the part of every American, that we have duties to ourselves, our nation and the world,

duties that we do not grudgingly accept but rather seize gladly. This is the price and promise of citizenship."

Choirs sang. The world's finest musicians performed. High school bands paraded. And tears streamed down faces, weathered and smooth alike, as the son of a white American and a black African immigrant ascended to his place in history.

The presidency of the United States of America passed from Republican George W. Bush to Democrat Obama at the stroke of noon, marking one of democracy's greatest gifts: the peaceful transfer of power.

EIGHT PAGES OF INAUGURATION COVERAGE

75¢ plus tax • One dollar outside Southern Arizona

Tucson, Arizona

www.azstarnet.com

Surveying the pieces
U.N. chief tours Gaza ruins, urges care in keeping fragile truce. – International, 8A

Fiat's drive for Chrysler
Deal forged to aid U.S. carmaker, widen Italian auto empire. – Business, 1D

Arkansas Democrat ✠ Gazette

ARKANSAS' NEWSPAPER

Copyright © 2009, Arkansas Democrat-Gazette, Inc.

Printed at Little Rock • Wednesday, January 21, 2009 ArkansasOnline.com 60 Pages 9 Sections **50¢**

President Obama

Bloomberg News/MARK WILSON

Barack Obama, with his wife, Michelle, holding the Bible used by Abraham Lincoln for the inaugural ceremony in 1861, is sworn in Tuesday on the steps of the U.S. Capitol as the 44th president of the United States.

1.8 million on hand to see history unfold

BY MATTHEW S.L. CATE
ARKANSAS DEMOCRAT-GAZETTE

WASHINGTON — Shivering in the brutal cold and shuffling through long lines and crowded streets, as many as 1.8 million people swamped the nation's capital in search of the memory of a lifetime.

Travelers bound for President Barack Obama's inauguration ceremony Tuesday clogged the city's subways, and a taillight-twinkling flotilla of charter buses invaded the city. And all that before sunrise.

Through it all, the weary visitors from across the globe — including at least several hundred from Arkansas — wouldn't let the particulars of the day distract them from celebrating the nation's first black president.

"We waited 40 years. We can wait a while longer," one woman said while stuck in a queue for a shuttle bus bound

for the National Mall.

"We waited 400 years," a friend replied.

There are no official estimates of the crowd that stretched roughly two miles from the U.S. Capitol to west of the Washington Monument. Unofficial estimates based on crowd photos put the number at more than 1 million. Some security officials pegged the number at 1.8 million, and others had projected a turnout of 2 million.

That's well below initial predictions of 4 million or more, but it would top President Lyndon Johnson's 1965 swearing-in as the biggest inaugural draw. The National Park Service, which no longer offers estimates, put Johnson's ceremonial crowd at 1.2 million.

Throughout the ceremony, the huddled pack of joyous
See **CROWD**, Page 4A

AP/SUSAN WALSH

Daughter Sasha congratulates the new president after the swearing-in.

He assumes office with call for unity, determined effort

BY JANE FULLERTON
ARKANSAS DEMOCRAT-GAZETTE

WASHINGTON — Ascending to office at "a moment that will define a generation," Barack Hussein Obama achieved a milestone in American history Tuesday by becoming the first black president, calling for "a new era of responsibility" as both individuals and the nation work to restore economic stability and global leadership.

Employing the sweeping rhetoric and rhythmic cadence that are the hallmarks of his speeches, the 44th president used his 18-minute inaugural address to call for "bold and swift" action to right the nation's faltering economy at home and bolster its slipping image abroad.

"Starting today, we must pick

ourselves up, dust ourselves off and begin again the work of remaking America," he declared.

An immense audience of well over a million people, who braved freezing temperatures to fill the National Mall from the steps of the U.S. Capitol to the foot of the Washington Monument and beyond, responded with exuberant cheers.

"For everywhere we look, there is work to be done," Obama said.

But Obama, who stood behind protective glass, punctuated his soaring prose with specific policy positions and unequivocally strong words for those who would do harm to the United States: "We will not apologize for our way of
See **OBAMA**, Page 4A

See **CROWD**, Page 4A
See **OBAMA**, Page 4A

WEATHER

LITTLE ROCK
Today Mostly sunny and mild.
High Mid-50s, light southsouthwest winds.
Tonight Mostly clear.
Low 32.

Home delivery
378-3456
Outside Pulaski County
1-800-482-1121

6 38333 00050 5

ON THE INSIDE

THE NEW PRESIDENT and the chief justice were tripped up by the word "faithfully" during the oath of office. Page 5A.

SOME MEMBERS of the Arkansas congressional delegation were amazed by the huge crowds. Page 5A.

SOME PEOPLE had never before watched an inauguration, even on TV. But Tuesday, many Arkansans joined watch parties in schools, museums and other places to see history in the making. Page 5A.

THE INAUGURATION gave schoolchildren a chance to learn about one of the biggest events in U.S. government. Page 5A.

HILLARY RODHAM CLINTON hit a speed bump on her way to Senate confirmation as secretary of state. Page 6A.

SEN. TED KENNEDY suffered an apparent seizure at a

post-inauguration luncheon in Obama's honor, but fellow senator from Massachusetts John Kerry visited him at the hospital and said Kennedy was "laughing and joking right now. He's got all his Irish dander up." Page 7A.

LESS THAN AN HOUR after Obama took the oath of office, former President George W. Bush and his family were in the air, now private citizens and bound for Texas. Page 7A.

OBAMA'S inaugural address. Page 6A.

AP/PAUL SANCYA

Ella Crawford (left), 73, and Mary K. Jones, 78, watch on television Tuesday from the nonprofit Hannan House in Detroit as Barack Obama is inaugurated.

San Francisco Chronicle

'THE WORLD HAS CHANGED'

THE INAUGURATION OF BARACK OBAMA

DOUG MILLS / New York Times

President Obama and wife Michelle step out of their limo for a brief walk of joy in the inaugural parade along Pennsylvania Avenue, heading toward the White House for the first time as the first couple.

A STEP INTO HISTORY: THRONGS WITNESS INAUGURATION OF NATION'S 44TH PRESIDENT

Complete coverage of the inauguration of Barack Hussein Obama, the first African American president of the United States, and the day of celebrations. **A4-A18**

'ALL OVER COFFEE' ARTIST OFFERS A PERSONAL VIEW OF THE CELEBRATION IN WASHINGTON

The Chronicle's Paul Madonna visits Washington and sketches his impressions of the festivities. **Datebook, C1**

FATIGUE BLAMED FOR KENNEDY'S SEIZURE

Sen. Ted Kennedy, who had surgery for brain cancer last June, suffers a seizure during a luncheon in Washington in honor of President Obama. But doctors say the Massachusetts Democrat is feeling better and is likely to be released today. **A19**

WEATHER
Chance of rain.
Highs to 63.
Lows to 38. **C8**
Index is on Page A2

7 38805 10005 1

Few presidents in modern history will encounter the magnitude of problems, domestic and international, that confront President Obama. His speech was sober about the challenges and powerful in its expression of resolve to meet them. He will need every ounce of the remarkable goodwill that was on display Tuesday.

– *San Francisco Chronicle*

Orlando Sentinel

January 21, 2009 75¢

CHUCK KENNEDY/MCCLATCHY-TRIBUNE

President Barack Obama takes the oath of office Tuesday as the 44th president of the United States, with his wife, Michelle, by his side at the Capitol in Washington.

Orlando, Florida

www.orlandosentinel.com

Chicago Tribune

WEDNESDAY, JANUARY 21, 2009 *INAUGURATION EDITION*

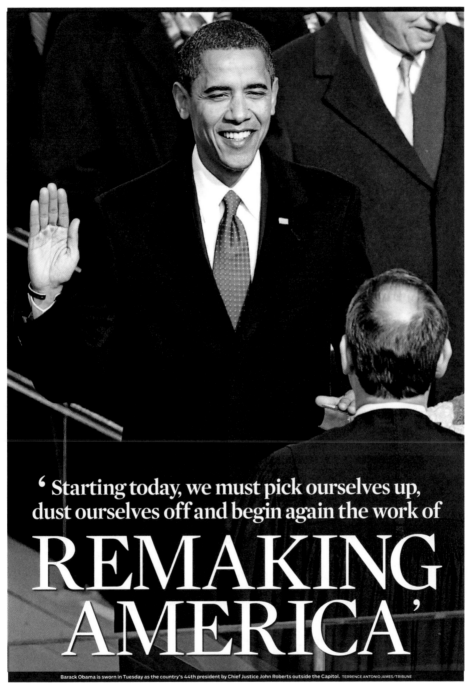

' Starting today, we must pick ourselves up, dust ourselves off and begin again the work of

REMAKING AMERICA '

Barack Obama is sworn in Tuesday as the country's 44th president by Chief Justice John Roberts outside the Capitol. TERRENCE ANTONIO JAMES/TRIBUNE

A moment that once seemed inconceivable became an irrefutable fact on Tuesday: An African-American, Barack Hussein Obama, is president of the United States.

Looking out over a crowd exceeding one million people, packing the National Mall where Dr. Martin Luther King told the world about his dream, Obama took the oath of office and described himself as "a man whose father less than 60 years ago might not have been served at a local restaurant" but who now will lead the nation.

Yet the new president tempered the celebration by acknowledging the multiple crises facing the nation: wars on two fronts, an imperiled economic system, and health care and schools badly needing reform – sobering words from a man who forged a worldwide reputation for soaring oratory.

The time for action is now, Obama said. But he warned the months and years ahead will require the resolute patience, determined labor and painful sacrifices that made the United States into a country that honors timeless values: "honesty and hard work, courage and fair play, tolerance and curiosity, loyalty and patriotism."

This," he said, "is the price and promise of citizenship."

FULL COVERAGE PAGES 2-27, 33 AND LIVE!

COMMEMORATIVE OBAMA INAUGURATION SECTION INSIDE

Chicago, Illinois

www.chicagotribune.com

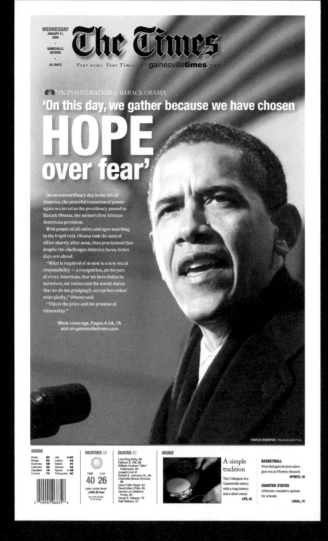

The Gainesville library audience watched the program intently and reacted almost as if they were at the live event. Some recited the Lord's Prayer along with the Rev. Rick Warren. When Obama was sworn in as president, they broke into applause. A few even shed tears.

HOPE RECESSION
TERRORISM HEALTH CARE
CHANGE ENVIRONMENT
IRAQ A NEW DAY
ECONOMY
TORTURE WAR UNKNOWN
CRIME UNITY POVERTY
KATRINA DIPLOMACY
EDUCATION FAITH
OBAMA RACE
GUANTANAMO DARFUR
MIDEAST TECHNOLOGY
IMMIGRATION HISTORIC
LIBERAL IRAN
CHINA BAILOUT
AFGHANISTAN ISRAEL
OUTSIDER RUSSIA
CIVIL RIGHTS YES WE CAN
MEDIA
CORRUPTION
DEFICIT Barack Obama
JOBS assumes presidency
AUDACITY against backdrop
FEMA of historic challenge
YOUNG and opportunity
DRUGS OIL
CUBA KENYA
HOUSING ILLUSTRATION BY SARA GREER/SUN HERALD
BIN LADEN MIDDLE CLASS
TALIBAN EQUALITY
CLIMATE CHANGE SECURITY
PALESTINIANS ENERGY
CHILDREN TAX CUTS

BARACK OBAMA, 44TH PRESIDENT OF THE UNITED STATES OF AMERICA

50¢ VOL. 125, NO. 110 LOCAL NEWS, A-2 www.sunherald.com

7 98256 00006 5

FOR HOME DELIVERY, CALL 1-800-346-2472 ez pay

THE INDIANAPOLIS STAR

WEDNESDAY, JANUARY 21, 2009 ★ *"Where the spirit of the Lord is, there is liberty"* II COR. 3:17 ★ 75 CENTS ★ CITY FINAL

"Starting today, we must pick ourselves up, dust ourselves off and begin again the work of remaking America."
PRESIDENT BARACK OBAMA

CHUCK KENNEDY / Associated Press

THE MOMENT: Barack Obama takes the oath of office as his wife, Michelle, holds the Bible used by Abraham Lincoln. Daughters Sasha (right) and Malia watched Tuesday at the U.S. Capitol.

'THE TIME HAS COME'

IN HISTORIC MOMENT, OBAMA TAKES OATH

More than 1 million witness inauguration of 1st black president

Barack Obama became the nation's 44th president Tuesday, telling a crowd that stretched from the steps of the Capitol to the Lincoln Memorial, and a watching nation, that "we must pick ourselves up, dust ourselves off and begin again the work of remaking America."

The ascent of the country's first African-American president, and the peaceful transfer of power in tumultuous times both at home and abroad, drew more than 1 million well-wishers and witnesses to history. Obama outlined the challenges facing the country: a collapsing economy, wars on two fronts, a lack of confidence in government and enemies who hate the very way of American life.

But Obama cautioned that the effort to address these challenges will require all citizens, no matter what party, age, skin color or status, to get to work.

"The time has come to set aside childish things,"

ROBERT SCHEER / The Star
IN INDIANAPOLIS: Daniel Gammons (left) and Rhonda Battles hug during inauguration festivities at Conseco Fieldhouse.

he said, invoking the Bible. "Greatness is never a given. It must be earned."

Obama was accompanied to the Capitol by President George W. Bush and sworn in by Chief Justice John Roberts. It was the first time Roberts administered the oath, and both men stumbled over the words. But the sight of the two youthful leaders — Roberts, 53, the second-youngest chief justice, and Obama, 47, the fourth-youngest man elected president — underscored the theme of generational change.

So did the presence of the youthful Michelle Obama and the couple's two grade-school daughters, Malia and Sasha.

Obama laid his hand on the burgundy-velvet-covered Bible that was used by Abraham Lincoln in 1861, and history again trembled.

— *The Washington Post*

INSIDE » REACTION AND PHOTOS FROM INDIANA AND AROUND THE WORLD ★ FULL TEXT OF OBAMA'S SPEECH
BUSH'S LAST DAY IN OFFICE ★ THE SCENE IN WASHINGTON, D.C. ★ PHOTOS FROM THE INAUGURAL BALLS

oaklandtribune.com

501

Volume 134, No. 336

Wednesday | January 21, 2009

75 cents plus tax

Oakland Tribune

Serving Oakland for 134 years

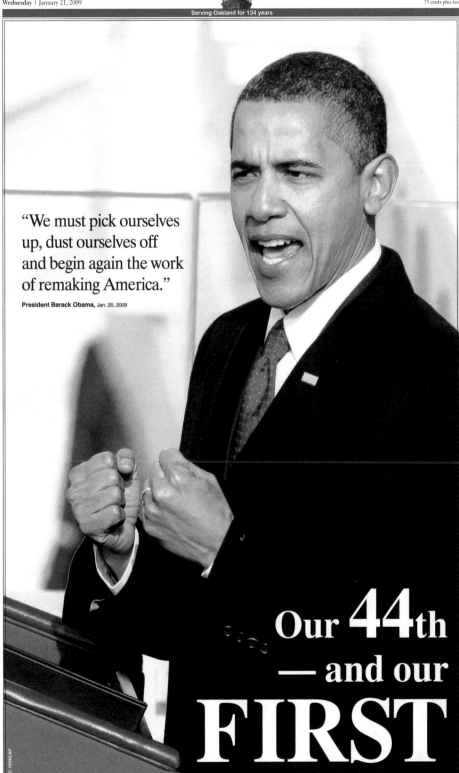

"We must pick ourselves up, dust ourselves off and begin again the work of remaking America."

President Barack Obama, Jan. 20, 2009

Our 44th — and our FIRST

JAE C. HONG/AP

THE EAST BAY MARKS NEW ERA	OBAMA'S SPEECH, WORD FOR WORD	COMPREHENSIVE COVERAGE FROM D.C.
PAGE A1	PAGE AA5	INSIDEBAYAREA.COM

Oakland, California

www.insidebayarea.com/oaklandtribune

**Crowds on the Washington Mall
celebrate moments after Barack
Obama is sworn in as president.**
PHOTOGRAPH BY MARK GREENBERG

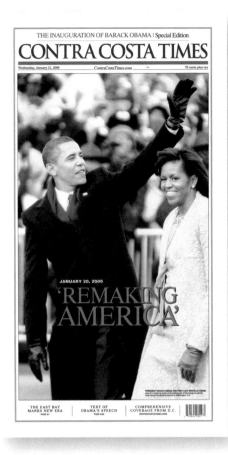

Contra Costa County, California

www.contracostatimes.com

Twin Falls, Idaho

www.magicvalley.com

Carbondale, Illinois

www.southernillinoisan.com

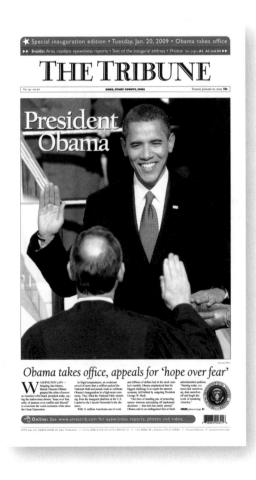

Ames, Iowa

www.amestrib.com

The Times-Picayune

'A new era of responsibility'

PRESIDENT OBAMA

The world watches as America inaugurates its 44th president

New Orleans, Louisiana
www.nola.com

KENNEBEC JOURNAL

BARACK OBAMA · 44th PRESIDENT

CALL TO ACTION

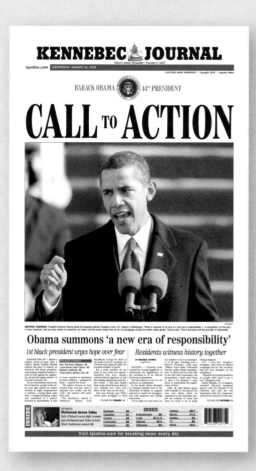

Obama summons 'a new era of responsibility'

1st black president urges hope over fear *Residents witness history together*

Augusta, Maine
www.kennebecjournal.mainetoday.com

SPECIAL INAUGURATION EDITION

Bangor Daily News

WEDNESDAY, JANUARY 21, 2009 75 cents

'REMAKING AMERICA'

A cheering nation welcomes first black president of U.S.

Obama's somber, hopeful speech inspires Mainers

Bangor, Maine
www.bangornews.com

Morning Sentinel

WEDNESDAY, JANUARY 21, 2009

BARACK OBAMA · 44th PRESIDENT

A NEW DAY

Nation's first black president hails 'hope over fear'

America watches as Obama makes history

In Skowhegan, Obama fans rejoice at inauguration party

Waterville, Maine
www.morningsentinel.mainetoday.com

The Star-Ledger

THE NEWSPAPER FOR NEW JERSEY

WEDNESDAY, JANUARY 21, 2009 / 75 CENTS

3EX00

A NATION CHEERS ITS NEW LEADER

PRESIDENT OBAMA CALLS FOR UNITY IN FACE OF CRISIS

BY J. SCOTT ORR FOR THE STAR-LEDGER

WASHINGTON — Barack Obama was sworn in yesterday as the nation's first African-American president, calling for a return to the values of hard work and honesty as America grapples with a recession and two foreign wars.

Sounding themes both optimistic and realistic, Obama refused to suggest the road to economic recovery would be easy, saying the nation must unify behind a shared agenda of sacrifice and selflessness.

"Today I say to you that the challenges we face are real. They are serious and they are many. They will not be met easily or in a short span

of time. But know this, America, they will be met," Obama said before a thunderous sea of a million celebrating hearts.

"What is required of us now is a new era of responsibility — a recognition, on the part of every American, that we have duties to ourselves, our nation, and the world," the newly sworn-in president said.

Obama's words were met by resounding cheers and joyous tears from an extraordinary gathering of Americans of all ages, races and ethnic backgrounds who braved the cold to witness history and stood shoulder to shoulder for 20 blocks across the heart of federal Washington.

There were some slight missteps during the 35-word oath of office, administered for the first time by Chief Justice John Roberts. Still, a faint expression of satisfaction pierced his otherwise serious demeanor as Obama made the

[See **SWORN IN**, Page 14]

AT LEFT: TIMOTHY A. CLARY/AGENCE FRANCE-PRESSE; ABOVE: DOUG MILLS/POOL PHOTO

The new president, Barack Obama, and the new first lady, Michelle Obama, thrill crowds along Pennsylvania Avenue during a parade to the White House.

OUR COLUMNISTS IN WASHINGTON

Bob Braun: Celebrations in the crowd show this was the people's moment. **Page 11**

Barry Carter: Human gridlock means it can take three hours just to cross a street. **Page 13**

Mark Di Ionno: On the bus ride from New Jersey, the long-held dream begins. **Page 16**

8 14186 00050 7

Newark, New Jersey

www.nj.com/starledger

The Charlotte Observer

'What is required of us now is a new era of responsibility – a recognition, on the part of every American, that we have duties to ourselves, our nation and the world.'

PRESIDENT OBAMA

CHIP SOMODEVILLA – GETTY IMAGES

KEEPSAKE SECTION INSIDE

■ Carolinians listen and reflect – at the National Mall, and back home in Charlotte.
■ Complete texts of the inaugural address, the prayers and poem.

WORDS EVOKE PAST, FUTURE

■ Obama takes the oath on Lincoln's Bible in a day rich with historical echoes. **4A**
■ **Analysis:** The president makes clear his intent to break with the Bush era. **5A**

ECONOMY WON'T WAIT

The economy continued to worsen before the ceremonies were done: The Dow staged its worst-ever Inauguration Day decline. Bank of America shares fell 29 percent. **1D**

@ **charlotteobserver.com**

 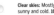

© 2009 The Charlotte Observer
Vol. 140, No. 21

37º 19º

Clear skies: Mostly sunny and cold. **10B**

Ask Amy**9E**	Editorial**10A**	Sports..........**1C**
Business**1D**	Horoscope**8E**	TV..........**4E**
Classified..........**7B**	Movies**4E**	Delivery assistance or to
Comics..........**8E**	Obituaries**4B**	subscribe...**800-532-5350**

7 83520 54321 8

Charlotte, North Carolina

www.charlotteobserver.com

For 19 minutes on Tuesday, Jan. 20, 2009, if you closed your eyes and opened your mind, everything was possible. There were no Democrats or Republicans. There were Americans.

PRESIDENT OBAMA

Record crowds cheer inauguration of nation's first black president

By DIXON McPHILLIPS
CRIMSON STAFF WRITER

WASHINGTON—Barack Hussein Obama was inaugurated as the 44th president of the United States yesterday before a record crowd of onlookers, taking his place in history as the first black commander-in-chief while calling on Americans to join together to confront the deepening financial crisis.

Obama, a 1991 graduate of Harvard Law School, took the oath of office just after noon on a chilly and crowded day in the nation's capital.

"With hope and virtue, let us brave once more the icy currents, and endure what storms may come," Obama told a crowd of well over one million people who packed the National Mall to witness the inauguration.

"Let it be said by our children's children that when we were tested, we refused to let this journey end," Obama said during his inauguration speech, which lasted about 20 minutes.

Obama was sworn in by Chief Justice John G. Roberts '76, a fellow Harvard Law graduate.

Obama and Roberts, both of whom were high-ranking editors on the Harvard

See OBAMA Page 8

Barack Obama, 44th President of the United States

MR. PRESIDENT President Barack Obama takes the oath of office from Chief Justice John G. Roberts '76 just after noon yesterday. During his inaugural address, he called on Americans to confront the deepening financial crisis.

"For those who seek to advance their aims by inducing terror... we say to you now that our spirit is stronger and cannot be broken."

★ ★
Barack Obama
PRESIDENT OF THE UNITED STATES

INAUGURAL FEVER Hundreds of onlookers at Harvard's Institute of Politics take in the historic inauguration ceremony. Viewers take pictures of the screen as Obama recites the oath of office while others snap shots of a cut-out of the new president. A number of locals attended the viewing at the IOP's John F. Kennedy Jr. Forum, which was also home to a similar election party on the night of Obama's victory two and a half months ago.

29,000 Apply For Class of 2013

Acceptance rate likely to hit record low amid record number of applicants

By JILLIAN E. KUSHNER
CRIMSON STAFF WRITER

Ph.D. Admissions Now Tighter

By BONNIE J. KAVOUSSI
CRIMSON STAFF WRITER

BY THE NUMBERS

15%, 9%

3%

8%, 5%

The Harvard Crimson
THE UNIVERSITY DAILY SINCE 1873 · WEDNESDAY, JANUARY 21, 2009 · CAMBRIDGE, MASSACHUSETTS

Cambridge, Massachusetts

www.thecrimson.com

Daily Journal · NORTHEAST MISSISSIPPI · WEDNESDAY, January 21, 2009 · Regional Edition
Volume 125 • No. 297 · A Journal Publishing Company product · A LOCALLY OWNED NEWSPAPER DEDICATED TO THE SERVICE OF GOD AND MANKIND. · 50 CENTS • TUPELO, MISS.

BARACK OBAMA
The 44th president of the United States of America

Today I say to you that the challenges we face are real. They are serious and they are many. They will not be met easily or in a short span of time. But know this, America – they will be met.

from President Obama's inaugural address

CONTINUING COVERAGE INSIDE

PAGE 2A ■ Inauguration Day notebook PAGES 4,5A ■ Obama opens new era ■ Speech highlights
■ Biden has his day ■ Bush bids farewell PAGE 6A ■ Students take part in living history
PAGE 10A ■ Legislators take in the day's events

Tupelo, Mississippi

www.djournal.com

Portsmouth Herald · WEDNESDAY, JAN. 21, 2009

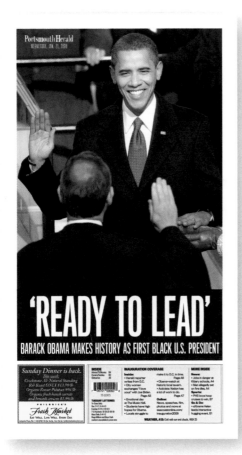

'READY TO LEAD'
BARACK OBAMA MAKES HISTORY AS FIRST BLACK U.S. PRESIDENT

Portsmouth, New Hampshire

www.seacoastonline.com

Wednesday, January 21, 2009
NEWS & RECORD
Greensboro, North Carolina • www.news-record.com

The nation has a new first family as Barack Obama takes the oath of office to become the United States' 44th president. From left, Michelle, Malia and Sasha Obama were part of the festivities at the Capitol.

Obama: Starting today, we must pick ourselves up, dust ourselves off, and begin again the work of

REMAKING AMERICA

NATIONAL
On his first day, president charts the way forward

By Margaret Talev
McClatchy Newspapers

LOCAL
A historic event through the eyes of Greensboro

Staff Report

MORE COVERAGE ONLINE AT NEWS-RECORD.COM

Greensboro, North Carolina

www.news-record.com

Erie, Pennsylvania

www.goerie.com

Sioux Falls, South Dakota

www.argusleader.com

Petersburg, Virginia

www.progress-index.com

Vancouver, Washington

www.columbian.com

TIMES UNION

timesunion.com

75 CENTS

ALBANY, NEW YORK ■ WEDNESDAY, JANUARY 21, 2009

❝ What is required of us now is a new era of responsibility ... This is the price and promise of citizenship. ❞

BARACK OBAMA, left, takes the oath of office from Chief Justice John Roberts on Tuesday at the Capitol in Washington, making him the 44th president of the United States as Michelle Obama holds the Lincoln Bible.

TIMOTHY A. CLARY/GETTY IMAGES

INAUGURATION COVERAGE

HARAZ N. GHANBARI/ASSOCIATED PRESS
VICE PRESIDENT JOE BIDEN and his wife, Jill, celebrate Tuesday.

Obama's message of hope over fear

BY STEVEN THOMMA
McClatchy

WASHINGTON — Barack Hussein Obama became the 44th president of the United States on Tuesday, the first African-American to reach the pinnacle of American political life, fulfilling at last the full promise of a nation born with the pledge that all men are created equal.

He took office as a confident young leader ushering in a new era with a promise of bold action to lift the country out of the worst economic crisis since the Great Depression.

Taking the oath on the steps of a Capitol built in part by slaves, Obama looked out over a sea of more than 1 million people, faces of every color, celebrating a turning point of history and looking eagerly for a new voice and vision to lead the country in a new century.

"Today I say to you that the challenges we face are real. They are serious and they are many," he said in a 18-minute inaugural address that was at turns sober about the nation's problems and uplifting about its prospects. "They will not be met easily or in a short span of time. But know this, America: They will be met."

To his countrymen, he urged "a new era of responsibility," but also a greater role for the government, help for the poor and a stronger hand in regulating private markets,

Please see **OBAMA A16** ▶

On the Web

For the ongoing updates on President Obama's first full day in office.

http://timesunion.com

■ **Watch** video of Inauguration Day in the Capital Region.

■ **View** photo galleries, both local and national.

■ **See** the full text of the inauguration speech.

■ **Check** out some past inaugural speeches.

■ **Twitter** from Kristi Gustafson on Washington, D.C. fashion.

■ **Watch** video of what Capital Region residents want President Obama to do in his first 100 days in office.

WEATHER

HIGH **20°** LOW **13°**

No winter thaw in store for this January./**A2**

MORE NEWS

Doctors sent to prison

Physician brothers who are AIDS specialists sentenced to years in prison in Iran./**B1**

State fees increase for businesses

Payment is due by month's end for a number of fees on businesses./**D1**

A busy night for high school hoops

There were 54 games on the schedule. Who won? We have it covered./**C3**

THE TENNESSEAN

WEDNESDAY, JANUARY 21, 2009 • NASHVILLE

'We have chosen hope over fear'

CHARLIE NEIBERGALL / ASSOCIATED PRESS

AS HE ASCENDED TO THE PRESIDENCY IN A HISTORIC TRANSITION TUESDAY,
BARACK OBAMA CHRONICLED THE NATION'S
CHALLENGES, CALLING UPON ALL AMERICANS
TO JOIN HIM IN BUILDING A BETTER FUTURE.

More than 1 million people in Middle Tennessee read our newspapers and use our Web sites every week.

Tennessean.com Metromix.com HighSchoolSports.net TennesseeGreen.com MomsLikeMe.com

VOL. 105, NO. 21
© 2009 GANNETT CO., INC.
ALL RIGHTS RESERVED
SUBSCRIBE: 1-800-342-8237

0 40901 05606 5

Nashville, Tennessee

www.tennessean.com

CORPUS CHRISTI

Caller Times

50 CENTS • WEDNESDAY, JANUARY 21, 2009 • CITY EDITION • caller.com

BARACK OBAMA 44th PRESIDENT OF THE UNITED STATES

JOURNEY BEGINS

New leader calls on nation to unite as world watches

President Barack Obama (left) shakes hands with Chief Justice John Roberts after taking the oath of office Tuesday *at the U.S. Capitol in Washington, D.C. At right rear is first lady Michelle Obama. More than 1 million people crowded into the National Mall and along the parade route Tuesday in one of the largest gatherings in the nation's capital.*

NATIONALLY
- Obama makes history at the helm 4A
- Prayer for racial equality brings hearty amen 4A
- Worldwide congratulations 4A
- Swearing-in a dream fulfilled for older black activists 5A
- Bush returns to Texas 5A

LOCALLY
- A&M-CC honors MLK with march before watching inauguration 6A
- Residents who remember sanctioned segregation celebrate strides 6A
- Local columnist in Washington: 'My life will forever be changed' 6A
- Area residents' thoughts 8A

caller.com
- Complete text of Obama's speech
- PHOTO GALLERY: Stars and statesmen turn out for inauguration
- VIDEO: Texas A&M-Corpus Christi students comment on incoming president
- POLL: How long a grace period will Americans give Obama?

WASHINGTON — Barack Hussein Obama claimed his place in history as America's first black president Tuesday, summoning a dispirited and divided nation to unite in hope against the "gathering clouds and raging storms" of unfinished war and grave economic woes.

A jubilant crowd of more than a million waited for hours in frigid temperatures to witness the moment as a young black man took command of a nation founded by slaveholders. It was a scene watched in fascination by many millions — perhaps billions — around the world.

Associated Press

Former President George W. Bush and his wife, Laura, *depart Andrews Air Force Base on Tuesday. They were welcomed back to Midland later in the day.*

'America, in the face of our common dangers, in this winter of our hardship, let us remember these timeless words. With hope and virtue, let us brave once more the icy currents, and endure what storms may come.' — PRESIDENT BARACK OBAMA

Corpus Christi, Texas

www.caller.com

INAUGURATION 2009

FORT WORTH
Star-Telegram

'Hope over fear'

Taking office as the first black president, Barack Obama calls for 'a new era of responsibility' to remake America

Six-page commemorative section, AA
Local celebrations, 1–2B More coverage, 13–14A, 18B

POOL PHOTO/McCLATCHY-TRIBUNE/CHUCK KENNEDY

MARKETS	**SHOPPING**	**DROUGHT**	**SOUTHLAKE**
Dow drops below 8,000 as Wall Street takes a beating 1C	Stock Show vendors report that business is surprisingly brisk 1C	Spell of dry weather could bring tighter water restrictions 1B	Hand-held cellphones banned for drivers in city's school zones 8B

Fort Worth, Texas

www.star-telegram.com

Barack Obama and his wife, Michelle, walk down Pennsylvania Avenue toward the White House after Obama has been sworn in as the 44th president of the United States. PHOTOGRAPH BY MARY F. CALVERT/THE WASHINGTON TIMES

Dublin, Ireland

"I'm ready to lead"

www.independent.ie

Seoul, Korea

"The Beginning of 'Change'"

www.donga.com

Rosa Parks sat so that Martin could walk; Martin walked so that Obama could run; Obama ran so our children could fly. – *The Independent, Ireland*

MILENIO

MÉXICO
MIÉRCOLES
21 DE ENERO
DE 2009

www.milenio.com

DIARIO • A[...] $10.00 •

periodismo con carácter

SUSAN WALSH/AP

Vocero de la PGR

Medina Mora no contrató al soplón

Bayardo fue llevado por Asuntos Internos de la SSP en 2006, afirman **página 29**

Convoca a rehacer EU, confirma el retiro de Irak y *olvida* el tema migratorio

Sube Obama, caen bolsas

- Tras su discurso de toma de posesión, el retroceso de los mercados
- La BMV se desploma 5.79% y el Dow Jones 4.01; el dólar, en $14.03
- Calderón y líderes del Senado avizoran una relación más estrecha
- Obama y el racismo • José Carreño Figueras **páginas 6 a 8, 16 y 32 a 37**

■ ■ ■ ■

El asalto a la razón
Carlos Marín

Diagnósticos preliminares

A punto de cumplir 77 años y operado hace poco de un tumor cerebral maligno, el senador demócrata por Massachusetts desde 1962, Edward Kennedy, se desmayó ayer durante el almuerzo en honor de Barack Obama, y es probable que su desvanecimiento esté relacionado con la secuela de la intervención quirúrgica.

Y ¡chin!: le sucedió lo mismo y en el mismo acto a su correligionario y compañero de bancada por Virginia Occidental, Robert Byrd, quien tiene ya 91 años y padece el mal de Parkinson.

El segundo caso quizá nada tenga que ver con oncólogos ni gerontólogos, pero sí con psicólogos y hasta psiquiatras, ya que se trata de un ex persecutor de negros que en sus años mozos militó en el Ku Klux Klan. Y ya estaba grandecito y era senador (lleva siéndolo 50 años: los mismos de Fidel Castro en el poder cubano) cuando, en 1964, combatió rabiosamente la Ley de Derechos Civiles.

Así que es de imaginarse al viejito intentando, junto con el almuerzo, tragarse el acontecimiento que estaba celebrando.

cmarin@milenio.com

Monterrey, Mexico

"Obama Up, Market Down"

impreso.milenio.com

My favourite moment was, while
leaving the White House, a mother
and her child were walking away.
The little girl was saying the names,
"Bush, Obama." With one of her hands,
she was holding her mom's, in the
other, she clutched an action figure
of the new President.

16 PAGES INSIDE SOUVENIR EDITION
Abel, de Souza, Corcoran, Kay, Gunter and more

MR. PRESIDENT

JOHN MOORE / POOL VIA BLOOMBERG NEWS

WED. JAN. 21, 2009
VOL. 11 NO. 71

nationalpost.com
Breaking news at
nationalpost.com

FP

DROPS TO 1%
Nobody's buying
bank's historic
cut. *Thorpe, FP1*

CANADA

DOUBT RAISED
Khadr's ID of Arar
questioned. *A13*

Published by National Post Company,
a general partnership owned by National Post
Holdings Ltd. and Canwest Media Inc.
Return undeliverable Canadian copies to
300-1450 Don Mills Rd., Don Mills, Ont. M3B 3R5

0 58778 00050 0
Publication Mail Agreement Number 40069573

'A new era of responsibility'

Obama pledges to "begin again the work of remaking America" in
address that reached out to the world and implicitly rebuked Bush.

nationalpost.com

For exclusive online commentary, transcripts of our mobile
live-blog from the streets of D.C., a gallery of inauguration day
images and much more, visit nationalpost.com

23 YEARS OF INDEPENDENT REPORTING

the namibian

STILL TELLING IT LIKE IT IS! VOL. 24 NO. 13

N$3 WEDNESDAY JANUARY 21 2009

PRESIDENT OBAMA!

The 44th President of the United States of America, Barack Obama waves to the crowd after taking the Oath of Office yesterday. Millions witnessed the historic event. See pages 2, 8 and 15-18

Tel: (061) 279600; Fax: 279602; PO Box 20783, Windhoek; e-mail: news@namibian.com.na; website: www.namibian.com.na

Madrid, Spain

"Obama Promises a New Era"

www.elpais.com

Caracas, Venezuela

"Obama: The U.S. Must Change"

www.ultimasnoticias.com.ve

You could feel the energy in the crowd, it was in the air. It's bigger than anything I've ever been a part of, said Jovan Mayfield (18), who travelled from New York to join a human tide flooding the National Mall and the parade route to the White House. – *The Namibian*

President Barack Obama and his wife, Michelle, dance across the presidential seal at the Commander-in-Chief Inaugural Ball in Washington, D.C. PHOTOGRAPH BY MARK WILSON/BLOOMBERG NEWS

There were – oh, I don't know, let's say a billion or so? – people watching around the world. Not to mention . . . every eye in the house locked on them and one of the country's biggest stars warbling just for them. Yet they murmured to one another, nuzzled and swayed comfortably around the stage as if it was a small gathering of friends they could temporarily ignore. If either felt the slightest hint of nervousness, self-consciousness or the nagging fear that – just possibly – expectations were getting a little out of hand, they didn't show it.

– *Kelly McParland, National Post (Canada)*

We the People

of the United States, in Order to form a more perfect Union, establish Justice, insure domestic Tranquility, provide for the common defence, promote the general Welfare, and secure the Blessings of Liberty to ourselves and our Posterity, do ordain and establish this Constitution for the United States of America.

Article. I.

Section. 1. All legislative Powers herein granted shall be vested in a Congress of the United States, which shall consist of a Senate and House of Representatives.

Section. 2. The House of Representatives shall be composed of Members chosen every second Year by the People of the several States, and the Electors in each State shall have the Qualifications requisite for Electors of the most numerous Branch of the State Legislature.

No Person shall be a Representative who shall not have attained to the Age of twenty five Years, and been seven Years a Citizen of the United States, and who shall not, when elected, be an Inhabitant of that State in which he shall be chosen.

Representatives and direct Taxes shall be apportioned among the several States which may be included within this Union, according to their respective Numbers, which shall be determined by adding to the whole Number of free Persons, including those bound to Service for a Term of Years, and excluding Indians not taxed, three fifths of all other Persons. The actual Enumeration shall be made within three Years after the first Meeting of the Congress of the United States, and within every subsequent Term of ten Years, in such Manner as they shall by Law direct. The Number of Representatives shall not exceed one for every thirty Thousand, but each State shall have at Least one Representative; and until such enumeration shall be made, the State of New Hampshire shall be entitled to chuse three, Massachusetts eight, Rhode-Island and Providence Plantations one, Connecticut five, New-York six, New Jersey four, Pennsylvania eight, Delaware one, Maryland six, Virginia ten, North Carolina five, South Carolina five, and Georgia three.

When vacancies happen in the Representation from any State, the Executive Authority thereof shall issue Writs of Election to fill such Vacancies.

The House of Representatives shall chuse their Speaker and other Officers; and shall have the sole Power of Impeachment.

Section. 3. The Senate of the United States shall be composed of two Senators from each State, chosen by the Legislature thereof, for six Years; and each Senator shall have one Vote.

Immediately after they shall be assembled in Consequence of the first Election, they shall be divided as equally as may be into three Classes. The Seats of the Senators of the first Class shall be vacated at the Expiration of the second Year, of the second Class at the Expiration of the fourth Year, and of the third Class at the Expiration of the sixth Year, so that one third may be chosen every second Year; and if Vacancies happen by Resignation, or otherwise, during the Recess of the Legislature of any State, the Executive thereof may make temporary Appointments until the next Meeting of the Legislature, which shall then fill such Vacancies.

No Person shall be a Senator who shall not have attained to the Age of thirty Years, and been nine Years a Citizen of the United States, and who shall not, when elected, be an Inhabitant of that State for which he shall be chosen.

The Vice President of the United States shall be President of the Senate, but shall have no Vote, unless they be equally divided.

The Senate shall chuse their other Officers, and also a President pro tempore, in the Absence of the Vice President, or when he shall exercise the Office of President of the United States.

The Senate shall have the sole Power to try all Impeachments. When sitting for that Purpose, they shall be on Oath or Affirmation. When the President of the United States is tried, the Chief Justice shall preside: And no Person shall be convicted without the Concurrence of two thirds of the Members present.

Judgment in Cases of Impeachment shall not extend further than to removal from Office, and disqualification to hold and enjoy any Office of honor, Trust or Profit under the United States: but the Party convicted shall nevertheless be liable and subject to Indictment, Trial, Judgment and Punishment, according to Law.

Section. 4. The Times, Places and Manner of holding Elections for Senators and Representatives, shall be prescribed in each State by the Legislature thereof; but the Congress may at any time by Law make or alter such Regulations, except as to the Places of chusing Senators.

The Congress shall assemble at least once in every Year, and such Meeting shall be on the first Monday in December, unless they shall by Law appoint a different Day.

Section. 5. Each House shall be the Judge of the Elections, Returns and Qualifications of its own Members, and a Majority of each shall constitute a Quorum to do Business; but a smaller Number may adjourn from day to day, and may be authorized to compel the Attendance of absent Members, in such Manner, and under such Penalties as each House may provide.

Each House may determine the Rules of its Proceedings, punish its Members for disorderly Behaviour, and, with the Concurrence of two thirds, expel a Member.

Each House shall keep a Journal of its Proceedings, and from time to time publish the same, excepting such Parts as may in their Judgment require Secrecy; and the Yeas and Nays of the Members of either House on any question shall, at the Desire of one fifth of those Present, be entered on the Journal.

Neither House, during the Session of Congress, shall, without the Consent of the other, adjourn for more than three days, nor to any other Place than that in which the two Houses shall be sitting.

Section. 6. The Senators and Representatives shall receive a Compensation for their Services, to be ascertained by Law, and paid out of the Treasury of the United States. They shall in all Cases, except Treason, Felony and Breach of the Peace, be privileged from Arrest during their Attendance at the Session of their respective Houses, and in going to and returning from the same; and for any Speech or Debate in either House, they shall not be questioned in any other Place.

No Senator or Representative shall, during the Time for which he was elected, be appointed to any civil Office under the Authority of the United States, which shall have been created, or the Emoluments whereof shall have been encreased during such time; and no Person holding any Office under the United States, shall be a Member of either House during his Continuance in Office.

Section. 7. All Bills for raising Revenue shall originate in the House of Representatives; but the Senate may propose or concur with Amendments as on other Bills.

Every Bill which shall have passed the House of Representatives and the Senate, shall, before it become a Law, be presented to the President of the

A More Perfect Union

The National Constitution Center
Philadelphia, Pennsylvania
March 18, 2008

"We the people, in order to form a more perfect union."

Two hundred and twenty-one years ago, in a hall that still stands across the street, a group of men gathered and, with these simple words, launched America's improbable experiment in democracy. Farmers and scholars, statesmen and patriots who had traveled across the ocean to escape tyranny and persecution finally made real their declaration of independence at a Philadelphia convention that lasted through the spring of 1787.

The document they produced was eventually signed but ultimately unfinished. It was stained by this nation's original sin of slavery, a question that divided the colonies and brought the convention to a stalemate until the founders chose to allow the slave trade to continue for at least 20 more years, and to leave any final resolution to future generations.

Of course, the answer to the slavery question was already embedded within our Constitution – a Constitution that had at its very core the ideal of equal citizenship under the law; a Constitution that promised its people liberty, and justice, and a union that could be and should be perfected over time.

And yet words on a parchment would not be enough to deliver slaves from bondage, or provide men and women of every color and creed their full rights and obligations as citizens of the United States. What would be needed were Americans in successive generations who were willing to do their part – through protests and struggles, on the streets and in the courts, through a civil war and civil disobedience and always at great risk – to narrow that gap between the promise of our ideals and the reality of their time.

This was one of the tasks we set forth at the beginning of this presidential campaign – to continue the long march of those who came before us, a march for a more just, more equal, more free, more caring and more prosperous America. I chose to run for president at this moment in history because I believe deeply that we cannot solve the challenges of our time unless we solve them together – unless we perfect our union by understanding that we may have different stories, but we hold common hopes; that we may not look the same and may not have come from the same place, but we all want to move in the same direction – towards a better future for our children and our grandchildren.

This belief comes from my unyielding faith in the decency and generosity of the American people. But it also comes from my own story.

I am the son of a black man from Kenya and a white woman from Kansas. I was raised with the help of a white grandfather who survived a Depression to serve in Patton's Army during World War II and a white grandmother who worked on a bomber assembly line at Fort Leavenworth while he was overseas. I've gone to

some of the best schools in America and lived in one of the world's poorest nations. I am married to a black American who carries within her the blood of slaves and slave owners – an inheritance we pass on to our two precious daughters. I have brothers, sisters, nieces, nephews, uncles and cousins, of every race and every hue, scattered across three continents, and for as long as I live, I will never forget that in no other country on Earth is my story even possible.

It's a story that hasn't made me the most conventional of candidates. But **it is a story that has seared into my genetic makeup the idea that this nation is more than the sum of its parts – that out of many, we are truly one.**

Throughout the first year of this campaign, against all predictions to the contrary, we saw how hungry the American people were for this message of unity. Despite the temptation to view my candidacy through a purely racial lens, we won commanding victories in states with some of the whitest populations in the country. In South Carolina, where the Confederate flag still flies, we built a powerful coalition of African-Americans and white Americans.

This is not to say that race has not been an issue in this campaign. **At various stages in the campaign, some commentators have deemed me either "too black" or "not black enough."** We saw racial tensions bubble to the surface during the week before the South Carolina primary. The press has scoured every single exit poll for the latest evidence of racial polarization, not just in terms of white and black, but black and brown as well. And yet, it's only been in the last couple of weeks that the discussion of race in this campaign has taken a particularly divisive turn.

On one end of the spectrum, we've heard the implication that my candidacy is somehow an exercise in affirmative action; that it's based solely on the desire of

wide-eyed liberals to purchase racial reconciliation on the cheap. On the other end, we've heard my former pastor, Jeremiah Wright, use incendiary language to express views that have the potential not only to widen the racial divide, but views that denigrate both the greatness and the goodness of our nation, and that rightly offend white and black alike.

I have already condemned, in unequivocal terms, the statements of Reverend Wright that have caused such controversy and in some cases pain. For some, nagging questions remain. Did I know him to be an occasionally fierce critic of American domestic and foreign policy? Of course. **Did I ever hear him make remarks that could be considered controversial while I sat in the church? Yes.** Did I strongly disagree with many of his political views? Absolutely – just as I'm sure many of you have heard remarks from your pastors, priests or rabbis with which you strongly disagreed.

But the remarks that have caused this recent firestorm weren't simply controversial. They weren't simply a religious leader's efforts to speak out against perceived injustice. Instead, they expressed a profoundly distorted view of this country – a view that sees white racism as endemic, and that elevates what is wrong with America above all that we know is right with America; a view that sees the conflicts in the Middle East as rooted primarily in the actions of stalwart allies like Israel, instead of emanating from the perverse and hateful ideologies of radical Islam.

As such, Reverend Wright's comments were not only wrong but divisive, divisive at a time when we need unity; racially charged at a time when we need to come together to solve a set of monumental problems – two wars, a terrorist threat, a falling economy, a chronic health care crisis and potentially devastating climate change; problems that are neither black or white or Latino or Asian, but rather problems that confront us all.

Given my background, my politics, and my professed values and ideals, there will no doubt be those for whom my statements of condemnation are not enough. Why associate myself with Reverend Wright in the first place, they may ask. Why not join another church? And I confess that if all that I knew of Reverend Wright were the snippets of those sermons that have run in an endless loop on the television sets and YouTube, or if Trinity United Church of Christ conformed to the caricatures being peddled by some commentators, there is no doubt that I would react in much the same way.

But the truth is, that isn't all that I know of the man. The man I met more than 20 years ago is a man who helped introduce me to my Christian faith, a man who spoke to me about our obligations to love one another, to care for the sick and lift up the poor. He is a man who served his country as a United States Marine, who has studied and lectured at some of the finest universities and seminaries in the country, and who over 30 years has led a church that serves the community by doing God's work here on Earth − by housing the homeless, ministering to the needy, providing day care services and scholarships and prison ministries, and reaching out to those suffering from HIV/AIDS.

In my first book, *Dreams from My Father*, I described the experience of my first service at Trinity − and it goes as follows:

"People began to shout, to rise from their seats and clap and cry out, a forceful wind carrying the reverend's voice up to the rafters. . . . And in that single note − hope! − I heard something else; at the foot of that cross, inside the thousands of churches across the city, **I imagined the stories of ordinary black people merging with the stories of David and Goliath, Moses and Pharaoh, the Christians in the lion's den, Ezekiel's field of dry bones.** Those stories − of survival, and freedom, and hope − became our stories, my story; the blood that spilled was our blood, the tears our tears; until this black church, on

this bright day, seemed once more a vessel carrying the story of a people into future generations and into a larger world. Our trials and triumphs became at once unique and universal, black and more than black; in chronicling our journey, the stories and songs gave us a meaning to reclaim memories that we didn't need to feel shame about . . . memories that all people might study and cherish – and with which we could start to rebuild."

That has been my experience at Trinity. Like other predominantly black churches across the country, Trinity embodies the black community in its entirety – the doctor and the welfare mom, the model student and the former gang-banger. Like other black churches, Trinity's services are full of raucous laughter and sometimes bawdy humor. They are full of dancing, and clapping, and screaming and shouting that may seem jarring to the untrained ear. **The church contains in full the kindness and cruelty, the fierce intelligence and the shocking ignorance, the struggles and successes, the love and, yes, the bitterness and biases that make up the black experience in America.**

And this helps explain, perhaps, my relationship with Reverend Wright. As imperfect as he may be, he has been like family to me. He strengthened my faith, officiated my wedding, and baptized my children. Not once in my conversations with him have I heard him talk about any ethnic group in derogatory terms, or treat whites with whom he interacted with anything but courtesy and respect. He contains within him the contradictions – the good and the bad – of the community that he has served diligently for so many years.

I can no more disown him than I can disown the black community. I can no more disown him than I can disown my white grandmother – a woman who helped raise me, a woman who sacrificed again and again for me, a woman who loves me as much as she loves anything in this world, but a woman who once confessed her fear of black men who passed her by on the street, and who on more than

one occasion has uttered racial or ethnic stereotypes that made me cringe. **These people are part of me. And they are a part of America, this country that I love.**

Now some will see this as an attempt to justify or excuse comments that are simply inexcusable. I can assure you it is not. And I suppose the politically safe thing to do would be to move on from this episode and just hope that it fades into the woodwork. We can dismiss Reverend Wright as a crank or a demagogue, just as some have dismissed Geraldine Ferraro, in the aftermath of her recent statements, as harboring some deep-seated bias.

But race is an issue that I believe this nation cannot afford to ignore right now. We would be making the same mistake that Reverend Wright made in his offending sermons about America – to simplify and stereotype and amplify the negative to the point that it distorts reality.

The fact is that the comments that have been made and the issues that have surfaced over the last few weeks reflect the complexities of race in this country that we've never really worked through – a part of our union that we have not yet made perfect. And if we walk away now, if we simply retreat into our respective corners, we will never be able to come together and solve challenges like health care, or education, or the need to find good jobs for every American.

Understanding this reality requires a reminder of how we arrived at this point. As William Faulkner once wrote, "The past isn't dead and buried. In fact, it isn't even past." We do not need to recite here the history of racial injustice in this country. But we do need to remind ourselves that so many of the disparities that exist between the African-American community and the larger American community today can be traced directly to inequalities passed on from an earlier generation that suffered under the brutal legacy of slavery and Jim Crow.

Segregated schools were, and are, inferior schools; we still haven't fixed them, 50 years after *Brown v. Board of Education*, and the inferior education they provided, then and now, helps explain the pervasive achievement gap between today's black and white students.

Legalized discrimination – where blacks were prevented, often through violence, from owning property, or loans were not granted to African-American business owners, or black homeowners could not access FHA mortgages, or blacks were excluded from unions, or the police force, or the fire department – meant that black families could not amass any meaningful wealth to bequeath to future generations. That history helps explain the wealth and income gap between blacks and whites, and the concentrated pockets of poverty that persist in so many of today's urban and rural communities.

A lack of economic opportunity among black men, and the shame and frustration that came from not being able to provide for one's family, contributed to the erosion of black families – a problem that welfare policies for many years may have worsened. And the lack of basic services in so many urban black neighborhoods – parks for kids to play in, police walking the beat, regular garbage pickup, building code enforcement – all helped create a cycle of violence, blight and neglect that continues to haunt us.

This is the reality in which Reverend Wright and other African-Americans of his generation grew up. They came of age in the late '50s and early '60s, a time when segregation was still the law of the land and opportunity was systematically constricted. **What's remarkable is not how many failed in the face of discrimination, but how many men and women overcame the odds;** how many were able to make a way out of no way for those like me who would come after them.

But for all those who scratched and clawed their way to get a piece of the American Dream, there were many who didn't make it – those who were ultimately defeated, in one way or another, by discrimination. That legacy of defeat was passed on to future generations – those young men and, increasingly, young women who we see standing on street corners or languishing in our prisons, without hope or prospects for the future. Even for those blacks who did make it, questions of race, and racism, continue to define their worldview in fundamental ways. **For the men and women of Reverend Wright's generation, the memories of humiliation and doubt and fear have not gone away;** nor have the anger and the bitterness of those years. That anger may not get expressed in public, in front of white co-workers or white friends. But it does find voice in the barbershop or the beauty shop or around the kitchen table. At times, that anger is exploited by politicians to gin up votes along racial lines, or to make up for a politician's own failings.

And occasionally it finds voice in the church on Sunday morning, in the pulpit and in the pews. The fact that so many people are surprised to hear that anger in some of Reverend Wright's sermons simply reminds us of the old truism that the most segregated hour of American life occurs on Sunday morning. That anger is not always productive; indeed, all too often it distracts attention from solving real problems; it keeps us from squarely facing our own complicity, within the African-American community, in our own condition, and prevents the African-American community from forging the alliances it needs to bring about real change. **But the anger is real; it is powerful; and to simply wish it away, to condemn it without understanding its roots, only serves to widen the chasm of misunderstanding that exists between the races.**

In fact, a similar anger exists within segments of the white community. Most working- and middle-class white Americans don't feel that they have been particularly privileged by their race. Their experience is the immigrant

experience – as far as they're concerned, no one handed them anything, they've built it from scratch. They've worked hard all their lives, many times only to see their jobs shipped overseas or their pensions dumped after a lifetime of labor. They are anxious about their futures, and they feel their dreams slipping away; and **in an era of stagnant wages and global competition, opportunity comes to be seen as a zero-sum game, in which your dreams come at my expense.** So when they are told to bus their children to a school across town; when they hear that an African-American is getting an advantage in landing a good job or a spot in a good college because of an injustice that they themselves never committed; when they're told that their fears about crime in urban neighborhoods are somehow prejudiced, resentment builds over time.

Like the anger within the black community, these resentments aren't always expressed in polite company. But they have helped shape the political landscape for at least a generation. Anger over welfare and affirmative action helped forge the Reagan coalition. Politicians routinely exploited fears of crime for their own electoral ends. Talk show hosts and conservative commentators built entire careers unmasking bogus claims of racism while dismissing legitimate discussions of racial injustice and inequality as mere political correctness or reverse racism.

Just as black anger often proved counterproductive, so have these white resentments distracted attention from the real culprits of the middle-class squeeze – a corporate culture rife with inside dealing, questionable accounting practices, and short-term greed; a Washington dominated by lobbyists and special interests; economic policies that favor the few over the many. And yet, to wish away the resentments of white Americans, to label them as misguided or even racist, without recognizing they are grounded in legitimate concerns – this too widens the racial divide, and blocks the path to understanding. This is where we are right now. It's a racial stalemate we've been stuck in for years. Contrary to the claims of some of my critics, black and white, I have never been so naïve as

to believe that we can get beyond our racial divisions in a single election cycle, or with a single candidacy − particularly a candidacy as imperfect as my own.

But I have asserted a firm conviction − a conviction rooted in my faith in God and my faith in the American people − that, **working together, we can move beyond some of our old racial wounds, and that in fact we have no choice if we are to continue on the path of a more perfect union.**

For the African-American community, that path means embracing the burdens of our past without becoming victims of our past. It means continuing to insist on a full measure of justice in every aspect of American life. But it also means binding our particular grievances − for better health care, and better schools, and better jobs − to the larger aspirations of all Americans: the white woman struggling to break the glass ceiling, the white man who's been laid off, the immigrant trying to feed his family. And **it means also taking full responsibility for our own lives** − by demanding more from our fathers, and spending more time with our children, and reading to them, and teaching them that while they may face challenges and discrimination in their own lives, they must never succumb to despair or cynicism; they must always believe that they can write their own destiny.

Ironically, this quintessentially American − and, yes, conservative − notion of self-help found frequent expression in Reverend Wright's sermons. But what my former pastor too often failed to understand is that embarking on a program of self-help also requires a belief that society can change.

The profound mistake of Reverend Wright's sermons is not that he spoke about racism in our society. It's that he spoke as if our society was static; as if no progress has been made; as if this country − a country that has made it possible for one of his own members to run for the highest office in the land and build a coalition of white and black, Latino and Asian, rich and poor, young and old − is

still irrevocably bound to a tragic past. What we know — what we have seen — is that **America can change. That is the true genius of this nation.** What we have already achieved gives us hope — the audacity to hope — for what we can and must achieve tomorrow.

In the white community, the path to a more perfect union means acknowledging that what ails the African-American community does not just exist in the minds of black people; that the legacy of discrimination — and current incidents of discrimination, while less overt than in the past — that these things are real and must be addressed. Not just with words, but with deeds — by investing in our schools and our communities; by enforcing our civil rights laws and ensuring fairness in our criminal justice system; by providing this generation with ladders of opportunity that were unavailable for previous generations. It requires all Americans to realize that your dreams do not have to come at the expense of my dreams; that investing in the health, welfare and education of black and brown and white children will ultimately help all of America prosper.

In the end, then, what is called for is nothing more, and nothing less, than what all the world's great religions demand — that we do unto others as we would have them do unto us. Let us be our brother's keeper, Scripture tells us. Let us be our sister's keeper. Let us find that common stake we all have in one another, and let our politics reflect that spirit as well.

For we have a choice in this country. We can accept a politics that breeds division, and conflict, and cynicism. We can tackle race only as spectacle — as we did in the OJ trial — or in the wake of tragedy, as we did in the aftermath of Katrina — or as fodder for the nightly news. We can play Reverend Wright's sermons on every channel, every day, and talk about them from now until the election, and make the only question in this campaign whether or not the American people think that I somehow believe or sympathize with his most offensive words. We can pounce

on some gaffe by a Hillary supporter as evidence that she's playing the race card, or we can speculate on whether white men will all flock to John McCain in the general election regardless of his policies. We can do that.

But if we do, I can tell you that in the next election, we'll be talking about some other distraction. And then another one. And then another one. And nothing will change.

That is one option. Or, **at this moment, in this election, we can come together and say, "Not this time."** This time we want to talk about the crumbling schools that are stealing the future of black children and white children and Asian children and Hispanic children and Native American children. This time we want to reject the cynicism that tells us that these kids can't learn; that those kids who don't look like us are somebody else's problem. The children of America are not those kids, they are our kids, and we will not let them fall behind in the 21st-century economy. Not this time.

This time we want to talk about how the lines in the emergency room are filled with whites and blacks and Hispanics who do not have health care; who don't have the power on their own to overcome the special interests in Washington, but who can take them on if we do it together.

This time we want to talk about the shuttered mills that once provided a decent life for men and women of every race, and the homes for sale that once belonged to Americans from every religion, every region, every walk of life. This time we want to talk about the fact that the real problem is not that someone who doesn't look like you might take your job; it's that the corporation you work for will ship it overseas for nothing more than a profit.

This time we want to talk about the men and women of every color and creed who serve together, and fight together, and bleed together under the same proud flag. We want to talk about how to bring them home from a war that should've never been authorized and should've never been waged, and we want to talk about how we'll show our patriotism by caring for them, and their families, and giving them the benefits that they have earned.

I would not be running for president if I didn't believe with all my heart that this is what the vast majority of Americans want for this country. **This union may never be perfect, but generation after generation has shown that it can always be perfected.** And today, whenever I find myself feeling doubtful or cynical about this possibility, what gives me the most hope is the next generation — the young people whose attitudes and beliefs and openness to change have already made history in this election.

There is one story in particular that I'd like to leave you with today — a story I told when I had the great honor of speaking on Dr. King's birthday at his home church, Ebenezer Baptist, in Atlanta.

There is a young 23-year-old woman, a white woman named Ashley Baia, who organized for our campaign in Florence, South Carolina. She had been working to organize a mostly African-American community since the beginning of this campaign, and one day she was at a roundtable discussion where everyone went around telling their story and why they were there.

And Ashley said that when she was nine years old, her mother got cancer. And because she had to miss days of work, she was let go and lost her health care. They had to file for bankruptcy, and that's when Ashley decided that she had to do something to help her mom. She knew that food was one of their most expensive costs, and so Ashley convinced her mother that what she really liked and really

wanted to eat more than anything else was mustard and relish sandwiches. Because that was the cheapest way to eat. That's the mind of a nine-year-old. She did this for a year until her mom got better, and she told everyone at the roundtable that the reason she had joined our campaign was so that she could help the millions of other children in the country who want and need to help their parents too.

Now, Ashley might have made a different choice. Perhaps somebody told her along the way that the source of her mother's problems was blacks who were on welfare and too lazy to work, or Hispanics who were coming into the country illegally. But she didn't. She sought out allies in her fight against injustice.

Anyway, Ashley finishes her story and then goes around the room and asks everyone else why they're supporting the campaign. They all have different stories and different reasons. Many bring up a specific issue. And finally they come to this elderly black man who's been sitting there quietly the entire time. And Ashley asks him why he's there. And he does not bring up a specific issue. He does not say health care or the economy. He does not say education or the war. He does not say that he was there because of Barack Obama. He simply says to everyone in the room, "I am here because of Ashley."

"I'm here because of Ashley." **By itself, that single moment of recognition between that young white girl and that old black man is not enough.** It is not enough to give health care to the sick, or jobs to the jobless, or education to our children.

But it is where we start. It is where our union grows stronger. And as so many generations have come to realize over the course of the 221 years since a band of patriots signed that document right here in Philadelphia, that is where the perfection begins. ★

Thanks to America's great newspapers . . . and newspapers around the globe. The world's media may be changing at an ever-quickening pace, but newspapers still play a unique and valuable role in our public life . . . and we all still want to commemorate life's great historic events with newspapers.

Produced and Directed by: David Elliot Cohen and Mark Greenberg

Design: Lori Barra, TonBo designs, Sausalito, CA

Digital Production and Color Management: Peter Truskier,
Premedia Systems Inc., Danville, CA

Copyediting: Sherri Schultz

Production Assistant: Josh Dodd

Publicity: Gareth Edmondson-Jones and Caroline Brown

Special Thanks to:
Michael Fragnito, Barbara Berger and Fred Pagan at Sterling Publishing Co., Inc.
Mark Liebman at Pictopia (www.pictopia.com)

The Photomosaic® on page 5 is © 2009 David Burnett (photo) Robert Silvers (art).
A poster of this Photomosaic is available at: **www.obamathehistoricfrontpages.com**

Good luck and Godspeed, Mr. President!